HOW TO SUCCEED IN
COMMERCIAL PHOTOGRAPHY

Insights from a Leading Consultant

SELINA MAITREYA

ALLWORTH PRESS
NEW YORK

11 10 09 08 5 4 3 2

Published by Allworth Press
An imprint of Allworth Communications, Inc.
10 East 23rd Street, New York, NY 10010

Cover design by Derek Bacchus
Interior design by Joan O'Connor
Page composition/typography by Integra Software Services, Pvt., Ltd., Pondicherry, India
Cover photo by John Soares

ISBN-13: 978-1-58115-491-7
ISBN-10: 1-58115-491-7

Library of Congress Cataloging-in-Publication Data:

Maitreya, Selina.
 How to succeed in commercial photography : insights from a leading consultant / Selina Maitreya.
 p. cm.
 ISBN-13: 978-1-58115-491-7 (pbk.)
 ISBN-10: 1-58115-491-7 (pbk.)
1. Commercial photography–Vocational guidance. I. Title.

TR154.M345 2007
770.23′2—dc22
 2007013161

Dedication

*This book is dedicated to my boys Sam and Jake
Oppenheim who are two of the finest people I
have ever had the pleasure of sharing a life
with. They continue to love, challenge, and
teach me about caring, integrity, honesty,
truth, and poker.*

*This book was written in honor of my dear
friend Bill Smith whose loyalty and friendship
was never in doubt and whose humor and love
will live on in the hearts of those who had the
honor to know and love him.*

CONTENTS

Acknowledgments vi

Introduction vii

PART I VALUES 1

1. Your Values, Your Business 3
2. Do You Have a Product to Sell? 10
3. Defining Your Visual Value 16
4. The Service Component 22
5. Success or Failure: It's All about Value 30

PART II VISION 35

6. Creating Success 37
7. Develop a Vision-Based Portfolio 43
8. Building a New Portfolio:
 Photographers Speak 48
9. Millicent Harvey's Vision Quest 53
10. Vision: The Client's Perspective 57
11. The Gift of Choice 62

PART III TEAM 67

12. Agents, Marketing Assistants, Consultants:
 Who Is Right for You? 69
13. The Realities of Representation 77
14. The New Breed of Agent 84
15. Objective Help from the Business Consultant 91
16. Team Armour 96

PART IV TOOLS 101

17. Habit or Trend 103
18. Building a Print Book to Envy 110
19. Online Portfolios that Sell 118
20. Truth, Lies, and Self-Promotion 125
21. Face Time 133
22. Turn the Page 141
23. Photography and Divinity 145

PART V PERSISTENCE 151

24. Working through Creative Blocks 153
25. Starting out Lou Roole Style 159
26. Persistence and the Art of Lise Metzger 163
27. Sherman Sells 167
28. A Success Story 172
29. Zave Smith's Consistent Message 176

PART VI FAITH 181

30. How to Survive during Difficult Times 183
31. Affirmations: Your New Marketing Tool 188
32. Walking Your Talk 193
33. Show Up 198
34. Fear 205
35. Photographers on Faith 210

Websites 217

Index 219

About the Author 225

ACKNOWLEDGMENTS

My thanks:

To the crew at Allworth for their patience and kindness: Tad Crawford, Nicole Potter-Talling, Derek Bacchus, Joan O'Connor, Michael Madole, and Allison Caplin.

To the following talented people who generously shared their thoughts, values, knowledge, and experiences and who are quoted within: Zave Smith, Lou Roole, Tom Johnson, Lise Metzger, Steve Sherman, Laura Bonicelli, Patti Silverstein, Leslie Burns, Ted Rice, Beverly Adler, Marc Hauser, Michael Grecco, Jonathan Hillyer, David Stewart, Scott Mullenberg, Kat Dalager, Ellen Gish, Robert Kent, Niki Kendall, Nancy Grant, Ira Kerns, Ed and Mariette White, Millicent Harvey, John Myers, Ralph Mennemeyer, Quitze Nelson, Karineh Gurjian Angelo, Jake Armour, Charles Imstepf, Karen Frank, Chris Peters, Simon Plant, Dave Wendt, Paula Lerner, Bonni Carson DiMatteo, Eric Kaas, Michael Furman, Jean Burnstine, John Sharp, Susan Austrian, and Edith Leonian.

My appreciation for fabulous cover art is extended to photographer extraordinaire John Soares, model George Hall, and jetpack maker Nancy Rider.

Everyone needs a home team, the beings that love and support you. The people that tell you like it is and listen to your thoughts about what you think the truth looks like. My team is amazing and I am indebted to them for their love and loyalty: Paula, Sage, Jenny, Jane, Rob, Michele, Tobi, Selma, Roz, Ralph, HOPE, Carol, Dave, Mark, Madelyn, Steve, Joanie, and Marc.

And finally I give continual thanks to Ralph Hubbard for his kindness, genius, love, and for the truth, acceptance, joy, and constant teaching that he shares with me every day.

INTRODUCTION

I didn't decide to be a
photographer; I just happened
to fall into it.

—BERENICE ABBOTT

Anyone can take pictures. Anybody can hang up a shingle and call himself or herself a photographer. However, building a successful photography business, one that will enable you to continue to reap the benefits of your hard work, is no easy task. In the last ten years and then again in the last five years, the marketing, selling, and servicing formulas in the field of commercial photography have dramatically changed. The truth is, they will always be changing and most likely at mind-boggling speed.

In order to build a business that meets your creative, financial, and professional goals while staying relevant in an ever-changing industry you will need to embrace a whole new paradigm for developing your business.

You must approach the task of building and maintaining a successful photography business from a holistic perspective, as it is no longer just about the bottom-line figures.

Some of the steps you will need to take include the following:

- Crafting a *vision* for your company.
- Continually defining and refining your *visual* product
- Building *value* around your product and increasing your perceived value within the industry you choose to serve
- Being aware of the many photographic *tools* and trends and deciding which ones are appropriate for you
- Choosing sales and marketing *tools* that will help you to build your vision and sell your product in order to build your brand
- Assembling your *team*, the people you select to work with you, those that handle your styling, sales, marketing, consulting,

and accounting services as well as your assistants, studio managers, and the models you hire
- Developing *persistence*, your ability to stay the course no matter how long, tough, and bumpy the road becomes
- Having *faith*, your ultimate partner, the key to producing more and enabling you to sustain anything!

It is no exaggeration to say that a positive attitude and approach, a deep commitment to developing your visual product, and the willingness to meet the market where it is with an open heart are as much a part of your success as having a large studio, catered lunches, and a budget large enough to support a high five-digit ad program.

For these reasons I felt it most important to write a book of teachings that includes the practical as well as the spiritual aspects of developing a successful photography business. The chapters within contain information on the six different aspects of the business that I have listed above (Value, Vision, Team, Tools, Persistence, and Faith), as each is an area that throughout your career you will need to consistently attend to.

After all, the vision that you had for your business when you began will not be the vision your business is guided by as you end your career. The way you "see," the eye you use, the visual talent you employ in the beginning of your profession will be different five years down the line. Your team will change many times. The assistant you had this year will most likely not be the assistant you have three years hence. The cameras you use now may not even be around as you end your career. (Digital photography anyone?) Favorite stylists may come and go, and the marketing assistant you started with may have helped so much that in a few years you are ready for an assignment agent.

These areas must always be the attention of your focus.

Finally, you will want to intentionally approach this constant task of observation and examination with enthusiasm and an open heart.

Within this book, each section includes different essays, each of which contains insights and truths as I know them to be. You may find that different essays resonate with you at different

times in your career. For this reason I have written for the very new photographer and for the most experienced. So you might want to revisit this book from time to time.

The book was written for you to read in sequence or in a random mode, selecting essays by simply opening the book and seeing which body of information pops up. If you choose to do this, trust that the information where you open is exactly what you should be reading. My ultimate wish is that this tome provides you with valuable information that you do not currently have and most definitely need.

MAYBE MY JOURNEY

Many photographers begin their careers with little or no business know-how. I know this from personal experience. I was going to be the next great photographer. Thirty years ago, when I was twenty-one and hanging around with my rock-and-roll boyfriend, he introduced me to photography. I became immediately entranced. I was a "young adult" who had been on my own for years. I struggled to find my spot but never came across a path that felt like me. Then I saw the work of Weegee and Diane Arbus and Annie Leibovitz's early work for *Rolling Stone* and I was hooked. I was convinced that I needed to add photography to my daily intake of late nights and rock music. After I took an adult ed course in the basics of photography my teacher encouraged me to save my bucks and go to photo school. He seemed to think I had talent. It took a year of managing a hippie-dippy bakery before I had saved the $4,000 needed to sign up for the first year of a two-year program at NESOP (New England School of Photography).

I began school in the dead of winter and I loved it. I spent hours in the darkroom, printing and inhaling fixer daily. I stood in Copley Square in subfreezing temperatures, attempting to get the right view of the Boston Public Library on my 4 inch × 5 inch glassviewing screen. When I severely underexposed film during an architectural shoot, older, more experienced students gently guided me. The pièce de résistance?

I got to shoot Tupperware ladies with my new wide-angle lens during their annual national convention. I was in photo heaven!

I planned on continuing at NESOP and decided to sell my beloved '68 Firebird in order to pay for my second year's tuition. My best friend, however, had other ideas. She borrowed my car, slammed back a pint of vodka, and totaled my Firebird on an old oak tree. My dreams of returning to school were dashed, but I decided I was not going to be deterred. I decided to waitress to make money, knowing that photo school was easily another year away.

While serving up chef salads and French dips, I ran into a photographer I had known a few years back in the early seventies. He had left the photo store where he had worked and was now freelancing. He begged me to be his agent, reminding me that I could learn the business during the day while representing him and while still being able to work at night, building up my photo hope chest with waitressing funds for my second year of photo school.

I knew absolutely nothing about the business, but I was eager to hang onto anything photographic and so I jumped at the chance.

He gave me a list of five art directors and his print portfolio and told me to take it to the people on the list. In those days I wore purple tights and a black Capezio dance skirt, and that's how I set out to show my new photographer's portfolio. Rock-and-roll queen meets the ad agency market.

When I called the five art directors on the list I had been given, none of them were there. They had all moved on to other agencies. My first and very brief database of contacts was worthless. I raced to the nearest phone book and started to compile a list of ad agencies. My career in the business of photography was off and running. The rest, as they say, is history. With lots of opportunity and much hard work, my repping career flourished. Two years later, when I returned to NESOP, I presented my first business lecture. I then went on to develop one of the first business courses for photography students in the country.

I happily taught that course at NESOP for many years.

Shortly after I began my teaching gig, I helped establish the Boston Graphic Artist Guild and began giving free information to all artists about the (then) newly crafted 1978 copyright law. It wasn't long before I decided to expand my information bank and my consulting career begun. I have

been counseling photographers from every discipline from portrait to advertising, from editorial to photojournalism, for the last twenty-eight years. My clients now reside across the United States and Canada, with some located in the United Kingdom, India, and Australia.

CHANGES IN TODAY'S BUSINESS

Beginning a career in professional photography as I did, with one year's worth of photo school and no business training, worked in the seventies, but today's market is jam-packed and the "business of having a business" today is extremely complex.

Due to the onslaught of the branding craze, clients now hire a photographer if there is a match between their corporate client's brand message (as exhibited in a layout) and the photographer's vision. This is a huge change from when an existing relationship between a buyer and a photographer was the exclusive reason to hire a talent.

Licensing, an issue since the "new" 1978 copyright law went into effect (which gave photographers the option to resell their work), is still a mystery to many, clients and photographers alike, and the onset of the digital age has waved in not only a new way of capturing images but a new way of seeing and pricing photography. Buyers now peruse Web sites with eyes once reserved for print portfolios, and prospects are seemingly younger and some would say far more inexperienced than their predecessors. Unbelievably cheap royalty-free photos, along with visually stunning stock photography images that come in every shape and size, have narrowed the assignment market dramatically.

Yes, today's world is not for the faint-hearted or for those who throw themselves into a business with little preparation or planning, and it is certainly no place for those who choose to approach their tasks with a negative "I can't win anyway" attitude.

Over the last two dozen or more years, I have had the opportunity to work side by side with hundreds of photographers. I can confidently tell you that with the exception of a few minor specifics, each area of photography requires the same type of attention, and the steps one takes to insure success are quite similar.

Contrary to popular belief, building an editorial client base is no easier than developing advertising clients. Portrait clients are not easier to obtain than corporate prospects. There is no one area of photography that is easier or quicker to succeed in and none that takes more time and attention to maintain. There are no shortcuts, but there are steps that you will need to take in order to be successful. Attitude is everything and a positive, proactive nature beats a reactive, negative approach any day of the week!

WHERE THIS BOOK WILL TAKE YOU

In this book I attempt to share my knowledge with you. The information, guidance, and perspective that I have gleaned over the last twenty-eight years are all here. You are now the beneficiary of my experience. This book covers the main areas that you will need to focus on as you take a fresh new look at how you will develop your business and constantly maintain and retain your client base.

It is my wish that the information in this book will be invaluable to you regardless of where you are in your career. New and experienced photographers alike are accountable on a daily basis for a boatload of tasks, many of which are foreign to them. I am hoping to demystify the process and enlighten you as you seek to do the following:

- Articulate your creative professional and financial goals
- Define and refine your vision
- Develop your product, your body of work that represents your subject of interest and your visual approach to your subject
- Begin to understand your prospects' buying habits
- Build the tools (Web site, print portfolio, e-mailers, and direct mail pieces) that are needed to facilitate your sales and marketing program
- Grow your team, the specialists who will help you to market and service your clients

- Begin the selling and marketing process
- Give all of your efforts time to mature
- Develop a positive attitude that ultimately builds your faith in you, your vision, your clients, and your success

I am exhausted thinking about all that you will be doing, and I am sure that you might be feeling a little overwhelmed as well. The good news—actually the great news—is that these responsibilities do not have to be attended to all at once. In fact, you will find yourself taking on tasks one by one, and if you are smart you will start at the beginning.

To my knowledge there is no book like this available to you. For inside these pages you will find not only my advice but also the voices of countless other photographers who graciously share their experiences and knowledge with you. There are many stories that highlight a single photographer, detailing his or her journey and the lessons learned. I have included advice from clients, agents, and other consultants in order to bring to you a comprehensive understanding of what I believe it truly takes to be successful in our industry.

I have very specifically not written this book as "a how to do book," for I do not believe that there is one way to create a business. The following essays were written because, individually and collectively, they contain information that is at the core of every photography business. These are the topics that you must constantly put your attention on, examine, and decide how to respond to. Many topics are discussed and explored, but the journey is ultimately yours to make.

A client who visited my class at NESOP many years ago shared with us the following words. This declaration is extremely powerful and speaks to the one defining element that must be present in any business that is poised for success. I have ended over one hundred lectures with this statement, and I share it now with you in the hope that it sets the tone for you as you embark on the journey of choosing success!

Until one is committed, there is hesitancy, the chance to draw back, always ineffectiveness. Concerning all acts of initiative (and creation), there is one elementary truth,

the ignorance of which kills countless ideas and splendid plans: the moment one definitely commits oneself, then Providence moves, too.

All sorts of things occur to help one that would never otherwise have occurred. A whole stream of events issues from the decision, raising in one's favor all manner of unforeseen incidents and meetings and material assistance which no man could have dreamt would come his way.

I have learned a deep respect for one of Goethe's couplets: *"Whatever you can do, or dream you can, begin it. / Boldness has genius, power, and magic in it."*

PART I

VALUES

THERE'S NO PARTICULAR CLASS
OF PHOTOGRAPH THAT I THINK
IS ANY BETTER THAN ANY
OTHER CLASS. I'M ALWAYS AND
FOREVER LOOKING FOR THE
IMAGE THAT HAS SPIRIT!
I DON'T GIVE A DAMN
HOW IT GOT MADE.

—MINOR WHITE

CHAPTER 1

YOUR VALUES, YOUR BUSINESS

Building a business based on your values is one of the most important responsibilities that you have as a freelance photographer. It is also a tremendous opportunity.

Being awake to ideals that you hold as "true" creates a state of consciousness that will positively affect every aspect of your business.

As you develop a body of work from a state of true awareness of your talent and market needs, you will be able to create online and print portfolios that clearly represent your visual value to buyers.

Your principles will also serve you well as you create your service goals. Making conscious choices about how you will meet deadlines, entertain clients, and follow up jobs will guarantee your clients a positive experience.

Business and licensing practices developed around your standards can be clearly and kindly communicated to clients as needed.

While most photographers do have values that define their company, few take the time to proactively examine, define, and build their businesses around them. Have you built your business with your principles in mind? Do they guide your daily decisions? Are your business goals in sync with your family and personal values?

BALANCING PRIORITIES

Ted Rice has been a successful photographer for many years. He is the person who comes to mind when I think of a photographer who is invested in building a business and a life from a position of being aware. He has recently made a life change that has temporarily taken him out of the mainstream photo world. He has made this decision in order to "live" the values that he has set for himself, and here he explains the decision:

> One of the things that I've always found interesting about the photography business is that there is not just one business model. There are a wide range of models, each of which can provide success. For a long time I made portrait and people pictures for the commercial market and was tightly focused on expanding the economic and aesthetic elements of my business. Over time I achieved many of my goals and at the same time began a family. My priorities began to shift and, as much as I loved photography, I loved being at home with my wife and kids even more. It has been hard to resolve the tension between work and family, but for me there has never been a doubt that my family comes first. My wife is an academic and this year I am taking a page from her playbook: I am taking a sabbatical in which I'm involved in activities that have nothing to do with photography, not the least of which is being much more involved in the day-to-day life of my family. I am still taking some jobs as they fit our family schedule and am happy to work when I do, but it is not the priority it once was. Hard to say where it will lead, but after struggling with this issue for several years, it seems best to just relax and see where "the river flows."

In order to deliver on your beliefs, as Ted continues to do, and to begin to develop a successful business based on your values, you will need to become familiar with what a successful photo business looks like to you. This is a large task and indeed the first step toward building a business that is developed around your values, a business that will be created to serve your needs.

Begin by examining your belief about success. What does success look like to you? Is it about the money you earn? The relationships you create? Being challenged by the work? Is it about having your work accepted in competitions like the *Communication Arts* photo annual? What does success *really* look like to you?

THE DREAM BIO

When I taught at a photo school years ago, I gave my students an assignment. I called it a "Dream Bio." They were to create their own. The assignment was designed to help them see what success looked like to them.

Regardless of where you are now in your career, the Dream Bio can be a tool that you can use as well.

Begin to create this tool in an atmosphere that is calm and relaxing. Have a free hour or more with no interruptions. Sit down and imagine that you are living five years in the future. What does your professional life look like? What are you shooting? Who are your clients? Do you have a team or are you a solo operation? What does your space look like? Do you have a studio or are you working out of an office in your home? How much money are you making? How many days a week do you shoot on average? What has been your best experience and what has been your biggest disappointment?

When you create this bio you are not in your head. You are in your heart. Don't think the answers; sense them. Write them down as soon as they appear without any editing.

If you have been able truly to write your bio without judgment (no scratched-out sentences), you have created a dream bio that will give you much information.

Don't spell-check. Simply put the bio away and plan a review date for two weeks later.

When you are ready to review what you have written, pull out your dream bio, read it with an open heart and no preconceived notions of what is attainable and what is not. You will most likely be surprised by what you see. Once you have read it through, begin to examine what you have written, looking to see where your priorities lie within your words. These priorities will begin to help you see what success looks like to you.

Was money your most important priority? Space? Your team? Recognition? What part of your bio did you write about the most?

As you read and examine, resist the urge to edit. Shush the voice that begins to tell you that this is all nonsense. Be open to the information that your answers have for you. These were your choices and they need to be heard. Honor the words and ideas that you wrote down.

Finally, look to see how close your current life is to what you have written down. Is it a hop, a skip, or a jump from where you are now to your dream bio life?

As you go through the process of reviewing, do not disregard any parts of your dream bio that seem like fantasy. It is all possible. You simply need to determine which goals are meaningful enough to you in order to commit to the hard work needed to reach them.

Once you feel that you are done reviewing and that you have gleaned as much information as possible, look at what you have written and begin to list for yourself what success looks like to you.

Once you have your success list, begin to compare it to your life as it is now, and evaluate the different areas of your business that need attention.

Historically, photographers find that when they initially take inventory, their visual content, their client relationships, and the amount of money they make is not in line with their dreams. This is not surprising as it is hard to accomplish exactly what you want unless you have specifically put your attention on it.

If you have realized through this practice that a value you have is to produce high-quality visuals for your clients, take an inventory of what now exists. Do your images hold up to your expectations? Are you showing a complete "body of work"? Will your prospects know which assignments to call you for? Is this the best work that you can do?

Being integral, walking your talk, begins with the work. Make sure that you believe in the work and are excited about the visual talent that you are selling.

Interestingly enough, I have consulted with many photographers over the years who could not understand why they could not inspire themselves to sell their work. They would castigate themselves, thinking that they should be out selling. When we got together and I reviewed the work, it often became clear that the

portfolio was not competitive and their efforts needed to be applied to developing a competitive body of work, one they would be pumped to go out and sell. Somehow they knew on an unconscious level that the work was not good enough. That's why they were not actively selling. Being unaware of where you sit with your work is not acceptable for people whose value is to create work that represents the best of what they have to offer clients.

Take an inventory of your images. If you have any doubt that you can do better, begin now to develop work that you can't wait to show and sell.

VALUES SHAPE RELATIONSHIPS

Your values will shape your relationships with clients.

They will also energetically attract clients with similar ideals. While this is not an exact science, my experience as a consultant has given me much opportunity to observe the businesses of several hundred photographers over the last twenty-eight years. It is no exaggeration to say that your attitudes and how you service clients will draw specific people to you.

People who are service-oriented, have a positive demeanor, treat others kindly, and price their work fairly tend to attract clients who are looking to work in a win-win fashion.

If you find yourself complaining about clients, whining about how you never get paid enough, and how all your clients never seem to appreciate what you do, you will draw to you people who also have this outlook on life. It's called the Law of Attraction and many books and films have documented how this works. If you see yourself in a whiny, complaining mode, stop it now, unless you wish to attract whiny, complaining clients.

Your job is to build a business around the values that are truly yours, knowing that in doing so you will attract the clients you seek.

The next step is to determine what type of relationships you would like to build with your clients. How will you serve those that hire you? While relationships in today's market look and feel different than they did ten years ago (clients had more time, there were no art buyers, and people answered their phones), relationships do exist and are often the reason why a photographer is hired for a specific assignment.

Consider creating service goals and making sure that everyone who works with you, from daily assistants to your monthly bookkeeper, is aware of and agrees to your ideals when it comes to serving clients.

HONORING YOURSELF FINANCIALLY

Pricing and licensing are perhaps the area of business where photographers have the toughest time creating and adhering to their values.

Leslie Burns-Dell'Acqua, author of the book *Business Basics for the Successful Commercial Photographer*, is a photo consultant located in California and works with photographers on licensing issues daily.

She urges photographers to become educated and to use the licensing system. She sees it as an expression of a photographer's professionalism and a benefit to his or her total well-being: "I think that photographers get several levels of benefits by structuring their businesses around the usage licensing model. On the most basic level—financial—photographers who license their work and who are the most stringent about pricing their licenses on the value of their images vis-à-vis their use, are, in my experience, significantly more successful. Simply put, they make more money." She continues:

> On a deeper level, they tend to be happier people. This is not only because they are making more money (after all, money is not the key to happiness); they're making that money in fewer hours of travail. In other words, those who license have more time for their personal and family lives because they don't have to work insane hours to make their "nut." Having a healthy balance between work and home lives results in happier creative. Having a healthy and happy life both inside and outside of work enriches the soul. That is vital to running a truly successful creative business. When you are calm, rested, and undistracted by fear, you can focus your mind on what you choose— you're in control. That ability to focus results in better

8

creative thought, which results in better creative work, which results in a better portfolio (online and print), which results in attracting better clients who are willing to pay well because they recognize the value of the creativity in your work.

All of this is essentially saying that photographers who honor themselves, their work, and their lives manifest their values by running their businesses in this manner. They also demonstrate respect for their colleagues and the industry as a whole. They even show respect for their clients. After all, when a photographer prices appropriately the usage for an image for an ad with, say, a million-dollar placement, they are showing the other creative involved and the end-client that all the creative work is worthy of that placement cost. "It costs more because it is worth more" is the old line, and true it is. The best part of living your life and running your business in a values-based manner (of which the licensing system is one facet) is that you then are living and working congruently with your authentic self. You make no false promises, you don't lie, and you don't have to juggle all the balls that deceit like that brings. You're free to focus on the positive, to explore your creative vision, and to be the artist and businessperson you really are inside. No apologies. And living in truth, well, you pretty much can't help but be successful.

When you chose to be a freelancer you gave yourself a superb opportunity to create your own destiny. You signed up to build a business that would meet your goals and would function based on your values. Clearly, your visual inventory, your choice of how you will service your clients, and your decisions about how you will price and license your images are three key areas about which you need to make decisions with your values in hand. This is only the beginning, so start here and begin to build a business based on your values—one that is indeed a business to value.

Chapter 2

DO YOU HAVE
A PRODUCT
TO SELL?

If I were at a party and the room was filled with photographers, I would be the person asking each shooter, "What's your product?" "What are you selling to your clients?"

Chances are that almost all of the folks responding would look perplexed and confused.

Commercial photographers rarely think the way a businessperson does. Fewer photographers than businesspeople think that they have a product to sell. This is a major problem. The reality is that your buyers see photography as a product to purchase. As consumers they need to be presented with a product that is easily defined and carries value. Your job is to define, develop, and market your product, making sure that its value is evident. Understanding, embracing, and utilizing this one concept can radically change your approach to your business.

Zave Smith, a successful lifestyle shooter based in Philadelphia, has the concept down:

> When I think about what my clients are buying I tend to think only in terms of my vision, my ability to create wonderful imagery. My clients on the other hand have a different perspective. They have a client to satisfy, a campaign to produce. My imagery is just one part, a key

element that all of their work may rest upon. Agencies require not only great pictures but also good service. By thinking of the whole package as a product, I have learned to make the front- and back-end process—from shoot concepting, to estimating, to file preparation, to final invoicing—as easy and simple as possible for our clients.

If you still think that you don't need to "have a product" because you are a photographer, think again. As a commercial photographer you are in business. As a businessperson you need to clearly show your potential clients what you are offering for sale.

I don't know of many industries where a manufacturer or service provider goes to market without a product to sell. Photographers are indeed both manufacturers and service providers, yet rarely do they enter the market with a finished product in hand. Developing a finished product as a photographer starts with having a defined vision that is identifiable. Buyers need to know what vision you offer. They need to know why they should hire you rather than pull their image needs from existing stock or royalty-free photo sources.

THE NEW PHOTO BUYER

The advent of royalty-free and high-end stock photography has created a new assignment buyer. Contacts hiring assignment photographers now tend to fall into one of two categories, and they all make their decision to assign photography based on the photographer's visual approach in relation to a pending assignment.

The first type of buyer is continually told to buy royalty-free or stock images and rarely gets to buy assignment photography. These folks need to justify an assignment buy, and it is usually the need for a very specific "look" that provides the justification that they need. When they are sourcing photography, they are looking for a photographer with a specific type of visual.

The second type of buyer is a high-end contact. These buyers may purchase images for regional or national or international

magazines, ad accounts, or collateral publications. They will always buy assignment photography, as their clients understand the value of assigning original talent. Their clients have a corporate brand, a look that communicates their specific message, and for each project there is a certain type of photography that they require.

When cruising for photography, these buyers know what their end product (ad, annual report, or identity piece) needs to communicate and they know the type of photography that they are looking for. Often they have budgets to hire top talent, and top talent is expected to have defined their vision into a marketable product.

Editorial photo editors have a similar task. They have a story to illustrate. Their magazine has a specific look and feel. The publication has a defined target audience. When they hire photographers to illustrate stories, they are looking for a visual match between narrative and illustration.

When prospects call in your portfolio, they are looking to see if your book contains a deep example of a visual approach that is right for the specific project that they have to assign. For all buyers it is clearly your vision—defined and refined—that is your product.

A UNIQUE VISION

"I always expect photographers to come to the table with a unique point of view. The top shooters have a look, a feel that defines their work," states Beverly Adler, a freelance art buyer based in New York City.

In order to compete in today's market you must develop your product and market aggressively. You no longer have the choice of being a passive observer. You either jump into the game or find another profession.

For clients, there is no value to a photographer who shoots many different types of photography with many different styles. While your professionalism and service are important, they are not what clients are immediately buying into.

It is your visual approach that clients will match to an assignment or that they will be unable to use for a project.

While clients may be introduced to your style via a direct mail or e-mail piece, it is your print portfolio and online gallery that are the strongest evidence of the product that you have to sell.

The old paradigm spoke to your portfolio as your sales tool. The new paradigm raises the stakes and positions your print portfolio and online galleries as the product samples that you offer prospects.

To get their attention, to interest prospects in hiring you, your portfolios must be well thought-out and be complete examples of what you visually offer. A finished print book and main Web gallery must speak to the type of assignment for which your talent is appropriate, and it must contain different applications of your visual approach to the subject area.

Clients need to trust that you will deliver on a specific vision. As in any other business, if you want your "product" to sell, it must meet the needs of your buyers! Portfolio as "product." A new concept? An old truth! Your book should encompass all that you will deliver on each assignment. It is the tangible form of what is otherwise a very intangible bill of goods. If your "product" is well developed and catches the eye of a buyer through effective marketing tools, your portfolio will be called in when an appropriate assignment is pending. Your "product" will be requested, and it is this step that gets you to the bidding process.

But what is the reality for most photographers?

Most photographers go to market without a finished product. They do not have a portfolio that gives buyers what they want. If a book exists, it's likely to lack a clear, deep, and identifiable vision. If it has vision, it may not contain depth (examples of the vision as applied to different industries). Most likely the physical format was decided without considering the images within. Rarely does a photographer spend the time, effort, and money needed to fully develop his or her "product." With the exception of commercial builders, I know of no other industry where suppliers would dare market a product that has yet to be fully built.

Yet photographers do it every day. As I travel the country presenting workshops I often hear the comment, "I don't need a portfolio, I have a Web site." Such comments drive me crazy! I also hear, "Why do I need a portfolio? I just use direct mail."

Please! Here is the truth. A mailer may be an introduction or reminder, a Web site may be a deep first glance, but your book, your print portfolio is the physical manifestation of your vision and service. It is what most buyers ask to see when they are ready to assign work. It is your "product." If you do not have a finished portfolio yet but have built a Web site or designed a direct mail campaign, you are wasting time and money. Many decisions to buy are made in committee with folks sitting around a conference table. They are not all hunched over a computer scanning Web sites. With this in mind, your best-case scenario can become your worst nightmare. Your marketing tools, including the Web and direct mail, may attract clients and get your book called in, but if your portfolio does not exist or does not tell prospects why they should hire you, all is in vain. In short, your product will not sell.

In order to avoid this all-too-common trap, look at your portfolio through the eyes of a prospective client. Ask yourself the following questions and, most importantly, answer honestly.

1 Does your portfolio tell prospects what you do (subject) and how you do it (style)?
2 Do your visuals have market application?
3 Are there many different applications or are images geared within your vision to specific markets?
4 Is your book well edited and do the images have relationship to one another?
5 Do the images flow well as the viewer progresses through your portfolio?
6 Have you chosen a paper that enhances your images?
7 Is the physical housing of your book in sync with the images within?

Now, take another test. Pretend you are a buyer. As you look at this book, what type of assignment would you give this talent? Does the product sample (portfolio) build trust in the photographer to deliver? Based on this product, should you trust them with your annual reports? Your national ad campaign?

Now, move back into the role of photographer. Take the last test. Is the type of assignment that you chose to give this

photographer the type that you are indeed looking for from buyers?

If you answered "no" to any of these questions . . . get to work!

Begin to develop a product that is whole and complete. Start to see your portfolio and Web gallery as partners. Not just as marketing tools but as product samples.

They must speak loudly and clearly to clients.

In the words of Ellen Gish, art buyer for the corporate retail giant, Target Corporation: "One Web, direct mail, or e-mail image can have the power to excite me in such a way that I will call in the portfolio. Once I have the portfolio, each image in the book must authenticate that creative vision. Whether there are six or sixty, each one must give me a consistent pure glimpse into that photographer's way of seeing."

Ellen is indeed looking for a complete product.

Examine your print portfolio. Scour your online gallery. If you have answered the questions listed above easily and you have indeed created a solid product, congratulations. Now it's time to get to work!

CHAPTER 3

DEFINING YOUR VISUAL VALUE

If you could hear the messages on my phone service, you would get a bird's-eye view of the changes in our industry. "Selina, I'm calling because for years I had a profitable business servicing ad clients. My clients were loyal, I was busy, and I never needed to market. Now my clients are retiring, companies have merged, and business is dead. I need to sell my work but I have no portfolio."

Then there was the message from a new photographer. "Hi Selina. Help! I have been told that my images look too stocky and I don't know what to do."

Talk with photographers and they will tell you that today's market is the toughest that creatives have faced in decades. Clients are less relationship oriented and more assignment driven. The availability of inexpensive and, in some cases, high-quality existing photography has drastically cut into an assignment market that was already sagging under the weight of too many suppliers. Every day photographers are asking me, "When did the rules change? How do we create and maintain profitable businesses? What do clients really want?"

THE VALUE EQUATION

What clients want is value. While value may look slightly different to clients depending on the specific market, the components that make up value do not. Vision, service, and

intelligent pricing are what clients consider when buying assignment photography. Crafting a well-defined vision should be your first step when looking to build a value-based business.

After all, if there is no vision for clients to witness, they will not call in your portfolio for assignments, and consequently there will be no need for you to quote or service an account. It truly begins with vision.

Developing an eye that is mono-focused is a new concept for most shooters.

While many photographers are now warming up to the concept that being a visual generalist (even in smaller markets) has gone the way of the typewriter, few have actively worked to define their visual approach to their chosen subject using a consistent vision. This is where you must begin.

Robert Kent, a successful photographer based in Vancouver, has hit the U.S. market with both guns blazing. He has developed a strong, steady U.S. client base in only a few short years. His agent, Nikki Kendall, credits the studio's success in great part to Rob's focus on developing his look—his visual approach.

"Once Rob's vision was established," says Nikki, "it became the focus of all of our efforts. Using it as the central hub, we created the Robert Kent brand."

You may be wondering how to begin to develop your visual approach.

You can initiate the process by defining the visual value you will offer clients. This can be accomplished through the creation of a "positioning statement," which is the description of your vision and subject matter.

Start by asking yourself, *What* do I shoot (your subject) and, just as importantly, what is my visual approach? How do I use color, light, and focus? Are people the main focus or are they props in my images?

In order to understand how important your visual approach is, let's look at the images of Robert Kent and David Stewart, whose work can be found on their respective Web sites, *www.robertkentphoto.com* and *www .dhstewart.com.*

Both David and Rob can be described as "lifestyle" shooters. However, their visual approaches differ hugely. Rob's work is clean and graphic. His locations are as important as the people in his images. In some cases the locations are even more important to the overall shot than the subjects are. Rob's people are props with body parts evident more than their personalities. The overall feel is hip, contemporary, elegant, and cool.

When we look at David's work we feel as though we are looking at a film or a painting. David's tones are dark; his lighting is rich and deep. We feel connected to the people in his portraits. We are voyeurs as we view the moments in the scenes he has carefully crafted. His models are elegant and often waiflike. The overall effect is moody, sensuous, and elegant.

Here we have two photographers who have chosen the same subject, but who have very different visual approaches. Their visual approach is what sets them apart. It is clearly the *how* of what they do. This visual approach is what a client is buying.

Your job is to develop and articulate your visual approach. Once articulated, you will need to write it down and use it as your main marketing message. Later, that description will become the editing tool for all portfolio images and for any visual mailers that are sent to contacts. In addition, it will be used to help you to select images for inclusion on your Web site and on ad portals. That is how you begin the process of building visual value and visual brand identity.

Robert Kent and his team pay close attention to the brand created from his vision, as Nikki explains:

> When we have creative, marketing, and strategy meetings, the brand is always the focus. It helps us to keep on message, because it is the message. It's as if the brand (look) becomes the client. As we create our sales tools from the images we choose to display on our Web site to our print portfolios, we are not meeting a "buyer's" needs, rather we are motivated by a vision that we have developed and are responsible for maintaining.

BE A CLIENT

In order to begin creating your positioning statement, pretend you are the client. Look at your current portfolio and pretend that you are a new contact seeing it for the first time. Now describe what you are seeing.

What is the message that you get? Do the images individually and collectively tell you what type of assignment you would hire this photographer for? Is the photographer's message clear? Is it deep and can you see application? Can you define and articulate the photographer's visual approach? What type of client would you hire this photographer for? What might that client's message be?

These are the questions that art buyers need to have answered when they look at your book or Web site.

Art buyers often keep files on talent, listing what they shoot and noting each shooter's approach to his area of specialty. Buyers who do this often bookmark Web sites and save promos. Some even go so far as to list words and categories that describe the talents' style so they can later remember what they have seen. They turn to these references when an assignment is on their desk. Many photo editors and graphic designers have told me they have similar practices. The descriptive words they use might surprise you:

- Illustrative product—heavy color, strong sense of graphic composition
- People—warm, emotional, portraits and moments
- People—lifestyle, cutting edge, motion, alive
- Architecture—big, bold editorial style, detail-oriented shots
- Corporate location—all subjects, strong lighting, great use of environment

It is obvious that buyers are defining you by not only what you shoot but also *how* you do it. Your responsibility is to give them the message to write on the back of your business card, the category under which to file your mailers.

While not all buyers are literally writing these words down, all are, most definitely, seeking a clear sense of what you shoot and how you create. That is how they differentiate one photographer

19

from the next. You need to give them the description that will set you apart. You need to show your visual value.

CREATING YOUR POSITIONING STATEMENT

When you are done playing client, you may find that your portfolio does not contain a consistent message. *Get to work!* Begin to craft your positioning statement by doing an exercise to help you determine the types of images that you are drawn to and the tools that you often use.

Go through magazines, annual reports, Web sites, award journals, and sourcebooks. Tear out images that represent photography that you would have killed to create. I call these your "wish-list tears." This is *not* about selecting work that you like; rather, it is about identifying the work that you not only like but also *truly want to do*. When you have about ten examples, start to analyze them. Use words to describe what each photo is about. Put the words on Post-it notes and go onto the next example. When you have completed the defining process, spread them out and start to look for similarities in your descriptions. The descriptive words you use repeatedly become the beginning of the *how* of what you are drawn to.

Look at how color is used, how selective focus is used. Are the images you chose about people? How are they photographed? Are they props? Or are they relating to the camera? Are we peeking in on their world or are they very present, connecting to the photographer?

Now, do the same thing with your portfolio.

Choose seven to ten images that are your favorites.

What are the consistent words you use on your Post-it notes to describe your imagery? What are the messages you are giving to clients? Do the descriptive words on the notes from your wish-list tears match those from your current portfolio? Check to make sure that the messages you are currently sending out are the ones you are looking to deliver. If you find that the messages are indeed different, don't worry, you have lots of company.

When you feel that you are ready to move on and craft your statement, begin by describing what you do and for whom.

Then add the *how* by looking at the similarities among the descriptive words on your Post-it notes. These words begin to define your visual approach.

Here's an example of a positioning statement for you:

> Marc Norberg creates compelling evocative portraits. Whether photographing CEOs of major corporations, blues musicians, or dogs named Bobo, Marc creates portraits that are as unexpected as they are revealing. Utilizing light as a sculpting tool, a strong sense of graphic composition, and an ability to channel the subject's spirit, Marc is intent upon creating evocative imagery that draws the viewer in, enabling his clients to deliver their corporate message or sell a consumer service.

Check out Marc's Web site at *www.marcnorberg.com* and see if this positioning statement rings true for you.

Creating a positioning statement should be the first step you take when you are ready to develop the visual value that clients seek. Once you know what you offer clients, you are then ready to take on the task of building the images that speak your message and are placed in your print portfolio and on your Web site. They are also placed on your direct mail and on visual e-mailers.

Defining your visual value is a task that should be taken on with an open heart and lots of enthusiasm. Start today by asking yourself these not-so-easy-to-answer questions, which will help you continue to define your visual integrity and build your positioning statement.

> What is it that I truly want to shoot? How is it that I create?

You may be pleasantly surprised by the answers you find!

CHAPTER 4

THE SERVICE COMPONENT

In today's marketplace the concept of supply and demand has never meant more. Clients have tremendous options for meeting their visual needs. Not only are there more and more photographers entering the market daily, but the volume of existing imagery is also immense. It's a given fact that clients can and do demand a lot. In order to effectively compete, assignment photographers need to clearly define and market the visual as well as the service value that they bring to a client's project.

We are in a service industry, and while it is the visual value you promote that initially interests a client in working with you, it is your commitment to serving your client that can make the difference between a successful career and one that fails.

COMMITMENT TO SERVICE, ON AND OFF THE SET

Michael Indresano is a photographer located in Boston who understands that service is not just about the shoot itself. Hugely successful, Michael is incredibly focused on delivering an excellent visual product and is equally committed to servicing his clients. He begins most days at 8 am and ends at around 6 or 7 pm. Shooting five or six days a week is not uncommon. Michael's studio is designed with his client's comfort in mind.

Client conference areas are in a quiet section of the space, and there is a digital workstation for them to use. While the physical extras are welcomed, it seems to be Michael's knowledge of the printing process, his attention to detail, and his complete desire to meet a client's needs on and off the set that make the difference to his clients.

Designer Tom Laidlaw worked on a Mead paper project with Indresano and comments on how the photographer's knowledge of the postproduction process is a valuable asset to him.

> Michael is completely focused on each project that we work on. He is a designer's dream, as he is thinking about how the image will reproduce while he is shooting. Most photographers know that their job is over once the final image is delivered, and few think about the printing process. Michael remembers that although his job is over, my job is just beginning, and he shoots with that in mind. The final images we receive are always print ready. It makes my life so much easier to know that I won't need to rework the images to death in order to go to print.

Tom's comments reflect that Michael's attention to postproduction is a valuable service to him. Unlike Michael, many shooters feel that color control and other postpro issues are solely the responsibility of the art director.

This attitude will not fly in the day and age of Photoshop. Postproduction is definitely a service that you must handle. Photographers who believe in full service might choose to learn as much as possible about the new postpro issues and then incorporate their knowledge into each assignment.

Many photographers choose to work with a digital illustrator. This talented team member works very closely with the photographer from the inception of the shot, creating the final postproduction changes needed. The goal is to produce an image that is as "finished" as possible.

This attention to detail beats a catered lunch any day of the week.

Excellent service in client's eyes is often represented as "doing whatever it takes to create a wonderful image."

Sometimes, whatever it takes has little to do with the actual shot.

A young art director worked with Michael on a shoot for a booth display at an international trade show.

Michael was to shoot images that would be displayed in the booth during a fashion show created by the art director to launch a line of designer phones.

It turns out that Michael's photography was not the only help his client needed.

The art director explains:

> It was a huge project for me. One that involved recreating a fashion runway during the trade show. I was new and at that time had no experience in hiring the models I needed for the runway during the trade show. I turned to Michael and his staff to help with the entire project, as I had very little experience working with models. Even though it was not at all a part of the photo shoot, Michael and his team did everything to help me. They helped me cast my runway models, they suggested stylists, and they basically helped me to produce the event.

Above and beyond the bottom line? Absolutely. But this felt perfectly natural to Michael and his team. The art director concludes, "What amazed and pleased me was that every member of Michael's team had the same interest in helping me. From his studio manager Heather to his assistants, everyone was consistently helpful and they were top-notch professionals."

These comments are important, for once you determine what service looks like to you, you will need to communicate your values to your staff. It will be important for all employees to follow your lead. Whether you are working with full-time or freelance assistants, everyone who works with you must have a similar work ethic and service philosophy.

Setting the bar with regard to service is your job.

Clearly, working as Michael does, from eight to six, five to six days a week, is not for everybody. Helping a client cast a runway show might not be your idea of service either.

You will need to establish your own philosophy. Whether you are an established pro or just beginning your career, you need to determine how you will service your clients. Don't assume that you have this one down cold. Start by listing the different opportunities for service. Then decide how you will handle each area. Below are three areas that are a part of your everyday business life. Read the questions, decide what you feel is an appropriate way to service, and begin to set your service goals.

PORTFOLIO VISITS

In today's world, where Web sites rule, many photographers feel that in-person visits are not welcomed by buyers nor needed. I challenge this notion. I know of no successful photo business that relies solely on marketing options. Each business has a sales arm, provides in-person visits, and uses travel portfolios on a constant basis.

I find it curious that photographers holler loudly about the devaluation of photography and then are content to show their images exclusively on a computer monitor, a one-dimensional format where images are rarely seen larger than three by five.

Is this not contributing to the devaluation? Photography is tactile. Your prospects need to see it, feel it, experience your vision.

When was the last time you actually went on an appointment to show your book? Successful businesses all have a selling component built in.

Clients still see photographers, and relationships are still important. While most photographers believe that all they need are Web sites and other marketing tools, the reality is that marketing tools alone do not make up an advertising program.

Prepare to go on appointments, and when you are there, consider asking your contacts to show you examples of campaigns or projects that they recently completed. Be ready to ask them questions about the projects they show you, questions that establish you as a photographer who is indeed interested in service. Many photographers would not dare to do this. However, I have found that clients like to talk about themselves.

Most (if they have the time) will pull out examples of past assignments.

The information you receive is invaluable if you ask the right questions.

If you create this opportunity, feel free to ask the following:

- What was the goal of the ad?
- Who did you work with on this assignment?
- Where did it run?
- Was the client happy with the results?

As a client begins to answer, you may find out who your competition is (the photographer they hired) and the scope of the campaign (budget information). Often you may hear about issues that came up for the client, and you can often learn about the client's needs from the issues that are mentioned.

While we do live in an age of e-mail, Web sites, and long-distance marketing, it is important to use your portfolio visits not only to set your vision clearly in a client's mind but also for you as a service provider to truly walk your talk. If your vision emphasizes creating together, then what better way to begin the process than to ask clients what is important to them. This can be determined from a portfolio visit if you take the opportunity to ask questions.

It takes a bit of bravery here, as some photographers might not feel it is appropriate to ask these questions. If you find yourself reacting negatively to this approach, if you feel it would be an imposition or not polite to ask them to show you their work, I ask you to consider how you would feel if an assistant came in and asked you to show them your recent assignments.

What if they said, "I know that you have been shooting for a while. Could you show me some samples of recent assignments, as I would love to know the type of work you do. That would give me have a better idea as to how I could be of help in the future."

Does that sound like confidence to you? Someone wanting to be of help? Or does that feel like someone asking inappropriate questions?

Suppose you started to show them some samples and they asked questions like the following: "What did you expect from

your assistant here? What could the assistant have done to be more helpful to you?" Would these questions sound offensive or would you think, "Boy, this person is confident and seems to really want to help." Would this candidate be more valuable to you? Would you be more likely to remember them?

The bottom line is that the information you give and get from a potential client is vital. This can be an opportunity to find out what contacts' needs are, who they are as creatives, and how they design.

It is also an opportunity to begin to establish yourself as someone who truly walks the talk about service. If you identify yourself as a supplier who is interested in a client's needs before a purchase order (PO) is a reality, you are distinguishing yourself as a supplier that truly cares about helping clients win and who brings value to the project. If you have a rep (or agent), make sure your rep supports your service philosophy of asking questions. Reps are your ambassadors to the world. If your service philosophies are different, your message is inconsistent.

PRICING AND QUOTING ASSIGNMENTS

Obviously, you need to ask all the questions pertinent to producing an accurate and fair price. You will also need to establish and consistently follow professional business practices.

I remember the words of Edith Leonian years ago in 1979 when she was teaching me the copyright law. The law had just changed, and as a fledgling rep from a small town I was eager to learn about the new responsibilities and options open to photographers. Edith (then president of SPAR) graciously spent much time answering my questions and priming me on the law. Her last words still ring loudly in my ears: "The client is not the enemy. We have new opportunities and new responsibilities and it is your job to help to educate your clients because, after all, that is good service, and good service is good business. Legal business and good business are not mutually exclusive."

While I went to Edith for information about the law, I came away with the lesson that understanding my professional

responsibilities and consistently following them was a way of servicing clients. Clearly, there is great value in providing clear, consistent pricing and usage guidelines for your clients and in educating those clients who are new to the concepts you are trying to explain.

Another opportunity to live your service values is to learn all that you can about a pending assignment. Ask questions, lots of them.

"What is the purpose of the shot? Who are we talking to and what are we trying to communicate?"

This was always the first question I would ask as a rep. Unless the contact had already covered this specifically, I wanted to know the most important factors: the audience and the message. After all, my entire job was to help my clients to do their jobs well. This should be your interest too.

Most photographers focus their questions on the areas that directly affect them: usage, format, due date, and so on. Being focused on all areas pertaining to the photograph, especially those that speak to the message the client is looking to communicate, demonstrates your interest in the client's needs, not just your own. Asking about the audience and the client's message demonstrates that you are looking at the *big picture*, not just at the slice that is yours.

For many photographers the most important factor is not the message and the audience, it's the usage of the shot. A photographer who asks about the audience and message, and then incorporates that information into the shot, is a visual team player. More value once again. By the way, a stock photo or clip disc can't ask these questions.

Today's world of Web grabs, stock agencies, and megamergers is a gift that provides you the constant and ongoing opportunity to position yourself and your studio as a service-friendly environment—one where clients and their goals matter.

LISTENING AND BEING PRESENT

Listening well is key. In day-to-day life, most people feel that others do not hear them. Being a good listener, being present and focused on a conversation with a client, requires little more

than concentrated energy yet delivers much value. Let your clients know that they are important to you. Make sure they know that they have been heard. Repeat information back to them. Be present at all times. Today multitasking is a way of life. Don't let it be your way when working with clients.

Review all information before writing a bid. Don't leave anything out or assume anything. Once a bid is accepted, review all possible variables. See if any change has been made. Write an assignment confirmation form based on all the new relevant facts. Send it before the shoot.

When you are with your clients, don't take phone calls. Shut your cell phone off during shoots and focus on the task at hand. Deliver projects on time, on budget, on message. Invoice based on the assignment form, and if you need to go over budget, inform your client directly and immediately as you see the need.

Call the client after the shoot. Make sure the client is happy with the results.

If a client does not call back, don't hound them, simply let it be and know that they know you checked in.

Live the fact that clients are important to you. Your service commitment to your clients, to their needs, is a big part of the value that you bring to a project.

Forget the presents, the tickets to the hockey game and ballet.

Bring on the service, combined with your vision, and watch the client list grow!

CHAPTER 5

SUCCESS OR FAILURE: IT'S ALL ABOUT VALUE

The success or failure of a creative business in today's market is often tied to the value that clients equate with the company. Clients only perceive value when it exists, when it hits them in the face over and over. More and more clients are asking for value during a time when some photographers seem to want to provide less.

First, let me be clear. This essay and my theories have absolutely nothing to do with negotiating and pricing. I strongly believe that appropriate fees (including fees for usage) are key to developing a successful professional operation. The value that I am referring to has to do with vision and service. These are the two main components that signal the type of value your clients will pay large fees for.

Your company's value is built over time. It is developed. But this can only be accomplished if you initially step out of your shoes and look at your business from a buyer's perspective. What are the attractive qualities that a new prospective supplier offers an ad firm, editorial publication, design studio, or corporation? If you responded "good images cheaply," think again. Those can be had from royalty-free discs. Clients purchasing assignment photography are still looking for vision and service. Although it sounds like a no-brainer to provide this type of value to clients, many photographers are still not hearing the call. Here's what you can do to begin to develop a business that has true value.

1. TAKE INVENTORY

Understand who you are as a creative, what you want to accomplish as a businessperson, and where photography fits into your life spiritually, financially, and creatively. These are not easy questions but they are necessary. Visit my Web site at *www.1portauthority.com* and download the photographers' work sheets. They are free of charge and will help you to begin your internal journey. For those of you who shudder at the thought of delving into your being, I urge you to (in the immortal words of Cher, in the movie *Moonstruck*) "Get over it!"

2. BECOME A CLIENT FOR A DAY

After taking internal inventory begin to look at the main components that clients see when they look for your company's value, when they recognize it or notice that it is lacking. Simply put, these components are your vision and your service.

Within these two categories there are many opportunities to increase or decrease the value that clients see. Become a client and view all of your visual and service components through the client's eyes. Are you offering value? Is it clearly evident to a new client? As you play client be sure to look at the following areas:

Vision

It is critical for you to develop your vision. Your end product does not need to be unique, but it must be well developed, commercially appropriate, and yours. Does this take time? Yes. Does it take effort? A considerable amount. Does it take money? Most definitely. Will you treat each of these as an opportunity or a block? That's up to you. I suggest that you invest the time, make the commitment to truly develop real visual value, and express that value in your portfolio. After all, how can you ask your clients to invest in you when you choose not to invest in yourself?

Use the work sheets you downloaded from the Port Authority site and begin to look at and work on your visual goals. Begin at

the beginning. If need be, commit to working on the vision in your portfolio. The messages that your book needs to deliver are *what you do* and *how you do it*. A clear message combined with a developed vision starts to build value with contacts who are yet to be clients, as you are showing them which category to place you in. You are filling their visual filing cabinet with the information that they seek. Don't be put off by this, and don't be fooled! Most photographers still do not do this.

When you are three-quarters of the way through the visual build of your portfolio, begin to look at your portfolio's housing. This is a key step. Make sure that the outside reflects the inside.

Your portfolio may not be the first opportunity your prospect has to experience your vision; many prospects may not even see your book before calling in for an assignment. These folks may access your talent via direct or visual e-mail or through your Web site. For this reason it will be important that your vision is front and center on all mailers, Web portals, and your Web site. Choose signature images that can be repeated during the year on all materials. Yes, I said repeated. Photographers seem to feel that repeating images is wrong. They are always eager to show their latest work. However, buyers need to be reminded of your vision. Advertising is all about repeat, repeat, and repeat. Your visual message needs to be clear.

Now, I am not suggesting that you have three images that you use for everything. What I am suggesting is that you select key images from your portfolio that can be used on a Web portal and on mailers along with other nonrepeated images. I call these key, repeated images "signature" visuals. Perhaps one of your signature images becomes the home page visual on your site.

Advertising slogans stay in people's minds: "This Bud's for you," "We love to see you smile," and of course the immortal "Just do it." You want your signature images to become visual slogans, to become identifiers. They can only be that if they have an opportunity to be seen repeatedly.

Service

Service is another component that builds value. Huge value. As you play client for a day, look at every aspect of your business, from phone call reception, to serving clients during

an assignment, and beyond to the invoicing stage. How does your business handle each step? Will you have a voice-mail system or a personal response?

I was dragged kicking and screaming by my fellow coworkers when they suggested a voice-mail system for Port Authority. I always wanted a personal touch. We have had voice mail for quite a while and it works well. The lack of a personal touch is addressed by our message, which is warm and friendly.

Look at your estimating procedures. Are they timely? Are your estimates clear and do you follow up with a phone call while being careful not to hound? When clients come for a shoot, how do you keep them happy? If you work long distance via e-mail, do you have a secure site? Is it a smooth and easy process for the client?

Look at every area and make sure that all of your employees, full time and freelance, clearly understand how you service your clients and what your expectations of them are.

If you find that your company needs internal structure in regard to service, consider creating a list of service goals. I often work with creative firms who are looking to develop value from the inside out; your small business is no different. We create positioning statements, mission statements, and a list of service goals. This can be your first step in developing real service value.

As I write all of this I keep hearing a little voice that says none of this matters without a commitment to building a business of value.

And it's so true. You need to have a burning drive and desire to succeed at delivering value to your clients. The end product of your efforts will look and feel different than any other competitive business. Develop your own set of service goals.

Finally, be committed to having a company that consistently offers a clear visual style and great service to all clients, thus allowing you to be the best creative supplier that your clients have ever worked with!

PART II

VISION

A PHOTOGRAPHER'S WORK IS
GIVEN SHAPE AND STYLE BY HIS
PERSONAL VISION. IT IS NOT
SIMPLY TECHNIQUE, BUT THE
WAY HE LOOKS AT LIFE AND THE
WORLD AROUND HIM.

—PETER TURNER

CHAPTER 6
CREATING SUCCESS

D uring the past twenty-eight years, as I have worked as a consultant to creative professionals, my role has been to help my clients be successful, advising them as they sought to reach their creative and financial goals. During this time, I have observed photographers as they worked toward success. I have worked side by side with my clients; some have been successful and others have not.

In an effort to understand the dividing line between success and failure, I started to note what each client did to contribute to his or her success. Over a period of time, it became clear that successful talent consistently took certain actions. Although each person's victory is achieved through different means, setting goals and adjusting your attitude are two key components worth looking at.

ARTICULATING CLEAR GOALS

The first action that is always present in a winning business is the articulating of clear, well-defined goals. After all, how can you be successful if you don't know what success means to *you*? The following sets of goals demand attention:

Personal Goals
You should not divorce your being from your business. It is important for you to know where photography sits in your life. Begin by asking yourself, What is it that you wish for in your life?

What part does photography play in that scenario? Is photography a vocation or your entire being?

Do you have a partner, a family? How much time will you spend with your significant others? Or are you solo, able to call the shots as you will?

What does an ideal week look like for you? Will you be shooting as much as possible for clients and for yourself? Or is life outside of photography your priority, with work providing money in order for you to play?

All answers are correct here. What is important is that you are honest with yourself.

Creative Goals

List your short-term creative aspirations. Consider skills that you want to learn, accounts that you want to obtain, types of photographs that you want to create, different media that you want to explore. What is your top-priority creative goal? Is it creating a new image for your portfolio? Is it building a new body of work? Are you just beginning to develop your visual integrity?

Define your priority goal and then list the others in terms of importance.

Professional Goals

Professional goals involve the structure of relationships and business practices. Create a dream business. What would it look like? What would your relationships be like with your clients? Would you work with the same people frequently or would there be many different clients all the time? Would you work closely with your clients or would you create by yourself?

What type of business practices are important to you? Will you be actively retaining the copyrights to your images or will you choose to create a library of images for clients, giving them unlimited rights for a fair price? Will you charge a fee for late invoices and, if so, how much?

Financial Goals

Financial goals tend to be the easiest for talent to list. After all, most people know how much money they need to exist and how much they want to save. Add to this list the following: What

type of profit margin are you looking for? What additional equipment do you need to stay competitive?

How much money will be spent on your sales and marketing program?

How much money do you need for employees? For taxes?

Look at your list of creative and professional goals. Do you need more income to achieve them? Will they generate more income for you?

Finally, consider how many days will be devoted to earning the income you desire.

Goal Inventory

Once you have reviewed each area, you will need to see how each of your goals works with or against the other goals that you have listed. Create a final list (for now) of your goals, making sure that each works in concert with the others. This is the inventory of aspirations that, for you, represents a successful life. Creating this record enables you to become aware of what is truly important to you.

As you continue on the path of developing a successful professional life, there will be many other actions that will be of help, but it will be your state of mind, your attitude, and your approach to your work and your life that will enable you to reach your goals.

Are you a positive person? Do you see the glass as half full? Or are your clients always "pestering you," asking for "more than they pay for"? Do you love working with all of the new art buyers or are clients "getting dumber by the day"? Are you basically happy or does life feel like a constant struggle?

CREATE YOUR SUCCESS

We have all heard that success is not given, it is earned. From what I have seen, success is *not* earned, it's created. "Earned" sounds very passive. But "create," now there's an active word. If you are ready to create success, put your goals in front of you and get ready to do some serious work!

Begin by assessing your current attitude toward your life. In order to determine how your outlook is effecting you, take a current inventory of your actions.

Start by examining your work ethic. How you approach this area of your life speaks volumes to clients and can shed a lot of light on your way of thinking.

Successful creatives have learned to meet deadlines and keep commitments. They put more than 100 percent into all of their assignments, self as well as client generated. In short, they have a strong work ethic. Shocking but true, none of us is perfect. In order to see where *you* need to improve, start by answering the following questions:

1 How many assignments in the last six months did you give 100 percent of your effort to? What about 120 percent?
2 How do you approach assignments? Do you listen to your client's needs carefully and then offer your creative thoughts? Or do you take the information supplied by your clients and only provide what they ask for?
3 How many times in the last six months did you commit to shooting for your portfolio? How many times did you meet that commitment?
4 How often have you said, "I have to put time aside to create a new set of goals for my business"? Have you taken the time?
5 How frequently do you utter the words, "Next time I'm going to do things differently"? Do things ever change?

Now look at how you *feel* about keeping your commitments to others and to yourself. Do you feel excited when you put everything you have into an assignment? Do you feel the same way when you simply "go through the motions"? Are you excited about new projects or do you feel overloaded and overwhelmed by them?

If you have answered these questions honestly and find your attitudes or work habits do not serve you well, you can be sure that they are not serving your clients.

Ask yourself what actions you could take to change your old beliefs. Commit to those actions and begin to create a new you, one who embraces the newness of life and is excited about all that is ahead.

RISK TAKING

Your next area for examination is your willingness to take risks. Risk taking is a part of our daily experience. We get in cars, we drive, and we step off curbs into busy streets. While these daily actions don't seem to pose a risk, they do. Anything could happen at any time. Successful photographers have maintained the attitude that risk taking is a daily experience. We are not talking bungee jumping here; an example of every-day risk taking can be seen in the way you choose to service your clients.

When you shoot for clients do you take their ideas as is? Or do you give your input? Most photographers tell me that they take the ideas a client gives them and unless it's undoable they shoot directly to layout. No creative input. No risk taking.

Clients welcome creative input from photographers. A photographer who listens carefully to a client's needs and then gently adds his or her suggestions is a valuable supplier. Don't assume that your clients know what they want or have all the answers. People hire you to know what will work technically, but they are also hiring you for your creative skills. Successful creatives know this and they bring all areas of their expertise to the table.

Successful creatives take this risk.

One common trait that links photographers who are successful is that they show up for themselves.

Do you find that you have no trouble meeting your client's needs, but somehow you never meet your own? Do you have endless ideas but no follow-through? All professionals need to create marketing campaigns for their businesses. Is yours in place? Photographers need to shoot constantly in order to continue to grow their vision. Do you set time aside for your portfolio build?

Photographers who answer yes are poised to embrace success. If you find that one or more of these tasks are still waiting in the wings for your attention, don't despair. Experiencing and getting stuck in despair is the ultimate distraction. Simply get to work.

One of the most common complaints that I continue to hear from my clients is, "I have no time. I can't find the time to

shoot for my book, or even create a monthly plan." The truth is we don't find time, we make it. Photographers who are poised to embrace success know this.

When you are ready to begin the journey of creating a successful business, begin by spending one hour listing the goals you have for your company. Then begin to examine your beliefs.

Sit down the next evening for one more hour and start to look at where your work lies. Review the previous night's efforts.

Do you need to better understand your goals, or is it your attitude that needs adjustment? Go wherever the work is.

Take the risk.

When your goal list is complete and you know where your work lies, choose an area to focus on. Spend time each day, whether it is thirty minutes or six hours. It's the daily commitment that resonates with you. It has been said that "we are our attention."

You will see that as you take each step you grow stronger and more invested in the process of activity, more excited about creating success!

Start now. Set an alarm for one hour and spend your first sixty minutes deciding which habit you are going to change, which goal you will begin to put into play.

The shoe giant Nike created an ad campaign a few years back that was hugely successful. They summed up the process of reaching success with three words and so can you: "Just do it!"

CHAPTER 7

DEVELOPING A VISION-BASED PORTFOLIO

Welcome to a new world! Your clients' buying habits have shifted dramatically and you need to respond. Preexisting relationships are no longer the initial factor for many buyers when hiring a photographer. Vision is the focus and the topic on buyers' minds. Each project that lands on a buyer's desk has a specific look, and that project demands that the buyer seek a photographer who has previously exhibited the ability to create the type of visual needed.

Your portfolio of images (both print and Web) is your opportunity to show prospects your topic of choice and your visual approach. These are the tools that give buyers a first, deep look at your distinct vision, and they are the channels that deliver your message to prospects when assignments are pending.

Many photographers still fear showing a distinct visual approach, but professionals like Nancy Grant, who are out in the field selling photography daily, know the importance of showing each talent's area of visual expertise.

A veteran agent located in Vancouver, British Columbia, Grant sells photography worldwide and believes in handling only photographers who have a singular vision.

"Having a consistent style that runs through a whole portfolio leaves a clear impression," she states. "Buyers are swamped. You need to break through to them. You need to give them the reason to match you with an assignment. Your vision is the reason."

Grant continues, "Many photographers are afraid of marketing a single vision. They don't want it to appear as if they

only do one type of photography, and thereby lose work. They try to be everything to everyone, which makes them nothing to everyone. They are missing the point. Marketing a single vision takes advantage of a photographer's strengths."

Ten years ago, it was common for photographers to have a portfolio that included different categories of photography, such as corporate location, food, still life, and portrait. That was when buyers were relationship oriented. They worked with one photographer on everything. Now, with an abundance of assignment photographers and stock photography, buyers are more sophisticated. In addition, companies spend millions of dollars developing a specific visual brand to which their campaigns are tailored. Consequently, agency, design, and corporate prospects buy portfolios that speak to the project's visual needs. They are not buying personalities.

Instead of shooting a lot of different categories, your portfolio should reflect a vision that can be applied to many categories. Different prospects will see your vision-based portfolio as it applies to their needs, needs that change over time. Rather than being restrictive, this kind of approach leads to many opportunities.

The alternative is to present a portfolio with a variety of techniques, subjects, and styles. Unless you have been photographing for years, diligently developing your style in many different areas, your talent is likely to be stronger in some areas and weaker in others. Thus, showing lots of different approaches or areas of focus not only confuses your public but leads to portfolios that have images that are not consistent in their strength. Clearly, creating portfolios that contain some hits and some misses is a big mistake.

Photographers often feel that showing only one vision limits creativity. They don't want to "do the same thing all the time." This is when I remind them that assignments should never be the only opportunity for creativity. You need to get into the habit of doing test shots, which push the envelope but don't always go into your portfolio. Ultimately, these tests might well reveal a new market for you to pursue. However, resist the urge to put any tests into your portfolio until there are enough that demonstrate a new application of your vision.

"Consistency is key when creating a vision-based portfolio," says Kat Dalager, past head of creative art buying for the Target Corporation, now with Best Buy. Kat, who buys photography

globally, adds, "Photographers need to resist the urge to chase the latest trend or throw in images that stray from their vision. Buyers don't want to try to hit a moving target; they want to know that they will hit the mark with *you*. An inconsistent vision will not prove to the buyer that you are 'well-rounded,' it will simply confuse them."

Confusion is not your goal. Clarity is.

In order to develop effective vision-based portfolios, samples that will resonate with buyers, you will need to understand how buyers think and how they match assignments with photo talent.

REFERENCE TOOLS FOR PHOTOGRAPHERS

Many buyers do not buy from Web sites. They use Web sites as reference tools to call in portfolios. A buyer with a pending assignment may go to your site, see work that looks appropriate, and choose to call in your book, among fifty others, to look at and assess its appropriateness for the assignment. This is the prevailing practice among buyers when hiring for mid- and top-level assignments. However, before your book can be called in, you need to have created an opportunity to be considered for an appropriate assignment. Marketing tools such as direct mail, visual e-mails, and Web sites will act as conduits, giving a client glimpses of your vision. Another potent and underused option is an in-person or a drop-portfolio appointment. These are powerful opportunities that enable you to create portfolio presence *before* a need arises.

Showing your print portfolio to buyers before they have the need for your services enables you to develop visibility with prospects in order for them to consider your book when an assignment is pending.

You will need to develop a print book for this option.

Despite what many photographers will tell you, viewers (while hard to reach) are still willing to see your book. Getting in front of buyers is a chance to bring your personality into the equation and provides an opportunity for viewers to experience your images as more than one-dimensional, icon-sized photos on a flat screen. Photography is tactile and needs to be felt and experienced, not just glanced at.

If you choose this option, consider making a minimum of four to six in-person appointments per month.

When looking at your book, viewers will be asking themselves a series of questions, which the book, not you, must answer.

They will be wondering, would I hire this photographer? What types of assignments would I give her? Which clients of mine would be an appropriate fit?

They may not see a direct match, but if they see a vision that appeals, one that is clear and deep (lots of examples with different applications), they will want to remember your work and you. They may make a note for themselves in order to remember your work, or they may ask you for a leave-behind and make a note on that.

When making notes for themselves, some buyers categorize photographers by describing their vision, subject, and approach.

When an assignment is pending, buyers go to their notes, to the bookmarks on their computers, to Web portals, to Web sites, and to the mailers they save. They are searching for a vision that matches the assignment. The next step is to call all the photographers whose work is similar to the assignment. Clients may call in as many as fifty books per assignment.

At this point, your portfolio serves a different function than it did when it introduced your work to potential buyers. It is here that the book must sell, it must be a perfect fit for the project. In order to maximize this opportunity, make it a point to ask your contact questions. These questions will help you to best meet the client's immediate needs.

Ira Kerns, a photographer who photographs kids for advertising, knows that when a book is requested he has an opportunity to match his work with the client's specific needs.

> I always ask my prospect questions. I want to be able to pull other images that may not be in my portfolio if they are appropriate for the job on the table. So I always try to ask, "Who is the assignment for? What is the photo of? What is the message being communicated?" Clients don't always have the answers but more often than not, if they are calling in books, they know what the project scope contains. If I have other samples of my work that speak directly to the project, I simply send them along with my portfolio.

Ira is correct to send his total portfolio with images that may speak to the assignment, as buyers at this stage are looking for your vision as applied to their subject at hand.

Your Web site is the other essential tool that communicates your vision. It amazes me how many photographers still treat their Web site as a storage depository for every image they have shot rather than developing a site that contains a solid body of work. Your Web site should have a gallery section that mirrors your print book. If buyers come to your Web site first, looking for a specific vision to match their assignment, and they see what they are looking for, they will call your book in. If your book is disconnected from the images on your site, you've lost the assignment. If your print book has only a smattering of the images that attracted them in the first place, you can bet that at least one if not three or four of the other fifty books called in has deeper content than you do, and the job may be awarded to them. It is vitally important that your print book and the main gallery on your Web site match.

ADDING PORTFOLIOS

Additional print portfolios can be added to your mix if the content is relevant to the vision that you are presenting. For example, if you are a portrait photographer and you have created a personal project of portraits on the ballet or for a nonprofit organization, or you have been developing portraits as you travel the world, your additional images in a separate photo book or section in your main print book would make sense. However, if you love to shoot still life and you want to add a section of still-life images because "maybe someone might need them," forget it. Adding your still-life images will, at best, just confuse your buyers; at worst, it will give them the message that you are not confident enough in your portraits that you felt you needed to add a still-life section.

The messages that your print portfolios communicate are critical to your success. While your visuals and the presentation of them communicate your professionalism and, to some degree, your personality, it is your willingness to explore, develop, and exhibit a singular vision that will determine your failure or success in landing new accounts!

CHAPTER 8

BUILDING A NEW PORTFOLIO: PHOTOGRAPHERS SPEAK

T alent-based portfolios (Web or online) are the backbone of every photo business. Yet the body of work that defines you as a commercial talent is rarely given the time, effort, and finances needed. Most photographers still create their portfolios based on client assignments or scattered personal assignments that happen when they "have time."

This is clearly a mistake, as client assignments are generated to meet a client's needs, not yours. Most photographers would agree that fewer than half of the assignments they receive truly represent their greatest abilities.

Building a portfolio when you "have the time" generally results in a book of singular images, and while, at best, they may be stunning individually, there is no cohesive message being delivered to prospects. At worst, building a book "when you have the time" never happens, as you will always find something "more important" to do.

If you are truly interested in "building a portfolio," a body of work that represents your vision and your value to clients, then you will need to commit to building a new body of work. Your new portfolio will need to be concepted, photographed, edited, paginated, and housed with great care. This valuable sales and marketing tool will be developed over the course of many months, during which time great trust and effort on your

part will need to be put forth, financial resources will need to be committed, and you will work harder than you have ever worked before.

Photographers come to this juncture at different times and for many different reasons. What is it like to go through the process of creating an entirely new book? How does it feel to have a completed book in your hands? How do clients react to your new and wondrous tool? I posed these questions to two photographers that I have worked with. Both of the photographers highlighted below are established but had never created a new portfolio before.

Zave Smith, an established still-life shooter based in Philadelphia, decided to photograph people and needed to develop a new vision as well as build a new portfolio. Ed White, an architectural shooter located in British Columbia, had a vast body of existing work that needed to be edited and paginated. Both shooters worked incredibly hard to develop a portfolio that spoke their visual language.

Before he built his new portfolio, Zave Smith was tired of watching his still-life business stall. He was enjoying his relationships but felt creatively stifled. Not satisfied to sit back and let all that he had created unravel, he decided to go back to the basics and began to analyze what was not in alignment.

I looked at the industry and saw a huge shift toward lifestyle photography in the advertising and corporate arenas. "Still life was still being assigned but I was losing more jobs monthly to stock then ever before. In addition, I realized that I was up for a new visual challenge. It had been quite a while since I had taken on the responsibility of creating a new direction for my work.

In addition, I seem to have reached the invisible ceiling in my career. When I showed my book around, people would smile and nod their heads but they did not call with the jobs. I had enough work to keep me going but I felt like I was treading water and the view from my part of the lake was getting extremely boring.

Zave continues by describing how he responded:

> In the past if business was slow, I would just shoot a
> photo for a new mailer. I knew that this time I was in a dif-
> ferent place. A very different place. I needed to develop
> new visual revenue stream. I needed to create a new book.
> What I did not know was that the experience would not
> only change my vision but that it would change me.
>
> I decided to take the plunge. I was committed to
> building a new portfolio that not only showed where I
> had been but where I'd like to go. I wanted to craft a
> portfolio that when sitting on a conference room table,
> surrounded by a group of its peers, would reach out
> and grab a creative director's attention. It had to be a
> portfolio that was so special that I could not wait to
> show it. Up until then I had found myself making excus-
> es while driving to appointments. My new book would
> shift my attitude, jump-starting me into action.

Zave's decision put into motion a full-blown portfolio build.
We edited existing images and were left with three as we began
our process. The following months found Zave and I concepting,
brainstorming, shooting, and editing, then repeating the process
over and over. Fourteen months later we had our first book.

Zave describes the process for his perspective:

> Once I began, reality set in and the first few weeks
> I felt as if I were at the base of a very large, tall moun-
> tain whose peak is hidden behind the clouds, and all I
> had was one pair of shorts and some old Nikes. I was
> grateful that I had a guide. My consultant's job was to
> show me the way. While she kept me on track, I realized
> that the climb was still mine to make.
>
> What was it like at the base of the mountain? There
> was a sense of glee that you might have before any trip.
> There was a sense of fear as I questioned if I was up to
> the task. There was a sense of mistrust, wondering if I
> had chosen the right guide and if she could really help
> bring me to the top. But I persevered through all of the
> challenging experiences.

Zave's comments reflect the fact that building a new body of work is indeed a true journey. Along the way you will have many opportunities to learn about yourself. Visually you will define and refine your talent, personally you will discover how deep your commitment runs. In the end you will be transformed. Zave was rewarded with an experience that was rich and loaded with payoffs.

"So what is it like for a journeyman generalist, a person who earned most of his keep from tabletop products and food, to show a book of lifestyle?" he asks, before answering his own question: "It feels great. My old still-life clients have not left me, and I am getting into the door and taking home the prize of many assignments that I would not have been considered for before. These new assignments are what I really all along wanted to be doing. I am one happy camper."

Zave's process was different than the steps that Ed White needed to take. White is an extremely professional and well-respected shooter with a healthy client list. His new goal was to obtain only top-level assignments, projects that would benefit from his visual interpretation. As Ed and I worked together on the project, our first task was to edit images from his vast collection and see what our current inventory was. The new portfolio would position Ed as a top-level shooter, and we knew that the images displayed in his final book would need to speak to market needs in a very "lyrical" way. We would be showing the best of the best, images with an arty feel. There would be no literal images chosen. No straightforward building shots for us. This was not a portfolio that simply showed what the buildings looked like; rather, we were going after the sense of what the space felt like, the design and the beauty inherent in each location. We were creating a book that displayed Ed's ability to see the space in a way no one else could.

The project was not an easy one at first for Ed, but he quickly realized that the result of our process would indeed move his career forward. That was a motivating concept for him.

I don't know if I am like everyone else or not, but the thought of creating a new book initially pushed me into new heights of procrastination. I was happy thinking about how the book would look, what material to

use for the cover, and what paper to print on. It seemed as if I could make decisions on everything but the content. When I finally caved in and called Selina, I knew I needed help. She was gentle in her assertiveness, and before long I had direction and a new sense of what my imagery was about. It was pretty easy and after that I just gave her tons of work to edit. We negotiated back and forth until we agreed on a final image selection.

Ed's comments reflect the difficulty that photographers have seeing outside of themselves. It is often difficult for photographers to establish an initial direction for their portfolio, but with help and ongoing effort on their part a direction is discovered.

How does it feel for Ed, a seasoned photographer, to have a complete portfolio that speaks to his vision? Ed tells us,

Having a new book that represents everything about me and my work so clearly is totally freeing. I no longer have mad rushes prior to meetings where I am trying to customize my book to the particular client. The book is me and that's what we are showing. I have gained a ton of confidence with it, as every image represents my vision, so if the client likes it, we are in. I am not trying to be something for them that I am not.

How do clients react?

"Wicked, the whole thing is one strong package. There is always lots of great dialogue about the book— its construction and, most of all, our images. No one's said nice pagination yet, but you can tell they are caught up in the flow of the book when they are looking at it."

After all is said and done, what's the best part for Ed?

"It is amazing how clients consistently identify their projects with our work," he enthuses. 'The phone has been ringing constantly. It doesn't get much better than that!"

CHAPTER 9

MILLICENT HARVEY'S VISION QUEST

In the world of spirit, a vision quest is a journey inward. It is a road taken in order to reach one's core, one's center. The goal is to receive guidance, messages that will help one to become more authentically who one is. The road is long with many turns and the destination is not of importance. It is the process, the work that itself becomes the answer.

For Boston-based photographer Millicent Harvey, the phrase "vision quest" defines the process that she began over a decade ago, one that has led her to develop a more personal approach, more visual authenticity, and a new body of work that represents how she sees the world.

A successful editorial photographer and teacher, Millicent was busy in the late 1990s, shooting assignments for *Inc.*, *Boston Magazine*, and other editorial publications. She created environmental portraits that gave the viewer a glimpse into the subject and were colorful and graphic. Clients loved her work. She was happy to be shooting, as she explains:

> I loved the creative process. The control was important, I would shoot a Polaroid in the beginning and I kept shooting 'roids until the shoot was completed. I was able to track lighting, gestures, and angles. Looking at the first Polaroid and then the last, I could see in front of me how I had created the entire shoot. I loved that challenge of starting with nothing and producing

an image that really worked. The control of the shoot was a big focal point for me.

A few years later, Millicent began teaching at the New England School of Photography. "Teaching forced me to talk about what I did. It was the first time I began to articulate my process and use words to explain what I had always taken for granted." It also provided Millicent an opportunity to reconnect with photographer Nubar Alexanian, as she comments, "Nubar was my very first photography teacher. I thought his insight would be helpful to my class, so I invited him in. After listening to his advice and comments to my students I mentioned to him that he should begin a critique group."

The idea for the group was not totally selfless. After years of feeling comfortable with her work, Millicent was starting to feel that her images were not pleasing her. While clients were still happy, the photographer was not. "I felt that I was busy solving other people's problems," she says. "I was meeting their agenda, and somewhere along the way, that became the primary focus." While other photographers might have ignored the clues, Millicent knew that it was time to begin to explore and redirect her vision. The quest had begun.

REKINDLING A PASSION

Millicent continues,

I knew I was unhappy with my work, but I could not articulate what I was unhappy with. I was thrilled that Nubar began a new critique group. The group was key for me. We were all working photographers who wanted to rekindle our passion for photography. It was during one of Nubar's critiques of my work that I realized that my produced images did not contain the spirit of who I was. That was the missing link.

I decided to try a different approach to creating images. I put my Hasselblad away, as I wanted to stop "producing" and worrying about the technical end of photography. I wanted to record found moments.

I started shooting with a Holga and directed myself to shoot different subjects than what I was photographing for clients. I started shooting kids, animals, landscapes. I wanted to document everything I saw.

As Millicent continued to shoot and present her new work to the critique group, she realized that she was beginning to show up more in her new images.

"My pictures had more emotional content," she notes. "For instance, my images of kids are a great example of how I was approaching subjects in a new way. Some shots felt warm yet others were very disturbing. But they were *all* about emotion and expression. I was recording what I saw."

It was here that more questions began to pop up for her. "I began to wonder," she says, "was what I was seeing what the subject truly felt? Was I recording what was actually happening or just my interpretation of what existed? In the end I realized that I was recording my response to the person, the event, the moment, and I was excited because I knew that in shooting from a position of personal response, I was trusting in my spirit, not in a Polaroid."

As Millicent continued to shoot and participate in the critique group, Nubar began to tell her that "it was time." Millicent wondered what he was referring to, and then she got it. It was time for her to create a solid body of work based on her new way of seeing.

"I decided to create a book in March 2003, and as soon as I realized that I was committed to the project, I became stuck. How do I get going? How much new work do I need to create? What should it look like? My mind was filled with questions." Nubar once again was a key collaborator for Millicent. "Nubar and I began by laying out existing images, and right away I started seeing relationships between photographs. That was all I needed," she says.

Millicent continued to work on the inside as she began to make decisions about the book's format and use. "I was not going to create a traditional portfolio for the commercial market. I wanted this body of work to be a limited edition, a bound book that would be sold to people who appreciated my point of view. This was a personal project and the finished result needed to be treated as such."

Millicent began the tedious process of learning how to produce beautiful digital prints and sourced out a bookmaker. The final product, titled *Inside/Out*, contains thirty-seven stunning black-and-white images bound in gray Asahi silk that is hand stitched.

Three months after the inception of the project, the first copy of *Inside/Out* was produced.

In experiencing *Inside/Out*, the result of Millicent's vision quest, we are invited to begin a journey of our own. Her images are evocative and ask that we, the viewers, get involved. Perhaps Millicent's friend and mentor Nubar Alexanian states it best when he writes in the book's foreword: "When I look at Millicent Harvey's photographs, I often wonder whether it is my memory that is being engaged or hers. Does the sadness I feel belong to me or her? Is the delight I see in her children based on my memories or the result of the narrative in her photographs?"

When looking at *Inside/Out* and hearing the response of others to Millicent's images, it becomes clear that the woman who started out on a quest to rediscover her personal vision has indeed accomplished her goal!

CHAPTER 10

VISION: THE CLIENT'S PERSPECTIVE

For the last several years the photographer's vision, his or her visual approach, has become the major defining tool for buyers. Shockingly, most photographers are still unaware of how important it is to define, develop, and market their vision.

Many still feel that their current relationships and their technical skills will win assignments. Look at your perception of why clients hire talent. Do you feel that your personality, technical abilities, and professionalism are the key elements that you are selling? Or are you clued into the truth that your clients are demanding that you define and market a specific vision?

Assignment buyers now look to each photographer's visual approach to clearly show them if the shooter is "right" for a particular project. While "the fit" was previously defined by the relationship with talent as much as by the photographer's abilities, it now seems as if the fit is defined by vision.

One of the reasons that this shift has taken place can be summed up in two words, *corporate branding*.

Corporations have spent and continue to invest tens of thousands of dollars to define, identify, and sell their "brand." The brand is their value message to consumers and that is what is clearly front and center in each annual report and ad campaign. In addition, companies have identified and defined their audience. They know who they are, what publications they read, what TV shows they watch, and what types of music they listen to.

Before art is assigned to any photographer, the art director has defined the look of the campaign and that look is based upon the corporate brand, with the target audience in mind. It makes sense then that an art buyer may need a lifestyle photographer whose images represent an active lifestyle for one campaign and then for another client look for a photographer whose lifestyle images are soft and moody, all on the same day. Different visual approaches speak to different company messages. You may be a lifestyle photographer, but have you defined your visual approach to lifestyle? Do you clearly show buyers what types of accounts your eye is appropriate for? Do you give them what they want?

Beverly Adler is a seasoned freelance art buyer who knows what her art directors want. "Vision is huge. When I am looking for photographers, for a project we [the team] are looking for a specific type of shot and a specific 'feel' to the imagery. The 'feel,' the style, is the intangible quality that often makes the difference." Beverly continues, "If an art director wants a sexy phone shot . . . they are not just looking for a product shot, they want to see a book that has the type of lighting or drama that they see using for their campaign. If the look isn't there the book is not sent on."

Ralph Mennemeyer, a top agent based in New York City, has opinions on a client's take on vision.

Sure, clients say they are looking for "new" talent all the time, but I believe what they really want is talent with a slightly different point of view to whatever is currently in style. Different enough to allow them to feel comfortable assigning the photographer work (which often has hundreds of thousands, if not millions of dollars of media reach scheduled for it) but conventional enough in most cases to provide them with a comfort level about that person's ability to "pull it off when it's show time."

The trick for most agents—and visual artists—is to understand how far you can push the envelope between new and irrelevant. Picasso would have been unemployed during the Renaissance, so often it's as much about timing and applicability as it is about "new."

Clearly, vision plus experience equal trust in buyers' minds. In years past, assignment photographers exclusively filled this need. Has the proliferation of stock photography reached those photo buyers who seek to meet the branding needs of clients? Are stock photos impacting this section of the market? Beverly Adler is quite clear in her response:

> Stock photography is often just as expensive as assignment work, and no company that has spent money, big money, branding is going to risk using stock photography for major campaigns. The image quality of stock is getting better and better all the time; however, it's the uniqueness factor that clients are after."
>
> They don't want to take the chance that the visuals they purchase have been used elsewhere. They want a specific vision for their company, one that will speak their message.

BRANDING IDENTITY AND BIG BIZ

In order to understand how corporate branding works and why it has achieved such a monumental place in the advertising process, let's look at the automotive industry and see how branding has affected the advertising process.

Each auto company has created its own brand identity. For years the Volvo brand revolved around safety. The car was not overly attractive, yet the safety records were remarkably high. The company focused on the vehicle's record for safety, which led them to determine (after market research) that their target audience was families. After all, teens and young adults are not as interested in safety as they are in looks, speed, and performance. The next factor considered was economics. As the price point of Volvos was high, the target family for Volvo was affluent. No trips to Kmart for these families. They were canoeing, skiing, or trekking to the local café. Images depicted families in these activities. As Volvo ad campaigns continued to focus their communication around the brand message, Volvo, in the minds of buyers, indeed became synonymous with safety.

A few years back, Volkswagen wanted to reposition its brand (value message), and after market research the decision was made to target buyers who were connected to the driving experience. The youth market (and those older folks clinging onto their youth, your writer included) were the target audience for Volkswagen as they created the "Drivers wanted" campaign.

The focus was on the experience of driving: the fun, the adventure. The images were full of energy, had a young lifestyle feel, were a bit quirky, and contained a bit of dry humor.

In the art buyers' world, the photographers chosen to shoot Volvo's "safety" campaign images were most likely not going to be the same folks that shot the "Drivers wanted" images for the Volkswagen campaign. These campaigns had completely different agendas. When a buyer is looking for a photographer to create images that contain warm family, connected moments (ones that represent keeping your family safe), the books they call in and the Web sites they cruise are not the same as those they would look for when searching for talent that exhibits images that are fun, quirky, and energetic.

While Volvo and Volkswagen produce the same type of product, the look, feel, and value (branding message) to the consumer of each product was vastly different. Consequently, each car line developed a different audience and a different sales message. The visuals that represented the sales communication also needed to speak the product message and thus were very different from one another. The photographers chosen for each campaign obviously needed to have different visions as well.

This example is repeated many times a week. Companies have specific messages to communicate to consumers. The messages have a look and feel that calls for a specific type of photography. Art buyers are looking for the type of imagery that speaks to the assignment in front of them. It is not unusual for an art buyer at a mid-sized or large firm to need ten to fifteen different photographers (each with a different vision) per week for different campaigns.

MATCHING VISION AND PRODUCT

The need to match vision and brand is repeated in the editorial and corporate markets as well. If you have any doubt that this is true, go to Barnes and Noble and you will find hundreds of magazines, each with its own niche message for viewers. The look, content, and art of each publication speaks to the magazine's branding position. The images inside are chosen to inform and to blend with the publication's visual and content mission.

It is clear that assignment clients are asking you to show up with a well-developed visual approach. They want to know which projects are a visual fit for you.

Your print portfolios, online galleries, and marketing materials are the clues that will lead the right buyer to you. But first you must accept the reality that buyers are looking to match vision to project. Your visual approach to a specific subject is what a buyer needs to see. Will you choose to give them what they want?

CHAPTER 11

THE GIFT OF CHOICE

O ne of the greatest gifts that you have been given as a freelance visual professional is the gift of choice. Using this gift actively and consciously can be one of the most powerful tools in your arsenal. The gift of choice is always present and is evidenced by the fact that you decided to own your business rather than to be an employee of a company. You chose not to punch a clock or have your salary dependent on a quarterly report written by a superior. You are not handed assignments that call only for your technical expertise, leaving creativity to the postproducers. Assignments are not chosen for you, so you get to choose which to accept and which clients to let go of if the road seems to be taking you in different directions.

In addition, this choice to "go freelance" has enabled you to make the decision about when to start your day and when to end it. You choose when to take vacations and how much to pay yourself.

But choice goes beyond, way beyond, these daily occurrences. Your choices will affect the totality of your world. With this in mind, consider the following questions as their answers begin to shape your business and your life.

What space in your life will your business take up? Will you work an eight-hour day? More? Less?

Is your work woven into the fabric of your life, holding a significant spot but not becoming the totality? Will you choose to accept your role as a visionary? What would that look like? How will you facilitate that? What type of relationship do you

seek with your clients? What does excellent service look like to you? Will you have a team? What will relationships between you and your suppliers look like? Between you and your clients? What will they feel like? What would a perfect business day look like to you? What would the perfect client look like? What type of attitudes must the people who work with you have? What type of atmosphere will you create in your business? Will you choose to have a positive approach to life?

These are the deeper decisions that you will make. All the choices that you make each step of the way will create your reality. For these reasons, "choice, conscious choice" should be your mantra.

Is it already? How often do you consciously use this gift?

Do you access the power of choice consciously? Are you grateful for the many options that face you daily? Do you examine each area and make choices based on your higher good and the higher good of your company? Are you excited about the decisions you have to make? Do you proactively guide your business?

John Myers is a successful lifestyle shooter located in Rochester, New York. John has a national client base and proactively guides his company. He is supremely aware of the effect that his choices have on his business. A positive man, he embraces the freedom that conscious choice provides

> I've always found it important to have goals. Goals are choices that I set for myself for my business. My choices guide me. I know I don't have total control over what happens in my life, but I have control of how I react to the situations that present themselves to me. I'm in charge of how I respond to everything. For example, I like being surrounded by people, so I chose to hire a full-time support staff. I choose to only go after projects that are a good fit for me. Most importantly, I choose to have a positive attitude toward life.

YOU HAVE THE POWER

As you read this essay, how are you feeling? Do you connect with the truth within or are you shaking your head, finding yourself saying, "Look Selina, I don't get to choose my assignments,

my clients choose me. My business stinks. I can't help it if the assignment market is slipping, I can't fight the stock photography option, and I certainly can't compete with the assignment shooters who low bid and are willing to give their services away. Life is not a choice, stuff just happens, and I struggle every day."

If you find yourself feeling as if you have few choices or if it seems as if the options in front of you are not options at all, I would invite you to examine your perceptions and look at your general attitude. No matter your current circumstance, seeing yourself as helpless is giving up your power. Feeling as if you have no power creates that reality. Ironically, *giving up your power to outside circumstances is indeed a choice that you are making*, an unconscious choice most likely, but a choice all the same.

Seeing the world as a place that happens around you, one that you just react to rather than one you actively create, is continuing the belief that you have no control.

In reality you hold all the control. Your thoughts create the idea that you have no power. In reality you are not a passive individual floating in a world that is happening around you. You can choose to stop those thoughts now. They do not serve you!

Instead, I would invite you to open your heart up for a bit and begin to entertain the belief that your view of the world, your perceptions of how things are, really might be limiting your options. I would ask you to suspend your beliefs for a bit and read on. You will see how you are indeed in control of what happens to you. You will see that you do have the power to create your life the way you would like. You will see that your choices, conscious choices, do truly affect your entire existence. They cannot help but affect you.

Choices make up your reality. Choices are our actions based on thoughts. Teacher Deepak Chopra, in his *Creating Abundance*, has said, "You are your thoughts. Your thoughts become your actions and your actions become your reality."

With this truth in mind, every time you choose a thought it will turn into an action, and through these actions you are indeed creating your reality.

Let's look at how this might work in your business world.

Let's suppose that you have been booked for an assignment that you are very excited about. It's the type of job that will

provide you an opportunity to work on a prestigious account, and, in addition, it offers an opportunity for you to creatively stretch. You are excited as you realize that the fees you invoice will buy you the new digital system that you have been dreaming of. The job is two weeks away and, as it is a substantial shoot, you have begun preproduction meetings with your team; everyone is ready to roll. Then the phone call comes in and the project is shelved. You're not told exactly why, but you are told to invoice for all kill fees.

You are immediately thrown. Your thoughts turn to the money you feel you lost and the equipment that you had "mentally purchased." You further despair as you remind yourself that this job offered you an opportunity to be a creative partner and that's lost too. Your thoughts generate feelings and you begin to experience disappointment, anger, and frustration. You start to experience a loss of power, and you feel that none of what happened was in your control.

While you are right that you could not control the fact that the shoot was cancelled, the reality is that the "outcome" is not the cancellation of the shoot. Rather, the outcome, the final piece of the puzzle, is how you choose to respond. It is here that you have total choice.

You can begin to take your power back simply by redirecting your thoughts. You can choose to react to the news by continuing to attach to your negative feelings, or you can choose to see your thoughts and experience your feelings but not attach to them, choosing instead to say, "It would have been nice if this job had come through as planned but clearly that was not to be." Then immediately move on to another activity. If you do this, you are then creating closure on your own terms.

The words "wouldn't it be nice if" truly shift the energy toward peace and away from anger and fear.

They have a special power that can be clearly experienced. It may take a few times of going through this exercise before you see and feel the effects, but life as we know it will certainly provide plenty of opportunity for practice.

While you are practicing how to observe your thoughts and recognize your feelings, do not *attach* to them. Remember that it is the attachment to negative thoughts and feelings that adds

to the process of giving up your power. Choosing to invest in negative feelings has very clear ramifications and none of them are helpful. So simply just observe.

Many studies have been performed that show that consistent negative thoughts affect physical and mental health. I would take it one step further and without hesitation state that negative thoughts totally affect your business. In my twenty-eight years of working with photographers, I have occasionally encountered photographers who have negativity deeply embedded into their personality. These are folks who I could not help, no matter how talented they were or how much I tried. Their negative attitudes and the energy they created was ultimately toxic enough to override all of their talent and our efforts. They lost clients due to their attitudes, and they did not replace lost accounts because of a number of excuses that they continued to heap upon themselves and anyone who would listen.

You, however, will hopefully make a different choice. As you continue to choose to not attach to negative outcomes, you will begin to experience yourself and your world differently. You will see yourself taking more responsibility for your thoughts, your actions, and your life. Once you accept that you are in control of your circumstances and you begin to consciously choose your thoughts and actions, great possibilities occur!

PART III

TEAM

VISUAL IDEAS COMBINED WITH
TECHNOLOGY COMBINED WITH
PERSONAL INTERPRETATION
EQUALS PHOTOGRAPHY. EACH
MUST HOLD ITS OWN; IF
IT DOESN'T, THE THING
COLLAPSES.

—ARNOLD NEWMAN

CHAPTER 12

AGENTS, MARKETING ASSISTANTS, CONSULTANTS: WHO IS RIGHT FOR YOU?

Today's market demands that photographers actively and consistently market their services. The question faced by many visual pros is how to facilitate the many tasks related to marketing while continuing to service clients.

The answer that most photographers immediately come up with is "I need a rep!"

While an agent (and I use the terms "agent" and "rep" interchangeably here) is indeed a solution for some, it is not the answer for most photographers. In fact, a marketing assistant and/or a freelance marketing consultant are more appropriate suppliers for most photographers.

Read on to discover how each of these three professionals might help you, and keep in mind that any relationship you forge with a marketing partner will require your continual effort, presence, and commitment.

AGENTS

While the responsibilities an agent will take on vary from rep to rep, there are consistent tasks that most will perform. Agents are historically responsible for the following:

- Creating an overall marketing plan
- Prospecting new client leads
- Sending and/or showing the portfolio
- Negotiating all assignment bids
- Licensing all images

In addition, some agents will work with you on talent development.

It may seem odd that I say that some agents *may* work with you on developing your talent, as you might be thinking, "Isn't that where we begin?" Indeed, talent development is a critical component to your success; however, many agents are looking to work with photographers who have done that piece at least initially. In essence, agents—unless they, too, are new—are not looking for new photographers. It is important to note that "new" to an agent is not just a statement that refers to your length of time as a shooter. The term "new" can refer to long-term photographers who are just beginning to actively market their business. These are folks who have built their company through referrals and have only recently come to the understanding that in today's market referrals just don't cut it. For the first time in their ten-plus years, these photographers have begun to create a focused body of work and are beginning to look for clients to serve.

In addition, most seasoned agents, those in the business for five or more years, are looking to rep advertising photographers. Clients in that market are comfortable with reps, and the fees generated by the usage of a photo drive the project rates to the highest paid in our industry. Agents take a commission of 25 to 35 percent of the project fee on new accounts and often look for an across-the-board 10 percent fee on your house accounts. They will immediately attach this fee to all of your current accounts and begin the process of negotiating for you.

Perfect "rep material" is the shooter who is a seasoned photographer with a highly developed vision and an active client list. It is a rare rep that will take on a new talent or one that services the corporate or editorial worlds.

You might be asking yourself at this point, "Why does a photographer with a vision and a client list need a rep?"

The answer is simple. A photographer who has done the initial work is ready to take on substantial accounts but may not have the connections to buyers or the know-how to appropriately negotiate assignment licensing fees.

An experienced agent is a business partner who understands and has developed relationships with contacts in the ad field and is extremely experienced at licensing and setting project rates. Obtaining assignments that are appropriate for your talent is an ongoing task for an agent and is one that involves much time and effort. Negotiating, pricing licensing fees, and sealing the deal are complicated tasks, as fees vary and deals are continually changing. These are the responsibilities on which most agents focus their efforts.

Michael Grecco, one of the country's leading photo talents, has multiple reps that handle his work in different fields of commerce. He has very specific ideas on the value reps bring to his business:

> Every photographer I know thinks a rep is the solution to all their problems. That's rarely the case. I use a rep so that I know I have a *closer* in place when I am on the road (I'm a closer also). What do I mean by a closer? That's someone that doesn't just sell, but can close the deal. A 'closer' gets you in the door *and* gets you the job. That's hard to find in an internal rep, which is an employee, and it might even be hard for you to close yourself. If that's the case, look for an agent who knows how to seal the deal.

If you sense that an agent is not right for you, you have a lot of company. A few years back the ASMP (American Society of Media Photographers) claimed that for every one agent, five hundred photographers were eagerly looking for one. I took that figure of five hundred and thought that maybe only 10 percent of those looking were truly rep material. If you are not sure that you are rep material or that an agent is right for you, don't worry, help is on the way.

MARKETING ASSISTANTS

In the past if you were not in the ad business or were not yet a seasoned, competitive talent with marketing tools developed (read "rep material"), a trained marketing assistant or freelance consultant would definitely be the perfect team partner for you. Today, a marketing assistant is popular within the ad community as well.

Ken Gehle, a busy photographer in the Atlanta area, opted for a marketing assistant, and he explains why:

> After spending some time defining my vision and building a book to support it, I began a program to market my work utilizing direct mail, e-mails, and some portfolio showings. My energy was spread too thin to be effective enough. Lo and behold, a young rep came a calling and after a couple of months I signed on for representation. It didn't work out and soon I was back on my own. Instead of looking for a new agent I decided to proceed with my backup plan of hiring a marketing assistant.

Ken explains the role of his assistant, saying, "Currently my marketing assistant works just one day a week but the database is being updated, the mailers are going out regularly, and all the books are constantly out. My assistant arranges for in-person appointments and I am seeing potential clients on a regular basis."

One wonders why Ken opted to go the marketing assistant route rather than try another rep. "A traditional rep with four to five photographers was not going give my business the attention that my marketing assistant does. I want someone to market me solely; I did not want to be one in a stable of talent. My marketing assistant seems to be the perfect option."

Ken's experience is not uncommon. A marketing assistant may be just the type of support that you need. While a marketing assistant is not a new option, most photographers look for a rep first. They don't understand the reality of representation and thus look for agents to handle the tasks that a marketing assistant usually does. The job of a marketing assistant is to perform the

tasks related to marketing your studio that you choose to give to him or her, or that you have little time to do yourself.

Generally, assistants will do the following:

- Research new account leads
- Call and make appointments for you to show your portfolio
- Oversee and facilitate a drop-portfolio program
- Develop a database for new prospect leads
- Facilitate your direct mail and e-mail database

As there is no central place to find marketing assistants, photographers generally cull prospects from a variety of sources. When looking for marketing assistant prospects, look at business graduate students, recently retired senior citizens, or previously working mothers who are looking for work that requires only a few hours outside of the home.

These are all people that may have past business experience and are not looking for full-time employment.

Look to local community groups, business network groups, university placement offices, and religious and spiritual groups that you may belong to. Usually after accessing these options most photographers do not need to run an ad in a local paper. This is, however, an option.

Knowing what tasks you want a marketing assistant to perform is critical, as you will then be able to articulate the types of skills your assistant must have in order to perform the job well. Take time to clearly list your service goals and make sure to share them with serious prospects.

In addition, create a short list of personal and professional skills that any potential prospect should exhibit. Spend time here and decide what type of personality you would be most comfortable with.

I remember a situation years ago when I was training new agents. We were talking about energy and the different types of personalities that seemed to do best with sales. As we were talking, one woman, a very shy person, shot her hand up and stated her concern.

"Do I have to be like you, Selina? You seem to be really energetic and almost pushy. That's not me!" She blurted this out and seemed almost apologetic. I laughed, realizing that she, as a quiet

person, was very concerned that she would need to be something other than herself. I reassured her that she should indeed be true to herself. I reminded her that many people enjoyed being with quiet people and that a person who was as well-grounded and organized as she was would indeed find her spot.

I was reminded then, as I remind you now, of the truth that we are all different, and you do need to consciously think about the type of person with whom you would like to work daily and, in addition, who would best represent your studio on the phone.

Consider the fact that you do not need a ton of money in order to hire a marketing assistant. This is usually a part-time responsibility, and you can start them off for as little as five hours per week. With tasks clearly defined and geared toward your sales and marketing needs, having as few as twenty hours of consistent support per month will surely improve your revenue stream. The busier you get, the more funds you will have and the more help you might need. Clearly this is a position that can grow as your business grows. Marketing assistants are usually paid by the hour, allowing you access to these important partners at any point in your career.

Should you find that you could maintain your daily tasks but have specific needs that require the advice of an expert, consider hiring a marketing consultant.

CONSULTANTS

The job of a consultant varies according to the skills and interest of each professional. As one of the first in the country, I have had the opportunity for the last twenty-eight years to watch my industry develop. Consultants' services usually revolve around one or more of the following categories:

- Talent development, that is, working with the photographer to develop a clear and focused vision that is marketable
- Creating sales and marketing programs
- Developing online and print portfolios
- Teaching photographers how to price, negotiate, and license images
- Training sales staff

When choosing consultants, call them up and have a phone conversation with them. Ask them about their process and their experience. Make sure to see if the services they offer match your needs, as not all consultants perform the same services. Additionally, check the consultant's background to make sure that his or her experience is related to the task at hand.

For instance, your project may involve talent development, but few consultants are truly trained or experienced at helping talent grow their vision. A consultant's direct experience may not be related to your area of photography. For example, some consultants come from an agency art-buying background. While they might be perfectly suitable for an advertising shooter, their advice might not be appropriate for an editorial, corporate, or consumer portrait photographer. Finally, watch out for those few consultants who see consulting as a "part-time money-making opportunity" or reps who are looking to supplement their income. You deserve a full time consultant who has dedicated his or her time to consulting in order to bring you the best, most up-to-date information.

During your conversation see how comfortable you feel with the consultant. This is the person who will be guiding you, and, while you do not need to be best friends, it is important to feel at ease asking the person questions and sharing your ideas.

Consultants generally have hourly fees for short-term work and should be willing to offer you a written proposal for any long-term projects. It is important that you and the consultant have a clear sense of the project at hand and agree about the steps to take to reach your goals.

I suggest that you always ask for recent references. Make sure to call them and ask the following questions:

- Did the consultant perform the services agreed to?
- Did he or she service appointments in a timely manner?
- Was he or she easy to work with?
- Did the consultant have his or her own agenda or were you and your business the focus?
- Would you work with the consultant again?

What you don't want to ask was whether the consultant "made them money."

A consultant is a guide, a coach. Consultants give guidance, and it is up to the photographer to use the advice or not. A great consultant can provide excellent counsel consistently, but if a photographer does not do the work the consultant is suggesting, progress will not happen.

If you are interested in repositioning your business, need help developing a portfolio that sells, or need guidance as you create a defined sales and marketing program, this team player may be right for you.

In order to determine which professional may be a fit for your company, list your short- and long-term marketing goals. Determine the tasks associated with each goal and honestly evaluate your skill set, your time, your budget, and your commitment to getting the job done. Review the tasks that you truly do not want to do or are not capable of doing well. As you look at them collectively, match the list of tasks with the responsibilities listed above under each service provider.

Be proactive. Spend the money it takes to work with a great professional who is dedicated to helping you grow your business. Do not get caught in the "I can't afford help" mentality. After all, if you won't invest in your company, why should clients invest in you?

CHAPTER 13

THE REALITIES OF REPRESENTATION

In a perfect world clients would seek out visual talent to hire. Photographers would have their choice of assignments. Clients would set fair prices and arrange lucrative licensing fees. And because they would be "selling" to the talent, creatives could focus their energy on doing what they do best: creating.

A nice scenario, but not at all realistic. The world is not perfect—shocking but true—and today's highly competitive market forces serious pros to spend a significant amount of time marketing their talent. Although there are no exceptions to this rule, there are several choices as to how to go about it. As many creatives feel uncomfortable in the marketing arena or have limited time, they may choose to obtain representation.

Reps are responsible for creating and implementing plans associated with developing new business, and for their efforts they earn 30 to 35 percent of the creative fee. In addition, some reps will also service house accounts, usually for 10 to 15 percent of the creative fee. In some cases agents insist on servicing house accounts. Beyond that, the job description varies a bit with each individual, but you should expect a rep to assume some or all of the following responsibilities:

- Develop a long-term business plan while setting and meeting short-term business objectives.

- Evaluate your current marketing tools (portfolios, mailing pieces, Web sites, e-mailers, and so on) and make suggestions that will benefit all of your promotional efforts.
- Target markets and research appropriate contacts for your talent.
- Actively promote your talent through portfolio showings, direct mail, Web site presence, and e-mail blasts.
- Negotiate licensing fees for all assignments generated through the rep's efforts.
- Obtain printed tear samples when available.
- Develop an ongoing client relationship once it has been initiated.

Sound ideal? Ready to sign up? Well, join the crowd. There have always been many more photographers seeking representation than there are seasoned, experienced reps. So before undertaking the search, make sure representation is a viable option for you. Ask yourself these questions:

- Do you have a strong belief in the commercial potential of your work?
- Has this belief been confirmed by clients? Are you billing $300,000 or more annually from advertising clients?
- Are you willing to spend at least $5,000 to $10,000 a year promoting your talent?
- Do you have a distinct, easily recognized visual style?
- Have you become too busy to seek out new business?
- Do you wish to go after a market that is outside of your geographic area?
- Have you been servicing clients for at least five years?
- Have you actively marketed your work (thirty to forty portfolio showings a year plus direct mail, e-mail, and Web portal placement) for the last two to four years?
- Are you able to be a team player, making decisions with another person?
- Are you willing to make a long-term commitment?

Most seasoned reps are looking for an affirmative answer to the questions above. It's a rep's market, and agents are interested in aligning themselves with people who have a

proven record of success. Few are willing to break in a new talent, not even when the artist has a unique vision.

Ralph Mennemeyer, a seasoned agent located in New York City, has much to say on the topic of taking on new talent.

"From a rep's standpoint," he says, "building a *new* talent is an investment. Agents don't just get you assignments; they build and develop a career for you. It is not a relationship that either party should enter into lightly."

The term "new" in itself is a double-edged sword, says Mennemeyer: "It takes time to build a career (often three to five years of hard work by both the rep and the photographer). Even if the talent has been shooting for years, if the buyers I am seeking to connect with do not know him, he is still a new talent to them. In addition, it takes time to make the connection in the buyer's mind that associates a given talent with a certain rep."

Is talent the most important quality that agents look for in a photographer?

CREATING A SUCCESSFUL TEAM

"Talent is a big part of the equation," Mennemeyer explains. "I have to love the work and know that it's marketable. But talent alone won't interest me. A photographer needs to be willing to work toward the goal for as long a period of time that's needed in order for the team to be successful. Photographers that are team players are the folks I choose to work with."

Mennemeyer continues:

> Often photographers will become impatient. They will be short-sighted and may be vested in obtaining individual assignments, not in building a career. They may "jump ship" in the hope of speeding the process along, and look for another rep. Most often that will have little or no effect. There is a difference between "scoring jobs" and "building a career," and in today's society of instant gratification, I think it's rare to find photographers who understand the difference. If I sense that a talent has a tendency to "jump around"

from rep to rep, that's a red flag that tells me to stay away, no matter how talented they are. I have learned not to invest my limited time and hard-earned cash promoting someone who'll easily leave.

Ralph clearly has his priorities straight. And, even though it is a rep's market, you still need to be choosy when you look for someone to represent you. So before launching the search, consider the traits you will be looking for in a rep and understand, as Ralph suggests, that you are looking for a long-term relationship, not a twelve-month affair.

Agents' most beneficial services are their ability to develop your career, negotiate and license your work, and build relationships with buyers. You will be looking for contacts that display the needed skills to accomplish these jobs.

When making a list of qualities that your agent must have, be sure to include genuine interest and excitement for your work as a qualifier for any rep you consider. A proven track record with talent and clients is important, as are organizational skills, marketing savvy, and confidence. Finally, a shared work ethic and common servicing values are a must.

When you start the search, be prepared to conduct an all-out effort. Get the word out on the street that you're looking. Discuss your needs among peers at art director clubs and similar meetings.

Peruse sourcebooks and Web portals; most have a general listing of reps in their directory sections. Look for pages reps have purchased with talent. Look for an agent who already has photographers that you feel have talent and are at a similar talent level as you are, but may not create the type of work that you do. Note as well the agents who might benefit from what you might bring to the rep's existing stable of talent.

Consider contacting SPAR (the Society of Photographers and Artists Representatives) in New York City. While sometimes difficult to reach—after all, they are busy working reps—SPAR publishes a directory of members. The list includes the type of talent the agent handles, as well as contact information. Consider an ad in the SPAR newsletter or in *PDN* (the national magazine for commercial photographers).

CONTACTING REPS

When you are ready to contact reps, be creative and organized. This might be your most challenging marketing objective to date because talent seeking to be represented solicits these folks daily. Do not call reps or send unsolicited portfolios. Instead, create a package of information that will instantly provide the rep with an idea of your vision and professionalism. In a cover letter, discuss your marketing efforts to date and your professional achievements. If you prefer, write an e-mail letter and link it to your site.

Talk up your client list and be prepared to sell yourself. This is no time to be humble. Make a follow-up phone call if you receive no response within two weeks of your mailing. If you do not hear from the agent following the phone call, I would assume that the rep is currently not interested. "Currently" is the key word. As with clients, a rep's needs change often. While additional phone calls are almost sure to be unwelcome, direct mail and e-mails, appropriately timed and containing relevant information (awards, new shots, new assignments), can be useful. Send your updates only to reps you are truly interested in working with, knowing that your efforts may produce results—eventually. Rejection is not the issue, timing is.

Ralph Mennemeyer has been on the receiving end of these requests for years and offers these thoughts:

> We often hear the phrase "timing is everything," but what's missed is the nod to persistence, because without it, timing is nothing more than dumb luck. You have to create the opportunity for the timing to be right and that comes by staying in touch gently. After all, this art is what advertising itself is based on . . . the idea of planting the seed in a person's mind so that when the time comes for them to make a choice you are considered. Too often people will press me with monthly calls or e-mails [or] postcards, which only makes me tune them out, and then they give up and wonder why they aren't more successful. What needs to

be considered is the sad truth that it takes *time* to work your way into a person's mind in a positive way—often a year or more.

What should you do?

"Use postcards . . . enter contests and e-mail me news of your account wins and ads or editorial pieces that are running," says Menenmeyer. "Show me that you have some momentum going and I'll want to be a part of your team. Call me with a desperate tone that reeks of 'I need work, can you give me some?' and I'll run like hell in the opposite direction," he explains.

BUILDING A GOOD BUSINESS "MARRIAGE"

If you take Ralph's advice and move slowly but consistently you will find yourself an agent. When you find appropriate candidates, be prepared to open your books, heart, and mind. The rep-talent partnership is a business relationship, true, but there are many similarities to a marriage. Two distinct personalities are working toward a common goal, and in order to be certain both of you are working in the same direction, you need to discuss personal, financial, and professional objectives. Determine the rep's expectations of you and talk about your expectations of the rep. Ask to see samples of work that the rep has obtained for his talent. Be prepared to show your body of work. If conversations progress, feel free to ask for references from talent as well as clients. Be ready to offer your own client references as well.

Once you find a rep, the real work begins. As with any relationship, clear and distinct goals are as important as common values. Respect, unfailing honesty, and excellent communication are needed in order for the relationship to succeed. Set team goals and yearly objectives. Monthly meetings to discuss long-term progress are essential—either on the phone or in person. Too often, talent and reps let this slide. Used to speaking on a daily basis about current work, future plans often get put aside. Communication—good communication—is an ongoing practice, and regular discussions outside daily activity

updates are a must. Outside of your meetings create a bit of space. Don't constantly pepper your agent with calls. Choose instead to list your questions and bring them to your weekly or monthly meetings. If you need to talk about real-life, real-time issues, call; otherwise sit back and simply trust.

Finally, expectations must be realistic. The bottom line is that the rep needs to bring in work, and you need to support that effort. Most relationships take between six months and eighteen months before the flow of assignments begins.

Provide the rep with a strong portfolio and update it with new images or illustrations monthly. Turn over all available leads to your rep and meet all deadlines for any promotional material. Accept all assignments from your rep and service them to the best of your ability.

Too often, photographers seek representation because they think a rep will take over all the business responsibilities and they can just sit back and wait for the bucks to roll in. This is not true. With a good rep, you will be working harder than ever, and not just on the assignments the rep brings in but on your talent as well. Be prepared to be an active partner in this unique relationship and the rewards will be well worth the effort!

CHAPTER 14

THE NEW BREED OF AGENT

T alent reps have been around for the last thirty-five to forty years, and in that time the rules of representation became fixed (some might even say rigid). Reps handled mostly top-end ad photographers, and lots of shooters were left to develop new business on their own. Although responsibilities varied, most reps concerned themselves with tasks directly related to obtaining assignments and licensing imagery.

The rep's role was once limited to bringing in new work and negotiating fees. It took much time and effort to perform these tasks, and agents were continually busy performing them while fielding inquiries from new talent looking for representation.

Today, the responsibilities of agents include the traditional responsibilities and talent is still knocking at their doors, but as the business has shifted, agents have found that their role has shifted as well. A new a breed of rep has emerged and new business models have been created. This shift has created a new look to the team approach. Where the operative word was once purchase order, these folks now speak of relationships, collaboration, and vision—and some now extend their services to art photographers, selling their images to consumers and industries for interior display.

There have always been fewer reps than those seeking them, and while the ratio of reps to talent hasn't improved, the rep-talent relationship has changed. We'll look at two

of the mavericks who are pioneering new approaches to representation.

BROKERING SUCCESSFUL RELATIONSHIPS

"I want my talent to win." Those words define the business approach of Dallas-based agent Quitze Nelson, of Q.ink. "I represent photographers who live their passion. These are photographers that have found their voice. They are committed to succeeding, and they thrive on the process of collaboration," she says.

Unlike traditional representatives, Nelson views both the talent and those who hire them as her clients. "The bottom line is that it is my job to bring two creative teams together so that they can produce the best results possible. When you work with people (photographers and clients) who love what they do and who want to produce amazing imagery, collaboration is a natural course of events."

Because producing great work is an inherent part of the goal, Nelson pursues new business selectively.

> I look at current campaigns, noting how someone art directed a shot, sensing how that person might think—I like to work with people who think outside of the box and push their work to the next level. I have a list of designers and art directors that we admire. While other agents only go after campaigns, I look to connect with buyers who exhibit great creativity. It's not the campaigns we target—but the people producing the marvelous work.

Quitze has chosen this path as it suits her values and it serves the talent she represents. She enjoys the process of collaborating with people, not just managing accounts. Her photographers are seasoned and deeply rooted in the creative process of working with clients.

The photographers represented by Q.ink are all at the top of their game: Paul Aresu has been shooting for over thirty years, providing clients with large production

capabilities. Aresu, located in New York City, shoots lifestyle, sports, and celebrity portraiture. Nelson describes Aresu's approach:

> In addition to his shooting style, Paul is grounded in understanding his client's needs per project. He is eager to partake in brainstorming meetings, which gives his clients the opportunity to work collaboratively with an experienced shooter who has a finely tuned vision. Paul goes beyond the layout; that's the type of talent that clients want to join forces with. It gives me the opportunity to witness and participate in a true creative process, it's thrilling.

John Parrish, Quitze's high-end jewelry and still-life shooter, has developed a niche audience. She explains,

> There is tremendous contact between John and his clients. He has been shooting with many of them for years. Often he works directly with a top-end jewelry designer. He is working artist to artist and he thoroughly understands their sensibilities. John is valued by his clients for his vision and his accessibility. He is totally available as am I and clients love the fact that both agent and photographer are deeply involved every step of the way. I handle the negotiations and scheduling and that clears the way for John and our client to work exclusively on the creative.

Clearly looking for a talent-client match in today's market is a challenge for any agent. Quitze's take on the Web site, print portfolio conundrum?

> With intricate and highly designed Web sites available, clients can view a photographer's imagery instantaneously. But many times they will still need a physical portfolio for client meetings or final decisions. My photographers have a developed look and I market their services to diverse markets, including corporate direct, agency, and design firms. Marketing

one vision to many industries is the sales paradigm in today's market. In addition to our Web site and print books, we use a variety of tools including direct mail and special promotions that we design together.

Following her mantra to personalize her relationships, Quitze believes that the personal touch helps win assignments.

Although you may have all the marketing materials and the photographic style that a designer is hoping for, it still comes down to the connection and the personality of the photographer. Many times, it will take the photographer and the creative team talking over the phone to seal the deal. The physical connection helps them all to realize that their combined vision for the assignment is what's needed for the current campaign. That's what I help to facilitate.

"I love what I do," Nelson says, explaining her reasons:

Working with creative agency talent, knowledgeable art buyers, clients looking for a solution to sell their product, the ever-changing advertising community, and photographers I truly admire and respect—it's a pretty great career! Agents are no longer just salespeople; we are producers, problem solvers, accountants, friends, and the point of axis for the many people and the process. We help the individuals to become a team and produce the best results—everybody wins.

THE FINE ARTS PHOTO REP

Sometimes veteran agents find that their original path can lead them in a totally different direction, one that enables them to apply their talents and experience to a new group of visual professionals. This is what Patti Silverstein is currently experiencing.

An agent who until recently handled only commercial photographers, Patti is located in the biggest ad market in the

country, New York City. Working in Manhattan offered her top talent to represent and provided a vast array of accounts to develop. After many years servicing national talent and advertising clients, Patti has chosen to shift her business and additionally represent the fine art as well as the commercial work that photographers create.

"I have been representing commercial photographers for over fifteen years and have always been drawn to photographers' fine-art work but never quite sure how to pursue that as a business," Patti explains.

I started to feel restless with the commercial world, I wanted to find a way to branch out. By talking to various people in the photo industry, I realized that I could create a company where I would represent photographers' fine art, selling their artwork to corporations, hotels, spas, hospitals, interior designers, and architects. This was a totally new world for me, something other than advertising agencies, graphic design firms, and magazines.

Was this veteran ad agent ready to break new ground? "It was a little scary to think about starting from zero, as I was entering into an area I knew little about," states Silverstein. "But somehow all the pieces began to fall into place, which for me is always a sign that I am on the right path."

So how does a veteran agent, one with a track record of many years, reposition herself in a new arena?

I knew one thing right from the start. I knew that my focus was going to be to represent art that people could look at and instantly feel calm and soothed by. It's important to me at this stage of my life to spend my time on work that affects others positively. People need a chance during their busy days to take a break, to stop a moment to regroup and refocus. My goal is to provide them with imagery that will enable them the opportunity to take that breath. For that reason I chose a tagline for my new company that reflected my mantra, and it is quite literally "Take a Breath."

Patti has named her new company Elemental PhotoArt—"elemental" because of nature and "all its glorious elements" and because the photographers' work she has been drawn to has been nature-oriented. "Photo art" represents the fact that she will represent other media in addition to photo. "I did not want to just limit myself to photography and realized that I needed a name that represented the full dimension of my product line," she comments.

Relationships are extremely important for this agent, and she began the development of her talent pool by turning to a close friend. "I want to work with people that have similar values," she states. "It made sense to begin by turning to those photographers in my life that I had a personal relationship with. I had a close friend of mine that I wanted to include in this new group of talent and from there I put the word out amongst my personal contacts that I was looking for a new talent pool. I was amazed at the support I received; the names kept flying in."

Patti was very focused on the type of imagery she was looking for and drew prospects from her ad days. "I have talked to many photographers during my years as an ad rep, and I began to contact those that I thought had the type of visuals and point of view that would be a fit for my new direction."

Patti chose the rest of her team based on their vision and their point of view on life.

> I have a clear vision of what I was looking for. The visuals need to be beautiful and speak to serenity and calm. I need my talent to know and be invested in creating that type of energy. In a way I am the client as well as the agent. The photographers who got what I was trying to do, the ones that understood my vision, were also the people I felt most connected to. Interestingly, they had images that were a perfect fit, calming and peaceful. Those were the people who were meant to be a part of this journey. It's a new way of partnering.

So what will her relationships look like?

"I have always worked closely with my talent," she states. "I like collaborating and the feeling of teamwork. I need to

know that my talent feels the same way. Collaboration is a very big part of an agent/photographer relationship for me. I am not looking to work with anyone who has their own separate agenda or comes to play with an attitude."

How can talent benefit from teaming with Patti?

My talent can expect that I am fully committed, extremely excited, and determined to make this a success. I am giving this my all and will work very hard to get this going and to keep it going. I expect them to be as committed, to work with me and to give me what I need to make this happen. I will respect them and their work and I expect the same in return. They must trust that I am doing my job and that I am watching out for their best interests.

Collaboration, communication, passion, and love of one's work are the key words and phrases spoken by these agents who are doing it differently. These two women are not simply going through the motions. They have very clear and distinct business models that speak to their values and goals.

The good news is that their attitudes represent many of the agents working in today's market. Perhaps Patti sums it up when she shares her final thoughts.

"This company is my heart and soul," she says. "It's one thing to represent photographers and simply show their work—I could be one step removed. I have no interest in being removed, I am totally involved and clients sense my absolute commitment!"

CHAPTER 15

OBJECTIVE HELP FROM THE BUSINESS CONSULTANT

In today's increasingly competitive market, photographers need that extra edge that will put their name in the limelight. Constricting economic attitudes, fluctuating style trends, and the ever-increasing number of people servicing clients are creating an environment in which photographers must be two steps ahead of the competition to succeed.

Two of the most significant challenges faced by visual professionals are knowing where the potential for creative and financial growth lies and creating effective plans to achieve desired growth. It is here that a business consultant can make a qualitative difference.

Experienced, seasoned photographers can benefit from consultation in a fundamental way. Consultants stay in close contact with the photo industry as a whole, watching market trends and economic attitudes while maintaining an objective overview. Photographers who spend most of their time shooting for existing clients have little, if any, time for this important task.

The consultant researches areas of maximum talent and financial growth and then devises a marketing plan specifically suited to the needs of the photographer. The strategy is to avoid relying heavily on existing accounts. The objective of establishing financial stability while obtaining exciting creative accounts can be achieved through an amalgamation of the old and new.

For an inexperienced photographer, the value of a consultant is more obvious. Consider the amount of time that is saved by working with someone skilled in discovering the inherent strengths in a photographer's portfolio and with someone who can direct the photographer to the sources that will provide the best possible contacts for his or her particular talents.

The decisions made by the new photographer must be hard and fast. It is critical to establish a vision, a perspective, and a marketing approach so that the work will shine in what is one of the most highly competitive markets in the country today.

The business of both established and new talent, more often than not, suffers from a lack of direction and organization. This is evident in both the photographer's approach to the market and the handling of day-to-day studio business procedures.

In the recent past, an all-too-common approach to obtaining clients has been to have no real plan at all. This "plan" involves personal connections, rumors, a little luck, and time when one is motivated. A portfolio of existing images is taken to a name obtained from a mailing list source or directory. There is little if any research involved, thus the potential client's needs remain a mystery. This approach might have worked years ago when fewer photographers were around and clients' needs were less defined. In today's market an approach of this nature is doomed. An educated consultant can develop a well thought-out, multilevel sales and marketing program specifically designed for your business.

The change in the copyright law in 1978 has given photographers a great deal of pricing and licensing flexibility as well as a whole new set of challenges. A capable consultant can help you educate yourself and your clients (without alienating them) and also supply you with sources where you can obtain the different purchase confirmation forms that must be used.

FINDING A CONSULTANT

Choosing a consultant is difficult, primarily because there are so few of us. Go online and google "photo consultants" or "creative consultants." Go to the *www.workbook.com* site and see which experts are listed there. Often consultants will lecture

through the major photo organizations. If your organization sponsors monthly talks, request that they book a consultant. This will allow you to gauge the knowledge, perspective, and personality of the consultant at a meeting, rather than during your first consult.

Whether a consultant was reviewed at a meeting or not, you will want to know a number of things about him or her, and an initial phone call is a good place to begin. Although most consultants will not charge a fee to discuss their background and service, it is a smart move to check first.

I was the first consultant in the country twenty-eight years ago. During the last several years I have watched many consultants come and go. Often reps, art buyers, and photo editors who are in between jobs act as consultants. While I am sure that these folks are well intentioned and knowledgeable, you are best served by those who have chosen to be full-time consultants. I would suggest that you not put your career choices in the hands of someone who sees consulting as a part-time or in-between job responsibility. Your consultant will be advising you on decisions that will affect your entire career. You need to align yourself with a consultant who has a long-term commitment to our industry.

You are looking for a consultant who is devoted to becoming knowledgeable about all aspects of the photography business that they seek to consult on. Full-time consultants spend countless unpaid hours researching, reading, and speaking with your buyers. They devote many hours to educating people and answering questions posed online on organizational forums. They may write articles because they want to reach as many creatives as possible. These are the people you need to seek out.

When talking with the consultant, inquire about the services offered. Some consultants specialize in marketing or motivation strategies, while others offer a full-service approach. Ask about the consultant's background, in and out of the industry. Some consultants come to the business from the agency world. While their experience might help photographers looking to work in the ad sector, their information may not serve the corporate shooter or the consumer photographer seeking to build a portrait and wedding business. In addition, if a

consultant's experience is limited to one agency or one or two in-house corporate agencies, that experience once again does not make that person the expert you need.

It is important to feel confident about the consultant's approach, personality, and knowledge base. The mode of operation is crucial. A consultant who is interested in establishing an ongoing relationship and is not just consulting on the way to another city or station in life is your best bet, as such people are more likely to have a vested interest in consulting in general and in consulting with you specifically. It is not necessary that you see eye to eye on every point. Remember, if you shared the same point of view entirely, the consultant's services would not be needed.

When you have found potential consultants that you are interested in working with, ask for references and call them. When you speak with photographers for recommendations, remember, a consultant's job is to advise, not to perform the task related to the advice that was given. The photographer is responsible for implementing the advice.

Often photographers looking for a consultant have asked me, during a front-end interview, "So, what's your success rate?" I always make sure to state kindly that I have no success rate to quote. My client's success is not my success, it is the client's. My client's job is to apply my strategies and advice, and whether the client chooses to do that or not is not in my control.

This does not constitute a lack of responsibility on my part; rather, it reflects the reality that a consultant's job is to ask the right questions, listen, and advise based on what is best for the individual talent. In addition, it represents my total respect for my client's individual efforts and success.

OUTLINE NEEDS

If you decide to schedule an appointment, be prepared to briefly let the consultant know your reasons for meeting. Since you will most likely be charged by the hour, it would be a wise idea to acquaint the consultant with your needs beforehand. Know the reason for the meet and be prepared with all the

necessary facts. Make an outline for yourself that contains topics important to you as well as your questions and ideas.

Knowing what you want from the consultation will not only allow you to spend your time wisely but also help you to later assess the consultant's effectiveness. Be open and honest. Be prepared to bare your accounting books as well as your deepest professional and creative desires, as a good consultant will want to know your short- and long-term creative, and financial goals.

Do tape the consultation or request notes from the consultant. (Extra fees are often charged for providing notes.) Make sure you have covered all of the immediate issues during the initial consult. If another appointment is needed, schedule it then.

A good consultant should be able to provide you with answers to general questions immediately. Ultimately, the consultant can help you to achieve short-term goals and long-term success. "Help" is the key word. The consultant can only supply you with new ideas, systems, and a different perspective. It is up to you to make them work!

CHAPTER 16

TEAM ARMOUR

Your defined and refined vision will get a client in the door, but it's the service you provide your clients that is the key to getting them back.

Jake Armour lives this truth. In a time when many photographers are wondering where all the clients have gone, Jake leads a team that has blown all of their financials goals right through the roof. While the Armour vision is tight, Jake and Hope Armour, his wife and marketing director, cite their team approach to servicing clients as the key ingredient that has led to the studio's continued and substantial growth.

> Team Armour is not just a phrase. It's what we are. It's the way we work together. We have two photographers and a producer here in our studio. In addition, Hope oversees the business direction and Jason handles all of our sales and marketing efforts. While everyone has specific tasks, we all step beyond the bounds whenever it's needed. Most importantly, we all follow the same mission—to provide our clients with the comfort of knowing that they can trust us to deliver the project they need, on time, on budget within an atmosphere that is casual, inclusive, and fun.

Armour clearly understands the value that the team concept brings to his clients. "Our clients are constantly busy. They look to us to deliver unique creative, sometimes within short

turnaround time. We are considered a can-do facility by one of our largest clients. I love hearing that because it means they know that they can trust us to deliver and, I know, trust means everything to a client," he proclaims.

For Armour, the concept of "team" does not apply only to the Armour staff.

"My client and I are a team. My full-time employees as well as all freelance stylists, producers, models, and assistants who work on each shoot are considered members of our team. Regardless of how long their tenure is, whether it's one day or one week, they become part of the team. For us, 'team' is not just a word, it's a philosophy and a way of working, one that we live daily," he proudly says.

KEYS TO TEAMWORK

Jake knows that in order to truly work as a team, there are several key elements that need to be in place. The team must be able to work together with all efforts focused on one goal, the success of the shoot. Communication is a vital element on the road to accomplishing this feat.

"We have daily meetings to discuss each shoot and every member of the team for that day's shoot is involved," he notes. "We review the project and everyone's responsibilities. There is no hierarchy; everyone has an opportunity to discuss the day. We not only listen but we *hear*. Lunch is a time for all of us from client to production team to sit down and to break bread together," states Armour.

In addition to the daily meetings as a communications tool for shoots, Armour is focused on the long-term goal of using the team concept as an approach for creating his studio service goals and mission statements. To this end, he and his employees created a studio mission statement together. To do this they initially chose to meet on a Saturday. Before attending, everyone was asked to list their contributions to the team as well as their interest for future responsibilities and their vision of what excellent service looks like.

As the day progressed, the group members discussed their individual ideas of the studio's mission. Each person

had an opportunity to talk about his or her individual roles, as well as the team's strengths, weaknesses, and challenges. The ultimate goal of the day was to create a document, a guide, that all of the daily team members would use when needed.

Included in the document was information about the services the team would supply and which team member was responsible for which task. Most importantly, the group created together a list of service goals detailing what excellent service looked like at each step of the client-studio relationship. "This document is key," states Armour. "In the throes of a shoot we need to live our words. Taking time out beforehand and consciously stating our service wishes helps us, when we are in the midst of client activity, to live our values."

While Armour credits his team with helping him to service clients, he knows that they are a representation of his commitment to service.

YOUR TEAM, YOUR MISSION

So dear reader, you may be shaking your head and saying, "My team is me. I don't have the staff that Jake does. I can't possibly consider a team approach to service." Think again. You and any supplier (assistant, stylist, bookkeeper) that you work with are a team. When you are assigned work, you and your client are a team. "Teaming," as we learned via Jake Armour, is an attitude, a state of being, not just a physical form.

One of the first steps toward determining how your team will function is to create a mission statement. This statement will deliver your company's purpose and your commitment to service. Contained within your mission statement can be a list of service goals. These goals are the guide that you live by and should be shared with all freelancers that work with you.

In order to develop your list, block time off your schedule for a working retreat. Rarely will time pop up, and it's easy to never get started if you do not commit to blocking time out for

this task. Give yourself a full day and commit to another if needed.

Begin your retreat by asking yourself what great service looks like to you. List all of the opportunities you have for delivering service to your clients. Begin with the task of answering phone calls and continue through marketing, pricing, estimating, shooting, and delivering assignments. Remember to "play client" and think about the type of service that you would want to receive. As you list each service opportunity and how you would meet it, write each as a goal. Ultimately, you will create a list of goals that you can post and refer to.

Once you know what excellent service means to you in each area, begin to examine how your service is currently provided. Are you now providing service up to your new service level? If not, list the areas that need improvement and the steps that you need to take to truly live your new service commitments.

Don't expect perfection. That is not the goal. Refer to your "needs improvement" list as you and your team tackle them one at a time.

This practice takes time and may feel a bit awkward when you begin. However, the result of providing your clients with consistently good service is well worth any initial discomfort.

Once your new service goals are committed to paper, post them on your wall. Look at them daily. Review your goals twice a year and update them as needed. When you hire assistants, make sure to share your goals with them. It's important for all the folks you work with to live your service goals while working with you.

Navigating client conflicts can be tricky, and it is here that your service goals can once again be helpful. Often when a conflict occurs, emotion takes over and the situation can easily escalate. In order to keep the situation under control and keep your commitment to excellent service, use your goals as a reference and check the specifics of the situation against your goals. Have you slipped up? Or is everything in order and you suspect your client is a bit out of line? If you feel that you have handled the situation in accordance with your mission and service goals, then graciously bring the situation to a close.

Whether you are using your goals by yourself, with free-lancers, or with paid staff, remember, you are the team leader and you set the tone for your client's expectations.

Jake states it best when he says, "My clients know that I will come through for them. Whether a photographer has a team or goes it alone, it all comes down to them, to their commitment to creativity and their vision of service. In this business it's all personal and it all resonates back to the person at the top!"

PART IV

TOOLS

OF COURSE, THERE WILL
ALWAYS BE THOSE WHO LOOK
ONLY AT TECHNIQUE, WHO ASK
"HOW," WHILE OTHERS OF A
MORE CURIOUS NATURE WILL
ASK "WHY." PERSONALLY, I HAVE
ALWAYS PREFERRED INSPIRATION
TO INFORMATION.

—MAN RAY

CHAPTER 17

HABIT OR TREND?

Photographers always want to know what buyers are thinking about and which visual styles and trends are hot. In addition, they often ask questions that speak to the popularity of specific types of image subjects. I am often asked, "Does anyone hire still life anymore? It seems as if all the ads I see are about people and lifestyle." Other shooters want to know about the nuts and bolts of presentation formats. A common query: "Are other photographers showing print books or single pages in a box?" It's pretty clear that digital photography has replaced film in every area of the business, but questions regarding the "new" colors persist: "What's with the new postpro colors? Do I have to change all the images in my book in order to have my color be competitive with the new look?" And simply everyone seems to be asking, "Do buyers want to see print books or do they just buy off Web sites?"

All of these questions speak to a photographer's interest in understanding buyers' patterns. Everyone wants to know how to attract more clients. It's wonderful that photographers are keenly aware that buyers' tastes and habits change, for being conscious of what's happening in our industry is a key to success. However, the information you glean should be a guide, not a taskmaster, and it will be important for you to distinguish between a trend that is passing and a habit that is here to stay. Finally, whether or not you should incorporate the information you obtain needs to be carefully considered. As you explore and begin to examine patterns, be sure you understand what you are looking at. Each time you come to a point

where you see a new precedent forming, ask yourself, Am I looking at a habit or a trend? This is an important question because many times photographers, in their quest to be competitive, jump hastily when, for instance, a new style of imagery seems to be popular, only to see a different trend take its place as soon as they are finished developing their new look.

If you are old enough to have been shooting in the eighties, surely you will remember Aaron Jones's light-painting techniques. If not, trust me, Jones's lovely way to paint with light took off incredibly quickly, with many shooters taking workshops and buying expensive equipment to create their own versions of a light-painting image only to see the trend become overdone and simply over within a two-year span.

Before we go much further, let's define the difference between a trend and a habit, as defined in my computer's dictionary.

Trend: a general tendency, movement, or direction. A current fashion or mode.

Habit: An action or behavior pattern that is regular, repetitive, and often unconscious.

Clearly, there is a difference between a trend and a habit, but often the difference is extremely subtle. In addition, a habit, which might have started as a trend, does not always hold. Habits also change, based on a variety of factors.

Light painting, cross processing, and Polaroid transfers are a few visual trends that have come and gone, never staying around long enough to become a convention.

However, other visual trends, like the use of black-and-white photography in advertising (after years of being a mostly color-oriented industry) and documentary style for annual reports and use by nonprofits, seem to be fixed into our creative culture.

FOLLOW THE FAD?

The use of lifestyle imagery is the latest change that started as a trend but seems to be here to stay. When I started as a rep thirty-odd years ago, very few photographers (with the

exception of those shooting fashion, editorial portraiture, or documentary) photographed people, and the term "lifestyle" didn't exist. Advertising was pretty much a world of still life and product. Today, lifestyle has developed into the one of the strongest styles and the use of this visual imagery crosses into every market.

Regardless of whether the change you are looking at is a trend or habit, it would be wise to ask yourself, Does this new way of creating best serve me creatively, financially, professionally, or not at all? In order to determine whether this new "option" will benefit you and your business, do some exploring.

If the trend or habit is visual, start looking around and begin to notice where it is being used. Are buyers in your industry using this approach? If not, can you see an application for it in your market? How would this new way of seeing benefit your images? Then ask yourself: Will this be a minor addition to your visual arsenal or will you be completely changing your whole approach? Does it require the purchase of new equipment? (Think film versus digital capture here.) Or is the method easy to accomplish with the tools you currently have?

Finally, go within and ask your higher self if this new option is truly what you want to do. Does it excite you and get you recharged?

Make sure that you have a good grasp on the answers to these questions—they will help you to determine whether (and why) you should invest your time, energy, and funds on this new photo choice. Once you have the answers you will be able to make a conscious choice, and the chances are excellent that your choice will benefit both you and your business.

HOW THE STOCK OPTION CHANGED THE BIZ

One of the biggest visual trends in photography (one that I hope becomes a habit) is the ever-increasing demand from clients that photographers show them their visual approach to

their chosen subject area. Clients are asking photographers for images that are more lyrical than literal. Buyers are often seeking images that a viewer can relate to, ones that elicit an emotional reaction. They are requesting a photographer's interpretation rather than his or her ability to simply "shoot a shot." That interpretation can take a variety of forms. The expression "art for commerce" is finding new legs in today's market. This new interest in art for commerce, I believe, was generated as a response to the proliferation of high-quality stock imagery and royalty-free libraries.

Originally, stock imagery purchases revolved around simple generic objects, still-life photos that were iconic with lots of sunsets, sky, and nature shots. Buyers were publishers and small editorial publications and companies.

Stock for them was financially feasible and a time saver. They could purchase a photo quickly and easily for many dollars fewer than an assignment shooter would cost. Ad agencies and mid-sized and large companies rarely considered buying stock images, as the quality and variety they needed was not available. Their clients were more discerning and they did not find stock images a viable option.

The major stock agencies wanted to compete for ad dollars. They saw an opportunity and moved quickly. In an effort to directly vie with the assignment industry for top-dollar ad accounts, they commissioned leading assignment photographers to create original images to be sold exclusively as "assignment stock." At this point the gloves were off and first-class stock imagery flooded the market.

Stock sites popped up, stock books were published, and all buyers were swamped with excellent existing images of every type. Stock was no longer marketed as a second cousin. It was now being touted, promoted, and sold as conceptual, high-quality imagery, all for less than the cost of hiring an assignment photographer. In addition, many buyers were enticed by the appeal of easily and quickly purchasing an image rather than searching for a photographer, hiring him or her, and producing a shoot.

Stock purchases now represent buyers in every market at every level, in all industries, with the exception of top ad campaigns.

At the same time that stock agencies began to promote their top-shelf lines, royalty-free libraries arrived offering low-budget clients many images (remarkably similar to the original simple iconic stock shots), which now can be purchased in large quantities for one low price.

The two-hit punch of high-level stock and low-level royalty-free images took its toll. In a market where supply and demand rules, assignment photography at every level has been deeply affected.

While we now find buyers of top campaigns and accounts still purchasing assignment photography, these prospects are demanding more of assignment shooters.

In fact, buyers at every level have a new definition for assignment photography. Prospects now have so much imagery at their disposal that their visual expectations of assignment work have been raised.

For instance, a buyer's ideas of what a lifestyle assignment image looks like has shifted. Images that just two or three years ago were considered assignment quality are now considered "stocky." I have had many clients tell me that when they show in their portfolio an assignment lifestyle image where everyone is looking into the camera smiling, everyone is happy, and the image is beautifully composed and lit, buyers tell them it's "too stocky." Is this because they have seen smiling people ad nauseam in stock catalogues? Are buyers lacking the sophistication to discern quality photography? Or do they simply want to see more variety in expression? Are they done with happy? Are they looking for images with a deeper expression? Everyone is asking whether this is simply a trend or whether the stock industry has truly shifted buyers' habits, pushing them to demand more visually sophisticated images from lifestyle assignment photographers.

We will need to continue to watch buying patterns in order to know the answer.

However, what we do know is that higher-level assignment buyers seem to be asking assignment shooters to bring more of their creative juice to the plate. They see so much in stock that it has raised the bar in regard to their expectations of assignment photographers. I think this is as wonderful as it is

challenging, as it pushes commercial photographers, forcing them to dig deeper into their creative pockets.

STAY AHEAD OF THE CURVE

In order to be sure that your information about buyer's trends and habits is complete, look beyond your vision. Look at sales tools and sales trails and make sure that you understand how buyers are choosing talent. Here are some marketing tools that have shifted for buyers.

Sourcebooks seem to be the dinosaurs of the industry. One would never know it by looking at the size of the major sourcebooks, but I am hearing all the time from buyers that Web portals (many owned and run by the same companies that publish the print sourcebooks) are getting all of the traffic. I am told that the books are glanced at and then go on a shelf. When buyers are searching, they go to the bookmarks of Web sites saved and on to online directories. Many prospects still keep direct mail and refer to notes from in-person visits.

While some photographers can track an occasional lead or assignment directly to a sourcebook page, it seems as if this once-successful addition to a photographer's marketing program is much less successful today then it was just a year or so ago.

Web portals, on the other hand, are hot. This makes perfect sense as we move further into a digital, online, e-mail, Web-oriented society.

For years I have been pushing my clients to use another recently popular marketing tool, visual e-mails. These mailers, containing a photograph with a short message or no message (but a clear link to a photographer's Web site) are currently huge marketing tools. While many shooters were resistant, they are now coming around as they see that clients are opening them and accessing their sites (in large numbers in some cases). Tracking software is a must as e-mail addresses can be harvested for future, in-person showings.

Visual trends, marketing shifts, and buyers' habits have always been and will continue to be a central part of the ever-changing landscape that we know as commercial photography.

Your job is to be alert and to expect changes. As you observe a shift, assess whether the change you are witnessing is passing or is here to stay, at least for a while. Decide whether this opportunity is a fit for you, and lovingly choose to let go those that do not serve you. Most importantly, do not panic or choose to become angry as you see your world changing so quickly. Choose instead to believe: All is as it should be. Make your mantra the words of an old Zen saying: Life is change, change is stability.

CHAPTER 18

BUILDING A PRINT BOOK TO ENVY

P hotographers' portfolios have always been their most important selling tools. The portfolio has also been the subject of many questions and misconceptions. In today's market Web sites have become powerful marketing tools, but for many buyers with pending assignments, the print book is still king.

"I've been in the business for years," states veteran art buyer Beverly Adler. "Print books are still being called in before a talent is hired; sometimes we view up to fifty per project and major decisions are rarely if ever made solely from Web sites."

This will be news to many photographers who continue to insist that they don't need a print book because everyone refers to their Web site.

While small ad clients, buyers at minor companies, architects, and some editorial photo buyers are assigning work based on Web images, it is a mistake for any professional to enter the market without a print book.

With only a Web site and no print book, your best-case scenario can be your worst nightmare. Consider this.

You develop a body of work and, convinced that your Web site is all you need, you work with a hot designer investing money, lots of it, to develop your site. You then spend more money on Web portals, enabling many viewers the opportunity to find your work. You design mailers and send them out religiously, reminding prospects that you exist. All of your efforts

work, and you get the call asking you to send in your print book, as a job is pending.

You choke as you realize that you have no print book to send.

This scenario has happened more times than I care to think about. In fact I'd be close to retiring if I had a dollar for each call that started with: "Hi Selina, I need your help. Today I got a call from a client who saw my photos on my site and they wanted to see my print book. I lost the opportunity because I never created a print book, so I had nothing to send them."

It's time to wake up and realize that the relevance of print books did not die with the onset of Web sites.

I like to compare the print versus Web site conundrum to the TV versus radio scare years ago. When TV came along, many folks in the ad world were convinced that radio was dead. However, they were wrong: Radio did not die when TV came along. Its use just shifted.

Over time, the popularity of radio ads waned a bit, but the interest in radio programming is strong and the audience today is bigger than ever. The message is clear: Portfolios are not dead, they are still needed, and if you have not invested in building a print portfolio, do so now.

PORTFOLIOS: THE THREE MAIN MESSAGES

Building a print book usually happens at the start of a photographer's career or when an experienced photographer realizes that in order to compete, a complete overhaul is needed and a new body of work must be created. As you begin to consider developing a new print book, know that it should not be just a well-edited collection of your best hits. It will need to be a comprehensive body of work that you develop over time.

I have worked side by side with hundreds of clients as we crafted their portfolios. In the beginning of my book build relationship with a client I continually hear similar questions: What do I put in? How many images should I include? Is this image too old? I don't want to shoot this, but do I need to show it anyway? What if I like it and no one else does? What type of format should I use? What will the book look like?

Photographers have lots of questions about the specifics of a portfolio, and often in the quest for answers they lose sight of the three main messages that every portfolio to envy must deliver.

Your book needs to clearly state the topic you shoot, illustrate your visual approach, and *build trust that you will deliver.*

What is your point of focus? Is it food? Still life or lifestyle? Do you shoot architecture or corporate locations? Having a portfolio that clearly expresses your topic is key.

Your visual approach to your subject must come through clearly in your book. If you are a lifestyle shooter, are your images warm and fuzzy? Are your images cool and contemporary? Are your people directly connecting with the camera, or are they props in your images, body parts that provide a bit of information but are not the main focus?

Trust, the last important message that your book must convey, is communicated through a book that contains a well-developed vision and is properly edited, paginated, and beautifully housed.

A portfolio that has been developed in this fashion is a portfolio that will sell and one that others will envy.

Creating a portfolio that sells is not a simple task. Much thought, time, and effort will be needed. As you begin, it is important that you know how clients source talent and that you understand today's buyers have many assignment and nonassignment (stock and royalty-free images) choices when purchasing photography. In addition, it is important for you to be aware of the impact that these choices have on a buyer's desire to get a clear, specific, and focused message from each portfolio viewed.

Today's buyer may be asked more often than not to purchase stock photography. They may be used to going to stock catalogs to pick out the exact image in a specific color palette that represents a simple concept. Because of this scenario, many newer buyers are used to seeing the image that they will use before they purchase it.

They have no need to use their imagination or to use their concepting abilities. Tasks are easily and quickly accomplished in this world of sort, look, and select.

When looking to work with an assignment shooter, these folks want to see quickly and clearly what you offer. They are not interested in your diverse range of subjects and approaches.

This fact distresses many shooters, but indeed it is a fact of life and needs to be accepted. Today's buyers need to be taken by the hand (visually that is) and led through a portfolio that quickly tells them what you do and what your visual application looks and feels like. While I am not at all suggesting that you talk down to buyers through your images, I am stating that you need to make sure that each shot in your portfolio has a role to play in delivering your entire visual message. A book filled with beautiful images that have no continuity or relationship with each other will not sell.

In addition, your portfolio must contain images that are appropriate for your target markets. A book of beautiful images that have little or no commercial applicability is a handicap.

In short, your book needs to deliver your visual and professional value. I call a portfolio that has been crafted from vision out, and is commercially applicable, a portfolio to envy.

Today, many photographers can create a portfolio that is a good example of their work but still not develop a book that sells. Often photographers have said, "If another person tells me that they like my work but they don't know how to use it, I will scream." Equally frustrating for talent is the response, "This is good work, I've seen it before, but what do you really want to do?"

Are clients trying to be difficult? Are they just contrary by nature? Obviously not. What they are saying is, "Show me something different and unique to you, but make sure I can use it."

They are in essence giving you permission to explore, to experiment, to develop your "visual integrity" and to market it, while also asking you to know what a commercially viable product is. It is this marriage between art and commerce that your book must speak to. This is what a portfolio that sells accomplishes.

Today's market requires photographers to create this type of portfolio. Buyers are no longer looking just for technical ability. They are searching each portfolio they view, looking for visual value. It is not unusual (and is indeed most likely the case) that a client needs one specific look for the project in front of him or her. Today's clients are more likely to be less relationship oriented and more project oriented during the sourcing stage, so your portfolio is more important to them

than ever before, as more often it is not a relationship they are reinvesting in, it is a vision they are buying.

ONE VISION, MULTIPLE APPLICATIONS

Clearly, developing your vision for your portfolio is your first step, but you need to take it further. It is important that your vision have two or three different applications. You need to offer clients more than one opportunity to hire you. While this may sound like a contradiction, it is not. Think of going to a restaurant. Today, each restaurant of merit has defined a cuisine that it offers. Whether ethnic or not, there is indeed a type of food that they serve. Within their menu there are many choices of food, all of which fit into the category and position that they have chosen for their establishment. You choose your restaurant based on their type of cuisine and your immediate interests (similar to those buying photography today!). Publications are another example of this style of thinking. Years ago, magazines contained information that was geared more toward the general public. Now, there are hundreds of publications, each directed toward a specific interest group or area of our population. Within each publication there are a variety of stories and topics that might be of interest to the reader.

It is this thinking that you must apply to your portfolio. What will your visual positioning be and what variety of examples throughout the vision will you offer? One way of thinking about this is to use the example of lifestyle photography.

Perhaps a lifestyle shooter who has developed a clear vision chooses to build a portfolio that represents her vision as it applies to the business, home electronics, and the health industries. The visual style remains constant but the content of the images changes based on the subject focus. One vision, three applications.

These efforts and this philosophy are the first step toward creating your portfolio, a book that *will* sell, and a book that others will envy.

THE OUTSIDE OF YOUR BOOK

Once you are on your way to developing the imagery in your new portfolio, you will need to begin to explore housing for your book. In this step of the process it is important to keep in mind that the inside speaks to the outside. Look to your images to be the key indicator for the type of housing that your book will need.

Check out all suppliers of premade and handmade books. Look to *www.lost-luggage.com* for very hip premade portfolios. The beautiful line is designed by Jason Brown, a graphic designer, and the books are appropriate for many types of photography.

Look to Scott Mullenberg of Portland, Maine (my top book builder), for handmade books covered in a variety of materials.

Frederic Neema, a corporate shooter from San Francisco, spoke on *www.apa.net* a while back and mentioned that developing his portfolio was one of the best investments he had ever made. The time, money, and effort spent, he said, made a difference in the assignment offers he received and the fees that he felt comfortable charging. The value he had to offer clients was front and center—a well-defined vision that was, in addition, beautifully and professionally housed.

The format for your book should not overwhelm or underwhelm the work inside. It needs to complement the imagery. During a portfolio review I become concerned when photographers are more interested in creating wonderful packaging than in providing needed attention to their images. I am equally concerned when little or no attention is paid to the housing of spectacular images. There are tremendous opportunities today; find out what's out there and then consciously choose a look for your book. In doing so you are focusing attention on your company's visual value.

Scott Mullenberg has worked building portfolio housing with many photographers around the United States. Scott believes that when developing housing, the images are king.

"Your portfolio housing should reflect and complement your work, not distract from it. It should be seen as an introduction to your work, easy to access and easy to read. There is a

hierarchy here and your work stands at the top. The structural part of the portfolio, or the house, should never rival the content, only accent it," states Mullenberg.

While there are many premade portfolio options that can work for you, a custom book developed by a bookmaker specifically for your body of work is a true gift.

Mullenberg opines, "The beauty of having a custom portfolio created is you have the opportunity to choose materials that reflect you and your work. There's a broad array of materials available, from leather, linen, silk, and synthetic that can be used to create a portfolio that makes it solely you."

Having a custom book created is not just a visual perk; it delivers a solid value message to your prospects. Mullenberg continues,

> A custom portfolio communicates to the prospective client that you have thought about your work beyond the images. The housing reflects thoughtfulness and care, and says that you are a photographer who is serious about your work, on every level, from collateral materials to Web site, to portfolio. The custom portfolio reflects the photographer in that it personalizes their introduction and takes it beyond the status quo found in most commercial options.

In addition to the benefits Scott mentions, the process of working with a portfolio builder is usually an exciting creative and collaborative opportunity.

Karineh Gurjian Angelo, a still-life shooter based in New York City, recently completed a book with Scott. Her experience was one that she loved.

Karineh speaks enthusiastically,

> Working with a book builder was a new experience for me. I knew the value from the first time I met Selina and saw some of the work she had created for her clients with her book builders. When it came time to work with Scott I discovered that it was a most amazing experience. I had finished the images that I was going to put in the book and was thrilled that I had created a

cohesive body of work. I could not imagine being any happier. I truly had no idea how much the housing would complete my vision. When we were done I was amazed as the housing pulled everything together.

The process of working with a custom book builder is definitely collaboration between two talents, each of whom has a perspective on the book that they bring to the party.

Karineh continues, "Scott worked closely with Selina and I, and he was able to see the vision we were creating for my book. Keeping that vision in mind, Scott provided us with samples of fabrics and leather from many suppliers to help us decide which was right for the book! The housing was the final touch for my portfolio and it is unique to my vision. The response to the book has been amazing."

Clearly, building a book to envy, one that will sell, is a commitment. It is also an experience that many photographers have described as difficult, trying, enlightening, uplifting, and inspiring. Not all creatives are brave, bold, and committed. There really are not many who will build from the inside out, not a lot who will create the visual and then house with the personality of the work in mind. These folks, those that choose to build a book this way, will be rewarded with a complete body of work that is indeed a physical expression of who they are as talent beings. These photographers will succeed in building the tool that will sell their work. Will you be one of these brave souls?

CHAPTER 19

ONLINE PORTFOLIOS
THAT SELL

Your Web site is not a place to dump your photos.

Shocking but true: Many photographers treat their Web site as a place to put "strays"—those images they love but that don't fit into their print books.

Your Web site is not a diary.

Why do some photographers feel that their Web site is the perfect spot to share last year's family photos?

Your Web site is your online visual calling card. It is the first introduction that many buyers will have to your vision, talent, service, and professionalism. The portfolio section of your site is now an enormous opportunity for selling as well as marketing, and photographers who think of a Web site as a repository for "extra images" must change their approach. Now it's time to begin to build online portfolios.

YOUR ONLINE BODY OF WORK

The online portfolio found within your site must succinctly deliver your visual message. The images must tell your viewers the type of work you shoot and communicate your visual style. While photographers are eager to develop Web sites, few spend the time, effort, and money to design and build an online portfolio. Why? It takes time, money, and

attention, lots of it. Internal and external effort is needed here, and many photographers will simply not show up to do the work.

Your vision must be apparent from beginning to end online, and the image selection must have legs but still remain within your visual range. The order and placement of your images need to represent the care that you have taken when developing this important area within your site. This section must truly be a complete body of work.

"Complete body of work" is the key phrase, as I am asking you to define your vision, understand your market's needs, and develop visuals that speak to both. Once images are created, they need to be sized and paginated. Sound familiar? It should, as I am suggesting that you develop your online portfolio with the same focus, effort, and dedication that you apply to your print portfolio.

In order to develop a successful online portfolio, first address your visual message. If you have a print book that has been worked on recently and clearly expresses what you do and your style of shooting, it's a pretty safe bet that the images within speak to your vision and are appropriate for your online portfolio as well.

Jonathan Hillyer is an experienced architectural photographer located in Atlanta, Georgia. Recently Jonathan created a new print book followed by an online portfolio. He shows the same images in both his main Web gallery and print book.

"I wanted my main photo gallery to display the depth and breadth of my work," he states. "I was eager to highlight my most dramatic images, as I wanted the body of work to draw the types of clients that did the type of work I was after. I wasn't looking for just any assignment, and in showing the type of work I wanted I was hoping to draw more of that in," he says.

While some photographers see their print book as the key component, Jonathan's Web gallery is his priority.

"I think the print book is an accessory to my Web site," he opines. "I am not out there showing my books as often as I should."

Does Jonathan go on in-person visits with his print book?

Absolutely, as much as possible. It's interesting I find it much easier to get appointments out of town than in my home town of Atlanta. For instance, when I go to Boston to shoot, I call as many people as I have time to see and everyone wants to see me. The print book allows me (on a personal visit) to talk about my process as well as show my work. I had one day when I had thirteen appointments. The reality is that over the course of a year, my print book does not get the exposure I would like it to, so I have invested deeply in my Web site.

Jonathan's Web gallery contains a main section that mirrors his print book and a section of new work that he updates regularly with shots from recent assignments. Contained within this section are two or three new client shoots (with about five to six images in each) that prospects can view. "I love having an area where I can show my recent work. I select the projects and images I want to show very deliberately as I want to continue the visual message that the main site promotes," he explains.

Another proponent of visual continuity, Charles Imstepf found himself in an enviable position when he was ready to build his Web site. He had just completed a new print portfolio before he began the task of building the visual section on his Web site, and he had a very large number of new images to send out to the world.

A food photographer located in Los Angeles, Charles had just completed a yearlong program redeveloping his vision. He had worked extremely hard to develop a new way of seeing, and Imstepf was excited to get his new imagery out via both his print book and Web gallery. He feels that each marketing tool needs to support the other.

"Constancy in vision is key to marketing success," states Imstepf. "Initially defining my visual integrity was an important act because my visual message directs my audience to what I do best. It takes them by the hand and says, 'See . . . hire me to do this.' " He continues:

Selina and my team had already journeyed into a vision quest to determine what works for me when creating my new print book. We tested and experimented with food subjects that I feel passionate about. Ultimately, I built a new body of work that speaks to my visual integrity, one that is defined by my personal choices for focus, color, texture, composition, subject matter, contrast, angle, environment, and intent. In the end we built a portfolio which speaks to our vision at Imstepf Studios. The visual in the print portfolio is my product and my Web site needed to speak the same visual message, as it is a key component in the marketing arsenal we use at Imstepf Studios.

CHOOSING A VISUAL DIRECTION

If you currently do not have a print portfolio that is vision based or have not yet to taken the step to define your vision, do so now and *then* begin to develop your Web site. To develop a site without an understanding of your visual message is the key mistake that too many professionals make. The format, color scheme, and design of your online portfolio won't matter if the content and message are scattered.

Developing your visual direction is no easy task. It looks different for everyone; however, there are key steps that you can take. Charles shares his process with us.

I knew that I wanted to shoot food, all of it. After much soul searching and experimenting, I determined that beautiful plate shots and still life were the two types of food shots that I loved to do. I was not willing to give up one for the other. I wanted two books and Selina kept pushing to incorporate it all into one body of work. I couldn't see what it would look like. Selina kept telling me that buyers are single focused and she said it would be difficult to market two separate books, one that promoted me as a still life shooter and one as an editorial food photographer.

121

Imstepf continues,

> I was committed to shooting only food, and the
> challenge was to bring both types (plate and still life) of
> food photography together. We brainstormed and
> decided to begin to create new visuals focusing on the
> plate shot first. Once a food was chosen and shot idea
> created, Selina suggested that I choose a component
> from each recipe to shoot as a still-life shot. It worked
> brilliantly and we then worked to create ideas for still-
> life shots around each plate shot I highlighted.
>
> As we were developing the book, it quickly became
> clear that we were on the right track. The connection
> between the two sets of images was apparent, and the
> style used in each type of image was consistent. In the
> end I was able to present two applications of my talent
> (plate shots and still life) to buyers, all within one port-
> folio. I was thrilled.

The next step for Charles was to create a presentation
format that would speak to the work. We decided that double-
page spreads were the way to go. As viewers open each spread
they see both a food plate and the still-life elements of the plate
shot side by side. It worked perfectly.

When considering the online portfolio, it made perfect
sense to carry this layout through to the Web site. When a viewer
downloads the portfolio section, they see two images within one
spread.

Imstepf concurs,

> I was so excited when the double-page spreads
> were discovered in the portfolio-building project
> with Selina. I was able to shoot plated food, still-life
> elements, and dance back and forth without break-
> ing up consistency. This allowed me to shoot what I
> love and present it in a format that made visual sense
> to me and to my audience. In short, the book
> exemplifies what I do with plated editorials, still life,
> product, and a sense of place. I felt that using the
> exact layout for our Web site portfolio made

marvelous sense, as the Web site branding reinforces professional consistency and builds a potential client's confidence in us.

INTEGRATING YOUR VISION ON YOUR SITE

After defining your vision, shooting new images, and sizing and paginating your online portfolio, you will want to work with your Web designer on the physical and design components for your site and for your portfolio section. The goal is to look to your current print materials (portfolio, mailers) and integrate the look of the site with your current tools. If you are due for a remake of your corporate identity, let the Web lead the way. Color, type, motion, and speed are all options that your designer will consider when creating a "look" for your online book.

The goal is to develop a series of advertising tools that all have the same look and feel. This creates consistency of design, which adds to the memorability factor.

Imstepf got it right away.

Our existing and new clients want an immediate look at what we do. An online portfolio is the answer for that need. Shooting mostly commercial products demands that we are able to deliver consistent results on deadline. We have a branding that identifies Imstepf Studios as a premiere food-shooting studio. The layout and design of our hardbound portfolio was carried over to our online portfolio. Branding consistency is key in marketing our visual integrity. This continuity speaks to the dependability and trust in us that our clients require. Selina helped us to understand the importance of branding, consistency, and refining our vision. Now it is a part of our daily message.

Vision, pagination, design, and branding are all factors to consider when building your online portfolio. For those of you

who are ready to throw your print books away, forget it. Don't be fooled. Buyers on most mid-sized and high-end assignments still make decisions based on print portfolios, many that they sourced via Web sites.

It is way too early to dump your print book for an online version, and it's never too soon to begin the process of building portfolios, both print and online, that clearly communicate your visual and value message to your prospects!

CHAPTER 20

TRUTH, LIES, AND SELF-PROMOTION

There is a ton of information available to photographers on the subject of self-promotion. There is also a great deal of whining and moaning about the state of our industry and the "thankless" task of self-promotion. In an effort to help you separate fact from falsehood and in an effort to counteract all of the kvetching, I have compiled a list of *truths* and *lies* for you to explore.

The following definitions taken straight from Webster's will provide context for you as you begin the exploration into the truths and lies regarding self-promotion.

> Truth: A statement proven to be accepted or true.
> Lie: A falsehood.
> Self-promotion: Promotion, including advertising and publicity, of oneself effected by oneself.

TRUTH: THE TERM SELF-PROMOTION IS MISLEADING

Your job is not to promote yourself, but to create visibility and credibility for your business. While creatives do know that self-promotion is about the business of promoting their business, it is not uncommon for a talent to, over time,

unconsciously confuse the two entities. The confusion between self and business is one factor that gets in the way of success for many.

An example of this confusion is the fact that many photographers *personalize* as they go through their day. If a portfolio is sent in response to a request from a prospect and the assignment does not come through, it is sometimes viewed as a personal statement of one's worth. Huge mistake!

The reality is that the book, the work (which is not you), was not appropriate for the assignment. This is a huge distinction. While some creatives would argue that they *are* the work, the reality for buyers is that your subject of focus or your approach to your topic was simply not appropriate for the assignment. It's not about whether they like you or like your work. Its not about *like* at all. It's about whether the work was a fit with the project on their desk. There are usually a multitude of reasons why a book does not make the cut. Perhaps the portfolio did not contain enough samples of the type of work they wanted to see, or the vision was not deep enough, or maybe they actually had a talent in mind to hire but they needed to show their clients other portfolio samples as well as the portfolio of their chosen shooter. Clearly, there are many reasons why a portfolio does not make the cut, and most of them are out of your control and not about you.

Make sure that your book is a complete and deep example of your talent and don't sweat the rest. Whatever you decide to do, do not take rejection of your book personally.

Another aspect of personalization can be witnessed during in-person visits. Prospects have less time to see talent these days and consequently in-person opportunities are slim. Web site visits and drop portfolios are a much more convenient option for clients.

You, however, still need to attempt to get appointments. Visits are extremely beneficial as they are truly the only tool that gives you the opportunity to be there in 3-D. Sometimes, in the quest to make appointments, talent gets impatient and put off when contacts have no time to see them. The reality is that contacts have no time to view portfolios. It may at that time not be on their list of priorities. Don't take it personally and don't stop

your activities. Simply keep calling other contacts so that you can reach your quota of sales visits.

Karen Frank, a senior photo editor, explains, "We always try to find time to see photographers or portfolios. However, if a photographer calls when we are on deadline there is no way we can see them. It's truly just a matter of timing."

In order not to personalize, it might be helpful for you to think of your business as a separate entity. Yes, *your* talent is the product you sell, and yes, *your* personality and professionalism are factors in the development of your product, but your *business*, the entity you create, is what you promote, and the value of that service (your vision) is what clients are buying.

Perhaps the last part of the self-promotion definition is where you should focus your attention: "effected by oneself." It is here where your personality and your efforts will most affect your business.

Be kind, upbeat, and proactive in your manner and positive in your attitude.

LIE: I DON'T NEED A PRINT PORTFOLIO; I HAVE A WEB SITE

Not so! Buyers use Web sites to source out talent and often to get an initial peek at a talent's body of work. When assignments are handed out, it is a portfolio not a Web site that has usually done the job. While some buyers go straight to Web sites (architectural firms, some small agencies and designers, and selected editorial buyers who have specific geographic needs), most buyers still report that they call in between fifteen to fifty books for each assignment. If you create a Web site and have no book to back it up, you will be on the losing end when a prospect goes to your site and wants to call in your book. "With all of the money that our clients spend on branding their corporate image, none of them are going to buy photography off a Web site," states New York–based freelance art buyer Beverly Adler.

TRUTH: SELF-PROMOTIONAL EFFORTS ARE CUMULATIVE

Self-promotional marketing efforts bear fruit over a period of time (two to four years). We always play catch up with our spending and with the time and energy we put into our efforts. It takes a great deal of front-end time showing your work, sending mailers, and contacting prospects before you receive an opportunity to bid on a job. Most photographers refuse to believe this fact and cease efforts long before their programs have had an opportunity to make an impact on the marketplace. Pull your expectations of results into alignment and know that you may not see significant results for quite a while.

Certainly review your progress as you move along. Does your Web tracking show a healthy open rate for e-mails sent? Is your Web traffic increasing? Are you getting appointments? Are prospects mentioning that they've seen your direct mail? Is your Web site receiving traffic from your Web portals? Is your portfolio being requested? These are some of the signs in the early stages of a sales and marketing program that your efforts are succeeding. You might be thinking, "Great, Selina, but what about the jobs?" Those come later. It's very rare for a business to take off right away. It needs to build and you must give it the time to do so. Unreal expectations sabotage all of your efforts, so get your expectations in line and keep plugging away.

LIE: NO ONE SEES PHOTOGRAPHERS ANYMORE

Boy, do I hate this one. My most successful clients (yes there are many successful photographers!) show their portfolios or have agents that show their books in person to prospects. Whenever our end of the industry is slow, prospects are most likely slow as well. When clients are not busy fulfilling assignments, they have time to see you and it's a good time to show your portfolio. Get your book to between six and eight buyers a month. Agents like John Sharpe in Los Angeles know how

important in-person visits are. "Getting in front of buyers is one of the most important jobs I have," he says. "Relationships are key and while I build many relationships over the phone there is nothing like face time."

LIE: PHOTO BUYERS HATE E-MAIL

Very few art buyers, photo editors, and graphic designers detest e-mail; others love it. Yes, there are spam blockers in place at some firms, yet most mail gets through.

As with direct mail, there are buyers who junk all mail and others who will keep your mailers. The goal of an e-mail is for a buyer to like what he or she sees, keep your e-mail as a reference, or simply bookmark your site for future reeds. That is all this promotional tool needs to accomplish. Buyers use different outlets to source talent. I have had clients whose portfolios were called in from e-mails. Some have gotten in-person appointments and others have received assignments that can be tracked directly to e-mail efforts.

I advise you to check local laws, the restrictions of your e-mail providers, and then give it a shot. Your job is to try different channels for putting forth your message. E-mail is immediate. It saves time, paper (think trees), and money.

Designer Eric Kass builds marketing materials for photographers and recommends the use of e-mailers. "E-mail is a financially and ecologically responsible way to keep in constant contact with prospects. Simple e-mails with examples of work or timely content and a link to a Web site with more complete info can be efficient and effective."

TRUTH: AN E-MAIL CAMPAIGN OR WEB PORTAL IS NOT A MARKETING PROGRAM

Don't ask your Web portal or e-mail campaign to carry your entire marketing program. All photographers need to develop a complete plan with three to five different sales and promotional actions. Action tools might include portfolio visits,

drop-book visits, direct mail, visual e-mail, Web site, Web site directory link, and a sourcebook presence. "I always advise my clients to develop a well-rounded marketing program," states Jean Burnstine, the Midwest Blackbook portal sourcebook rep. "I get really concerned when talent just relies on us to pull clients. We (sourcebooks/portals) should be one of many tools that photographers use."

LIE: I NEED AN AGENT TO BE SUCCESSFUL

The majority of photographers do not have and should not have agents. Agents are not portfolio schleppers, therapists, or miracle workers. They are business partners who are responsible for developing your business over time. This means that they market your work, obtain assignments, and license your imagery. They primarily work with experienced advertising photographers who have a healthy client base. While some agents will take a chance with someone new, most will not.

If you have a distinctive visual style that is geared toward the ad industry and you are billing over $300,000 and you are willing to pay 30 percent of your new income to an agent, consider a rep. If not, learn how to best rep yourself and get marketing assistants to help you with marketing tasks. (See chapter 12.)

TRUTH: BUYERS HAVE A VERY NARROW FOCUS WHEN VIEWING PORTFOLIOS

Of course they do, that's their job. If a graphic designer has a mandate to create an annual report that tells the story of a corporation through its employees and she knows the company is a very cool, hip Internet firm, she will not be looking for a book of editorial images that are warm and fuzzy. She is going for hot, hip, and cutting edge. If, on the other hand, an art buyer on an insurance or health care account has an

assignment that calls for a lovely, warm family moment, he is not calling in books of surfer dudes surrounded by sunsets created with deep saturated postpro colors.

Clients have tons of visual options to draw imagery from and their job is to call in books that speak (visually) to the assignment at hand. Make sure your work has a distinct style and enough depth (many samples) in that area in order for your contacts to know that your work is right for their clients.

LIE: WHY BOTHER DOING ANY MARKETING, ASSIGNMENT PHOTOGRAPHY IS NO LONGER A VIABLE BUSINESS

I have heard this statement often in the last several years and it scares me because it is not true! Our industry, along with countless other industries, has been hard hit by a poor economy and shifts in the marketplace. Look at the world of medicine, of law, and even of civil service. The shifts in each of these worlds have been tremendous. If you need more evidence that all industries are always shifting, consider this: When was the last time you saw a car phone? Not a cell phone, a car phone. Think fax machines? You think their sales are as strong as when they came onto the market? The salespeople for those products have shifted their focus and, if they are smart, they have moved onto selling other products.

Our market has shifted dramatically. You do not need to leave photography; you do, however, need to be aware of the shifting needs of your clients and adjust your processes accordingly. Clients are demanding more of assignment photographers.

Relationships do look different and you are competing with stock and royalty-free images. However, assignment photography is alive and well. There are shooters doing very well throughout the country in many different disciplines and across geographic markets. Shooters are in the black, with many reporting high six-figure incomes and more than you would think billing over a million a year. This may not be the easiest time to be a photographer, but our business is an extremely viable one!

131

The ultimate *reality* is that creatives who continue to search for truth and refuse to invest in the lies, the kvetching, and the complaining will be the sought after suppliers. The photographers who are able to keep perspective, who use the shifts as opportunities for creative, personal, and professional growth, will thrive. They are the talents who will help to reinvent our business.

Make sure that you are one of them!

CHAPTER 21
FACE TIME

In our world, where Web sites and drop-portfolio appointments are the norm, "face time," that is, visiting in person, is more important than ever.

"Agency creatives are swamped with impersonal contacts from suppliers in general," states agent Laura Bonicelli. "While e-mails, Web sites, and direct mail are important marketing efforts, no program is complete without face time. An in-person visit allows you to build and maintain relationships, and relationships are what win the job 90 percent of the time."

Bonicelli, who got her start as an agent in Minneapolis, has recently developed a national team of photographers and is selling nationally. Laura felt so strongly about photographers' work being seen that she has developed her entire sales program with in-person visits as the key sales tool. She knows how important in-person visits are and she recognized that most photographers had little interest in setting up appointments, or, if they had an interest, they had little time to consistently go on visits themselves. She recognized (as her history as an agent proved) that the work, the vision, is what ultimately sells, but the opportunity to build personal rapport was a huge sales advantage.

"A face-to-face meeting gives the work immediate attention and provides an opportunity for feedback. During a meeting, I can ask a buyer what they are working on and see if my talent's work is a fit for a client's immediate or long-term needs," states Bonicelli.

Photographers who are married to their Web sites and refuse to build a print book into their sales program are convinced that buyers don't want to see them, but Chris Peters, an art buyer at Colle+McVoy in Minneapolis, feels it's essential that he meet photographers in person.

"I love meeting photographers. It gives me an opportunity to see who the person is behind the images. Meeting the photographer gives me the chance to see what their personality is like. I then have a sense of what they might be like to work with. This is a huge piece of information for me that I can't get off a Web site, no matter how much bio info I read," he notes.

When asked if it's hard to get an appointment with him, Chris laughs. "Absolutely, we have so little time to do all the many tasks we have. We established a portfolio-drop program as we always need to see new work and we don't always have the time for in-person showings," he admits. Visits, however, are still encouraged.

"It's the photographer who keeps after me and is patient that gets in," he informs. "It's not personal. We don't try to be difficult; we just have so much going on. When a book comes in or a photographer has an appointment with me, it's really just luck as to which art director is available at that moment to see them. It's really all about timing."

Many photographers cite the difficulty of getting an appointment as a reason not to try.

"I rarely have a tough time getting enough appointments, as I just stay on the phone until I am booked up," says Bonicelli. Her opinions are mirrored by those of Susan Austrian. Austrian, a former rep that has developed and runs a successful portfolio delivery service for photographers in Minneapolis, says, "It's definitely tougher than three and way tougher than ten years ago to get an appointment, but the appointments are definitely there. I need to call more people than ever before to get in, but my calendar is always full."

Bonicelli adds, "At times some contacts are tougher to reach than others." The solution she offers? "Have lots of people to call and if a contact or an agency seems extra hard to reach, give them a break and move on. Get back to them in a few weeks and see if they are any more accessible. And never take it personally!"

Many photographers point to Web sites as a reason not to show a print portfolio.

"Big mistake!" states Austrian. "Almost every buyer I see is always eager to see the 'real book' in 3-D. Photography is tactile. People want to get close and touch it."

Web sites are very important and every photographer should invest in one. However, a physical portfolio is still *the* most important selling tool for the advertising, corporate, and editorial photographer because an in-person appointment is the ultimate opportunity to show the work and build visibility.

In order to maximize an in-person visit, consider the following tips.

CREATE A HOT LEAD LIST

This list is more targeted than your e-mail and direct mail list, which will be larger and broader. Use your database of contacts and begin by researching contacts within a four-hour drive of your location. Check out Web sites of ad agencies, corporations, and design firms to see their client list and what the current creative looks like. You are looking for clients who can utilize your services based on their current sense of design and clients. Those who exhibit your level of taste and can possibly use your style of approach are potential clients, as are contacts that may be a bit behind the taste or style curve you display. Consider making appointments with these folks, as you may be able to create a buy-up opportunity in which these clients purchase photography of a higher caliber than needed for their assignments.

You will want to start your calling when you have approximately seventy-five to one hundred contacts (individuals, not firms).

CALL YOUR CONTACTS TO MAKE APPOINTMENTS

Never just show up or send your book without a prior appointment. Contacts are very difficult to reach but voice mail is a help. *Yes*, a big help. Choose ten contacts to call each week.

Call them several times a day between 8 am and 6 pm, leaving only one message on Monday and one on Friday, letting them know of your interest in scheduling an appointment. (Don't expect them to call back!) The rest of the time, hang up when you get voice mail. This system gives you the opportunity to try several times each day to catch them in their office. (You could never do this with a receptionist on the other end of the phone.) I have found that this system enables clients to reach three to four contacts by the end of the week. It seems to be more effective than scattered random calls to tons of people.

If you do get someone in at 8 am or as late as 6 pm, chances are they are looking for a bit of quiet time. Ask them if it's ok to talk or if they would like you to call back. While this seems counterproductive to your effort, it is very considerate, and most people will not only appreciate your consideration but indeed will continue the conversation. Any contacts not reached after a week of consistently phoning should be contacted via e-mail the next week. Go through this process twice (for a total of four weeks) and backburner any contacts not reached, calling them again in two months' time.

When you reach a live body on the phone or via e-mail and he or she is interested in seeing you, ask if there are other contacts that will be joining you or if there are other contacts that he suggests you call for an appointment immediately following his.

ON THE VISIT

Make sure your book is in great shape a week before your appointment. There is nothing worse that checking your book as you are going out the door only to see that it is in rough shape.

I remember a story a client from Los Angeles told me years ago. She said she once got a call to see a potential client about an assignment. She rarely showed her book, so she had to really look for it as she ran out the door.

During the appointment she had a great conversation about the job with her prospect and then began to show her

book. As she opened her case, a huge cockroach ran out onto her client's desk.

Can you imagine? She was able to recover her composure, make a joke, and secure the assignment. While my client's cockroach experience is most certainly an extreme case, it points to the fact that keeping your book clean, updated, and in perfect condition is a must.

Once you get to the appointment, be patient if you have to wait. Physical space can tell you a great deal about a company. Look for clues while you wait.

Look around for samples of the company's work on the walls and note the energy of the people who wander in and out. Be an observer. Is this a crazy, hectic environment or a bit more relaxed?

When you meet with the clients who are the creators (photo editors, art directors, designers, art buyers), ask how much time they have and, if they are not in a terrific rush, ask them to show you their favorite finished piece that they have created to date. You are asking to see finished tear sheets that they have art directed.

They will either grab onto this request immediately, show you samples, and start talking, or they will look at you as if you were from Mars.

If you get the Mars look or contacts who do not seem interested in sharing their work, simply let them know that you have asked because you love creativity and were hoping to see how they create. If time or inaccessibility to the work is a problem or they just don't seem comfortable with the idea, immediately offer to show them your work.

When you ask your prospect to show you completed assignments, you create the opportunity to see who they are as creatives and you are able to develop conversation that can give you information about their buying habits and needs. You can learn much from viewing clients' work. You will have the opportunity to ask them, "Who shot this for you? Did the project meet its goals? How often do you hire photographers?"

This presentation style opens up the possibility of learning information that will help you to determine how hot a prospect this contact is.

Contacts' reactions as well will be telling. Are they open to collaborating? Are they extremely busy with no time to do anything but quickly flip through your book? What do you think of the tear they created? Does it represent your level of photography? You are observing here, not forming judgments about your prospect.

I fell into this process of presentation as a new agent and found it to be so beneficial to building relationships that I always started my meetings this way and showed my talent's portfolio as soon as it seemed right to do so.

Be daring. Try this. Be willing to risk and be open. Be ready as well to show your book first, if the situation is not ripe for a client presentation to you. This is not an arrogant way to conduct a portfolio showing; you should be genuinely interested in how your clients create. You should want to see their work and be interested in understanding their visual needs.

You are not there just to sell to them. You are there to see if there is a creative relationship to build.

DROP BOOKS

Often a buyer does not have or want to invest the time to see you in person. Please remember that buyers have much to do and not every photographer is as organized as you are, which translates into a lot of wasted time for art buyers, as they probably see many photographers whose work is not appropriate for them or just not up to par with their standards.

For this reason we utilize drop books as an option when a prospect does not have time to see you or for a contact that never schedules in-person visits. You might be thinking, why would I send in a portfolio if I can refer these folks to my Web site?

In the last few years you may have developed a strong Web site presence, but it would be a mistake to expect a Web site to carry the load of your total sales program. In addition, there is nothing like seeing photography in 3-D. Photography is tactile; it should be felt, seen, and handled. Finally, as most photographers do not take the step to set up appointments, any personal contact you have with prospects immediately

creates more visibility for you, thus speeding up the development of your relationship.

Web sites help do help to market your work. But in-person visits and drop portfolios are selling tools. Every photographer needs marketing *and* selling opportunities. While I know few photographers who enjoy the selling aspect of developing a business, I also know of no photography business that is consistently successful and utilizes only marketing tools.

The print book you develop as a front-end sales tool will also be sent when a client requests it. While photographers report seeing jobs awarded based on a Web site alone, most sophisticated clients still prefer to view a physical portfolio, and many art buyers agree that a print book reflects a great deal about how you work as a photographer and the care you have for your profession.

Having a print book organized, clean, and ready for clients when they request it is indeed "showing up."

Chris Peters states,

> We use Web sites to search for talent. If a photographer's work on his or her site is appropriate for the job we will call in his or her book. If the content does not match the job or the vision is right but the book is a mess, we send it back. I won't take a chance with a photographer who seems to have the right stuff on their site but chooses to send in a book that's beat up or in lousy shape. If he doesn't care enough about his work to present it well, then how can I trust him to take care of my assignment?

Access to the real deal, the portfolio, is key during the assignment process. Art directors do not cluster around terminals when assigning work to photographers. They meet in conference rooms; they pass portfolios around. You will need to build a print portfolio and maintain it in excellent form for this selecting process. In addition, buyers cite the need to sometimes share your work with their clients before a decision is reached. Once your book makes the initial cut among the art staff, it may be sent to the ultimate decision maker, the client of your prospect. You will not be present during this process and it is here that your print book needs to work for you.

But in order for your book to be called in when an assignment is on the table, you need to have already created visibility for your work. E-mailers, direct mail, and Web sites help to maintain visibility, but *face time* is king!

While relationships may look and feel different, buyers are still assigning work to YOU, not to your computer terminal, Web portal or visual e-mail mail piece. You are the extra special component in many buyers' decision making process.

Your job is to be present to your program. Develop and add a drop portfolio component to your ad program and by all means make in-person appointments and simply show up!

CHAPTER 22
TURN THE PAGE

If there were a twelve-step program for book addicts, I would be a charter member. My son Sam would be close behind. Books have been a part of my life since I was four. That's when my mother decided it was time for me to enter the sacred society of readaholics. There was (happily) no going back.

As my career began and throughout the last twenty-eight years, I have turned to books often: for knowledge, inspiration, hope, and escape. As a teacher, I have recommended various books to clients and have been excited as reports filtered back about new insight and knowledge that was gleaned.

Reading, not just looking at lovely photography, should be a part of your workweek. Yes, workweek. All too often photographers feel that reading is a luxury. It is not a luxury; it is a necessity. Creative people need to feed their souls and their minds. There are many avenues that will provide the fuel you require, but books offer the extra bonus of creating a silent space around you. For people who need a bit of quiet, for those who lead hectic lives, books can be a blessing.

In an effort to encourage you to integrate reading into your business lifestyle, I have compiled a short list of titles to consider adding to your collection. Photographers and agents, friends, and clients of mine were kind enough to suggest the following books.

Tops on most people's list is *The Artist's Way* by Julia Cameron. I first discovered the book years back and have since bought several copies as gifts for others. It is a workbook that

can literally change your life. Julia Cameron suggests exercises that help you to become present, aware, disciplined, and creative. This book seems to enter people's life at the right time. Be prepared for change. What I love is that you transform while developing the habit of performing daily practices.

Marc Hauser suggests *Your Heart's Desire* by Sonia Chiqua. He swears, "It is a great book that will help you dive right into happiness."

In addition, Marc (one of the nation's great portrait photographers) loved Twyla Tharp's new tome, *The Creative Habit: Learn It and Use It for Life.* "The book will help you to reach for your greatest creative potential. It's an easy-to-follow program that lifts the veil off of the creative process and opens the door to the artist in you," states Hauser.

Often books will not only offer practical advice but will be the wake-up call we need.

Simon Plant, a photographer and client of mine from the UK, suggests a book titled *Shooting Your Way to a Million: A Photographers' Strategy for Success,* by Richard Sharabura. This is what he says about the book's effect:

> I read this book when I was starting my photography career. At that point I was very naive about earning a living from photography. It opened my eyes to the top end of the profession and made me realize that I knew nothing! At the time I was already working as a photographer with my own business but reading the book prompted me to stop and go back to assisting. I looked and found a very established photographer who needed an assistant. I did that for nine months, which proved to be an invaluable learning opportunity as I learned so much about the business from him. After that, I was truly ready to continue in my own business.

We never stop learning about business or about ourselves. Even the most experienced professionals continue to seek new ways to become better at what they do. Case in point is veteran agent Laura Bonicelli. Laura is one of the key players in the Minneapolis market and she recommends *Selling the Invisible: A Field Guide to Modern Marketing,* by Harry Beckwith.

"After reading it, I came to the conclusion that it is a very comprehensive guide to modern marketing principles. It talks about selling intangibles and that is exactly what I do as an agent. I am selling vision and personality. These are two unknown entities to all prospects I go to see; this is truly a sell of intangibles."

Dave Wendt, past president of the Cincinnati chapter of the ASMP, has created what some would call the perfect work world. His business, Wendt Worldwide, produces calendars that showcase some of the world's most expensive cars. Dave has taken his love of automobiles and built a business that finds him driving, shooting, and enjoying some of the most expensive cars in the world, and he gets paid for it. As his life is a model of integrating the external and internal, it is not surprising that Dave's list of books includes titles that represent his attention to his inner and outer life. *The Tao of Being* by Ray Grigg, *Illusions* by Richard Bach, and *Oh the Places You'll Go* by Doctor Seuss join *Do Less, Achieve More* by Chin-Ning Chu and *It's Only Too Late If You Don't Start Now* by Barbara Sher.

As you have chosen to be part of the commercial end of photography, reading about business principles is important. Ted Rice of Ohio has steadily built a successful career photographing people in his own unique style. Initially servicing the editorial world, Ted's client list has grown to include national graphic design firms and advertising agencies.

"*Good to Great* is the book I would recommend to any photographer," he states. "It is a business bestseller that it is simply written and articulates principles that the author discovered were inherent in companies that achieved long-term success. Those principles apply to sub-micro-mini-businesses as well as Fortune 500 companies."

My personal favorites include the following:

The Tipping Point, by Malcolm Gladwell, is a fascinating look at trends and ideas and the magic point that occurs when the trend crosses a threshold, tips, and spreads like crazy among the public.

The War of Art, by Steven Pressfield, should be on every creative person's bookshelf. It details the resistance that all creatives experience, and in a funny, irreverent, and spot-on style

will help you to recognize and take steps to rid yourself of the blocks that we all experience.

Eckhart Tolle has quickly become a guru of sorts to many seeking to be present. His book *The Power of Now* contains truth on every page. If you are interested in beginning the process of quieting your mind and working from your soul, this book is a wonderful resource.

How to Think Like Leonardo Da Vinci, by Michael Gelb, has topped almost everyone's list of late. It's a wonderful book about accessing the power to become a multi-christo talent. (A multi-christo individual is a person who has developed his beingness in a level of reality and in a level of spirituality so that he works on both the inner and outer worlds.)

The Do It Yourself Lobotomy: Open Your Mind to Greater Creative Thinking, written by advertising veteran Tom Monahan, quickly became my business book of the year shortly after I received it as a gift from client Michael Waine. It is a kick-butt book that literally shows you how you limit your creativity and then offers you several ways back.

My favorite author these days is Paramahansa Yogananda. Yogananda was an Indian teacher whose teachings are still impacting students throughout the world. He has written many books. It's been a year and I am still going through his work *Journey to Self Realization*. Every page holds deep revelations about self, soul, energy, and right relationship with self. All wrapped up in the wings of love.

Now it's time for you to grab a mug of coffee, a cup of tea, or a glass of wine, choose a book and get to work. Yes, start reading, and get to work!

CHAPTER 23

PHOTOGRAPHY AND DIVINITY

Photography has long been referred to as "the marriage of science and magic." While many photographers spend long hours working on the science of photography, perfecting their technique, most never get close to accessing the magic. Yet this intangible quality, the mystery that probably drew them in to begin with, is indeed what every viewer responds to.

Have you invested in discovering the magic or are you grounded only in the science?

The science relates to the technical end, your knowledge of equipment, how light falls, graphic composition, and focus.

An experienced photographer will tell you that true creativity cannot be accessed until you get these basics down. These tools are what photographers read about, study, and work hard to understand and employ as they create imagery. But creativity is not about technique alone, which is why stopping here, giving no credence to exploring the unexplained aspect of photography, is a big mistake.

The magic I refer to and that I believe in is your connection to your divinity.

I would ask you to consider that a conscious connection between you and your higher self (with your scientific skills deeply rooted in your experience) is what enables your creativity to flow.

CHANNELING CREATIVITY

Photographers who have tapped into this conscious connection open up a channel that enables energy to pour through their camera. This connection can be seen, sensed, and felt, but words fall short. Photography, however, is not about words, it's about connection—and through it your bond to divinity can be truly experienced. When present, it will fill each image. It is the channel through which your concepts will flow. It is what inspiration is made of. It will weave its way in and out of creative brainstorming sessions.

A clear example of divinity at work is the concept of being "in the zone." Many photographers, when attempting to explain the feeling of being deeply connected while shooting, often refer to "the zone" as a very real state. It is a place where they forget about time and space and are truly present with what is in front of them. It does not matter whether it's a connection to a person, a landscape, or a still life set up in their studio, the zone is accessed sometimes for a moment while other times for hours. I believe that the state these shooters are in opens up access to the divine and that is indeed what they are sensing.

Your vision defined and refined may be the ultimate physical manifestation of your divine connection. Photographers who work to develop their visual approach are technically savvy, *and* they have a deep respect for the unknown, the intangible that infuses all of creativity. These are the folks who continually spend time looking at photography and art that inspires them. They may not know, but they may sense that what they are moved by is indeed a manifestation of the divinity that exists within originality. They go to museums and bookstores scouring the walls and shelves, always seeking the muse. They know that time spent simply looking is time well spent. Ultimately, this exercise, this seeking to connect, helps to fuel the process of developing their own way of seeing.

If you are ready to enlist, to begin the journey of accessing your divine connection, congratulations. Keep in mind that learning how to access the magic will be a very personal journey. While schools teach the science of photography, I doubt that any

have courses on tapping into your divinity. Creativity maybe, but divinity, I don't think so. People often confuse a spiritual quest with religion, and schools shy away from this topic.

Additionally, not every photographer is interested in this approach.

I have heard lots of photographers talk about buying a new digital system, but rarely have I heard them say: "Can't wait to take that new spiritual workshop on creativity and the divine!"

Yet, I would bet that every photographer of significance— the greats you know and the talented that you will never meet—I would bet that on some level, they all have accessed their connection to their holiness.

BEGINNING THE JOURNEY

If you are ready to begin the journey, purchase a copy of *The Artist's Way*. In her bestseller, author and teacher Julia Cameron urges photographers to work to open up their connection to divinity. It is not surprising that her book has sold more than two million copies worldwide. The popular tome is a spiritual workbook for artists and has been heralded and coveted by creative professionals from filmmakers to potters to photographers and beyond.

As it is a workbook, you will indeed be using it daily. There are many exercises, like her famous morning pages that ask you to free-flow thoughts daily upon waking, as well as practices that enable you to begin to open up channels that you most likely have never opened before. The goal is to awaken your inner self and bring it forward.

As you begin your quest, you may notice that you have a hard time refocusing your efforts. You may begin to feel impatient with yourself as you sense that you have put much importance on the science and little value on the magic. Do not chastise yourself. That would be a distraction from the work at hand. Distraction is a trick of the mind that often surfaces during the initial stages of a spiritual journey. It takes a while to get into the mode of looking at life a bit differently. Be gentle and kind with yourself and continue on.

The popularity of *The Artist's Way* is significant, as I believe it indicates that creative people are searching for practices that inspire them and provide opportunities for their creative growth, for their divine connection.

You will find as you open this door to new worlds that you are eager and excited, and you may want to continue to move forward.

At this point building quiet time into your life would be extremely helpful.

Becoming still is difficult for many people. We live in a fast-paced, action-filled world complete with multiple screens and pop-ups galore. Yet going to quiet, simply sitting with eyes closed for a few moments a day, adding a few minutes every day to your quiet time, is truly a first step toward accessing your higher self.

Many teachers have stated that it is only in the quiet that our inner voice can be heard.

When you first begin to go to quiet, you may feel uncomfortable because you may have many messages going through your head at once. Instead of telling your brain to hush up, see yourself sitting beside the noise and simply smile. The idea is not to make your brain stop. You won't be able to. Instead, notice each thought as it appears and then let it go. After a while the thoughts will indeed stop, and you will go to a place where you will begin to experience quiet. For me it feels as if I am deep inside my physical body and I sense the feeling of looking outward.

Once quiet comes, simply sit with it.

When I go to quiet (something that took me many years to accomplish), I often see a light in front of my eyes. As it moves, my attention moves. I find that this light takes me deeper into my being.

As you become more adept at going to quiet, you will want to spend more time here. Go with it. This quieting of self truly changes your receptivity and opens up channels that allow ideas, thoughts, and visuals to come through.

Don't expect ideas to pop in when you are in quiet; most likely they won't. After all, the entire goal is silence. What may happen is that you begin to experience unusual connections to people and/or events. Synchronicity may become a common

occurrence. Over time, creative ideas will seem to come out of nowhere during different times of the day. You may feel as if they were simply placed in your head. These are all signs that you are beginning to open up to the energy that has always surrounded you.

You may experience very subtle changes or you might sense a surge of ideas and creative energy. Don't expect lightning bolts of creativity to hit you while you are driving to work. Simply be open to all the possibilities and ideas that will flow through you.

Perhaps the most powerful gift you can give yourself in the quest for connection to divinity is time alone. Set time every day (short as it may need to be) for you.

In addition, schedule time each week—one afternoon or evening, morning, or day—and claim it as yours. During this time you may want to meditate, go to the museum, close your eyes and just be open to possibilities, journal, or work with *The Artist's Way*. You may find that the first few times you do this you feel indulgent, impatient, uncomfortable. If you experience this, just breathe, allow thoughts and feelings to arise if any negative impressions come up for you, bless them and send them on their way. As time goes on, use this opportunity to work on your portfolio, create new shot ideas, or refine your visual direction.

Plan to book this weekly "time out" in your appointment calendar or palm pilot ahead of time. This is a key step toward keeping your commitment to yourself. If a personal or business commitment arises and conflicts with your "time out," see if you can reschedule the new commitment. If it is impossible to do so, willingly give up your time, book your new commitment in, and immediately book out another time that week for you.

While you can indeed find any number of very valid reasons not to keep this commitment to yourself, I would encourage you to try this. For years I told myself that I had no time for me. I had two boys and a career and it was, in a word, "impossible" to set time aside for myself. In reality, I was simply unwilling. I realized this when it was pointed out to me that I could arise early (5:30 am) and simply walk in order to have "my time."

If you find yourself believing that it's impossible to set time aside, push yourself. Look at your calendar from every which way. Be open to times that may not seem perfect and, whatever you do, make it happen! Taking the time you need and seeing it as sacred are ways you commit to bringing in the magic.

Photography is indeed the marriage of science and magic, and while others can teach you the science, it is you and only you who can access the magic, the divinity you hold within your being.

PART V

PERSISTENCE

SUCCESS IS WHAT HAPPENS
WHEN 10,000 HOURS OF
PREPARATION MEET WITH ONE
MOMENT OF OPPORTUNITY.

—ANONYMOUS

CHAPTER 24

WORKING THROUGH
CREATIVE BLOCKS

The experience of developing your talent is often exhilarating, exciting, and demanding. Photographers invested in visual development thrive on the opportunity to create new images and move onto a new artistic path.

There are times, however, in every photographer's career when the experience of changing direction or creating new images feels almost impossible. This temporary lull in creative thought may quickly pass or it may not. If the moments turn into days and the days into weeks, talent may be indeed be stuck, caught in a place where movement is temporarily impossible. The well for ideas has dried up, concepts for images are nonexistent, and the desire to push feels very far away. While this is not a fun time, it can be an incredible opportunity to learn about yourself, your talent, and your spirit.

Many photographers will experience moments like this. It can happen when attempting to solve a client's problems or when you feel the need to break out and go in a new creative direction. While it's clearly more exciting to quickly and easily find the flow for your creativity, being stuck is a very real place to be. It is all a part of the process of creativity and as such it needs to be acknowledged and, yes, appreciated. Appreciated because there is always a message when we are stuck. Your creative block can be the messenger you need but did not ask

for. Don't rush here. Pay attention, as what you learn may be a catalyst for your future personal and creative growth.

When talent is stuck, some may choose to go it alone, deciding to work through these times as well as possible. Others seek the help of trained guides. Ian Summers is one of those guides. Well-known, respected, and loved by the many creative people he has worked with, Ian consults one on one and holds Heartstorming workshops throughout the country. An artist in his own right, Ian entered our business on the client side. A creative director for some of the largest ad agencies in New York, Ian ultimately landed at Random House as the creative director for the publishing giant. Through a series of steps and, as Ian acknowledges, "missed steps," Ian found himself on the outside of the industry that had defined his career. This was a low point in his life.

A man who knows how to listen to his inner being, Ian decided to turn a tough time into inspiration and a new career advising talent was born.

For the last twenty-one years, Ian has devoted his time to helping creative people understand again why they are here and get back into what Ian calls "alignment." Many creatives who experience immobility have turned to Ian for his help. Ian describes this process:

> Artists of many disciplines come to me for help overcoming their creative blocks. Those who seem to have the most trouble come from the commercial art fields of photography, illustration, graphic design, and art direction. I find that blocks experienced by commercial artists often come from the confusion between art and commerce that they may sense but do not have words for. Commercial artists often choose their profession because someone along the way told them that if they were to be an artist it is necessary to make a living. So they wander into a field that demands problem solving, which I believe to be the antithesis of creating. In this country and in most fields, we are trained to be problem solvers and we are rewarded by how innovative and practical the solutions may be. With problem solving the impetus comes from the outside; someone presents you with a problem. The role of the artist is to

make the problem go away with an often-innovative concept that sells more widgets. This is required for most commercial artists and most are good at it; however, it is not art, it is art for commerce. In problem solving, the energy comes from the outside.

Ian elaborates,

Commercial artists remember what it was like to make work that comes from their hearts—work that has a sacred quality—work that may be cherished and may challenge—work that demands participation from the viewer—work that does not need to sell anything. I believe that creating is causing what you love or what matters to come into being. And with this definition we can see the frustrations that lead to some forms of creative block. The source is profoundly different. The energy comes from the heart, not the brain and not someone outside of oneself. So we look inside. The challenge for most commercial artists is to go back and retrieve the energy they experience as younger artists before they chose to sell widgets. When creatives are blocked, they are working in their head not their heart.

How does a photographer get back to his creative heart? Ian has a plan.

I evolved a process, which I call Heartstorming, which helps people rediscover what they love and what they love about what they love. The process helps photographers find the energy and the desire to manifest their dreams, and it invites people to find ways to synthesize what they love in their workplace. When commercial artists are doing what they love, they stop repeating themselves and imitating others. They develop vision that shows others where they are going rather than where they have been. They find courage to bring their loves into being. The word "courage" is an interesting one to me. Courage comes from the French word for "heart" or "core."

Ian concludes: "I have discovered that most people do not know what they love. When creatives begin to synthesize their heart energy, there is an abundant resource for overcoming creative blocks and for building portfolios, which energize and motivate others. This is the true core of the Hearstorming experience."

Ian has developed a specific process, one that is described below. It is one that you too can utilize.

THE HEART OF HEARTSTORMING

The first step is to manifest love.

According to Ian, when we think of the concept of love, we often remember an experience of romance. There's that person across the room. Magic happens. Energy is exchanged. We fall in love. Consequently, we take on the belief that love is something we fall into. We see it as a response to someone or something or another. Something happens to us. Therefore the love is a response and not the cause.

Love can be created not just found. It is this truth about love that Ian encourages photographers to focus on. "When you are creating, it is the act of creation, the process, that you love, not the form it needs to take. You don't need to love a specific image or visual idea. Holding the love for the act of creating, as a separate piece in and of itself, is the first step in moving past blocks."

Ian continues, "Love is generative rather than responsive. The finished object of your love does not yet exist. Quite often it isn't even established in your mind. A creator is able to love something that doesn't yet exist—even in the imagination—and bring it into existence. From the notion of the love, something is formed."

Ian's goal is to move the photographer from his mind back into his heart. He tells us, "Your vision will become clear only when you look into your heart." This exercise moves you from your focus on "creating the product" (mind related) and centers your attention on being aware of your love of the creative process (heart centered).

Ian reminds us: "Remember to tell yourself: The reason I create is simple; I want the creation to exist. In fact, I love the

creation enough that I will take whatever steps are necessary to bring the creation into the world. This is how it is for all creators, although we have been taught not to admit it, for when we talk like that we can be accused of being mystics, elitists, or fools."

Ian continues, "What about the real world? You can't live your life doing what you want. You must be realistic; you need to come down to Earth. But, if the only love we experience and express is the love that happens to us, the love we fall into and not the love we originate, then we miss an entire dimension of love. So we need a way to combine our love and our real-world responsibilities."

Clustering

This exercise has been created by Ian to take you to the next step of bringing your love into your work.

In the middle of a large piece of paper write the word "loves." Draw a circle around it. Then free-associate something that you love. Try a person, place, thing, animal, activity, or something that matters to you.

Write it down and draw a circle around it. Draw a line between the two circles. Ask yourself what you love about what you love. There are many things. Draw circles around the words and connect them to the root love. Keep going until you are stuck. Go to another root love and continue the process.

Work quickly and easily. Don't let your analytical mind get too involved. Don't judge your words as you write. Free-associate. Be playful. Let it flow randomly. Have faith your loves are in you and you are just letting them out. At some point you will sense you are done. Go back over your love clusters. Place a red circle around the things you love that are not present enough or may be missing from your work and your life.

I Am . . .

Using the loves you identified in the clustering exercise, write at least thirty sentences starting with the words "I am." You will notice that you are not only what you love, but also what you love about what you love, which is very significant. Here are a few examples.

- I am someone who loves creating new universes.
- I am someone who loves discovery, adventure, and exploration.
- I am someone who loves to be the center of attention.
- I am someone who loves to read and become part of the book.
- I am playful and often silly. I love that.
- I love being with children and playing make-believe.

Get the idea? Spelling and grammar don't count. Just get it down. Read it to someone else. What does it feel like to describe yourself through your loves?

I Want

Now go back over the clusters and circle all of the loves and the things you love about what you love that are not present in your career right now. These are usually the culprits for creative block and they are what need to change. Your next step is to develop a plan to manifest these wants and desires. Putting the elements that you love back into your life will help you to become unblocked.

Heartstorming exercises ask you to leave your mind and return to your heart. A bit esoteric for some, yet truly grounded in truth, Ian's Heartstorming exercises have helped many to move from a focus on "I need to create new images" to understanding that blocks are about bigger issues. The information you discover about yourself and your loves, wants, and desires will affect the totality of your life, which in turn will not only release the block but help you to reach back to the heart of who you are.

Try Ian's exercises, use them, and begin the process of remembering why you are here and what it is that you truly love about creating! When you begin to approach a block from this perspective, the veil will lift, leaving you with new opportunities, hope, and a truckload of energy.

CHAPTER 25

STARTING OUT LOU
ROOLE STYLE

S tarting out as a professional photographer does not need to take tons of money and a huge studio filled with equipment. All it really takes is talent, belief in yourself, commitment, and lots of time. Ask Lou Roole; he's got it all going.

Eighteen years ago Roole was a man with a degree in architecture and no interest in using it. He joined the army, bought a camera, and began to shoot the people and places he saw.

Roole completed his army commitment and, four years later, decided to get serious about photography. He signed up for courses in lighting and composition, attending night school at Miami Dade Community College, all the while selling real estate. While others might have complained loudly about having to work so hard, Lou simply did the work that needed to be done.

While taking photo classes Lou looked at lots of photography.

I loved the masters, but Weston and Mapplethorpe were my favorites. It was Mapplethorpe's portrait of Grace Jones that nailed me. It was incredibly powerful and I knew then that photographing people was what I wanted to pursue, but I knew I needed to know more about the craft. I had the belief that I had talent but I knew I needed to learn more about photography. There was no choice; I had to work and I had to shoot. I was not ready to be a photographer; I knew I needed to know more.

Lou took more courses, fitting them in and around a forty-hour workweek.

Five years after starting his first photo courses he felt fully committed to becoming a professional photographer. Knowing he needed more training in the business, he chose to assist, as he felt it would offer him the biggest opportunity for growth. New York was the place to continue the quest, so he packed his gear and moved north.

"I packed up everything and relocated to NYC. I wanted to assist but nobody would hire me. I made the rounds but I had no experience and I couldn't find anyone who was willing to take a chance. I knew I had to find a way to keep my vision going and I refused to be a starving artist. I took a night job at UPS and decided to shoot in the day. I still continue this schedule."

Has Lou ever gotten despondent during the long hard process of trying to kick-start his career?

"I've gotten down a few times but I refuse to stop progressing," he comments. "Even though I have little money to produce shoots, I still mange to shoot. I can't afford to pay models, producers, or support people so I photograph the people I meet. I find subjects in the street, on trains, in cafés. The city is my backdrop," he concludes.

Lou began to receive a few assignments through word of mouth but felt that he needed feedback on his work before actively seeking more assignments. He decided to go straight to buyers for advice: He put an initial book together of the people he had photographed and began to send it out to photo editors and agents.

"I wanted to know if I was ready to go after work," he says. "The answer I received was no. Everyone who saw my images said I had talent and that they liked my work, but they all said I needed to focus more."

This is a spot where many photographers get stuck, as they have a hard time with rejection and comments like "not ready yet, focus your vision more" provide them with the excuse to stop all activities. Roole, however, was not deterred.

"I've spent most of my free time shooting for the last seven years. It's left me not much money for a social life and almost no time for anything else. But this is what I love and I know I

can do this. I refuse to get down and I just keep working at UPS for money and shooting as much as I can," he says.

Knowing that he could not find the focus that everyone was telling him he needed, he called me.

FINDING THE FOCUS

"My goal was to try to get better, I didn't know what to do to, I wasn't sure what it meant, to focus more. I had heard that Selina was the person to talk to, so I called her," he states.

Lou and I had an initial portfolio review. I was absolutely blown away by the talent displayed in his work. I loved his images. His work was composed of environmental portraits and moments. His subjects were everyday people. There was no production value evident, yet his images were extremely powerful and serene at the same time. I found this dichotomy quite interesting.

Lou used the street, the subway, alleyways, and low lit apartments as his backdrop. His images were graphically composed and striking. The most compelling element, however, was that he created moments that I could feel. I could literally sense the energy in the room the minute the camera clicked.

As I looked through his visuals I realized that he had a ton of work but that many images were a bit repetitive, so we took inventory and tightly edited the initial group.

Lou and I discussed the types of people he might consider photographing to round out his portfolio, and I then gave him direction and assignments to shoot, noting the specific types of images we needed. We ended up with a final list of about fifteen images that would need to be added in order to complete the first round of shooting.

Knowing that Lou had a day job and that money and time were tight, I fully expected all types of excuses and reasons why he would not be able to meet the assignments I had given to him. Instead Lou said, "No problem. I'll be in touch when I have the work."

Months later Lou called with news that he had the images we had discussed and he was ready for another review date.

After a brief conversation and some editing, the book was completed.

Lou's process and his commitment to it are not at all typical. There is much that everyone can learn from this man who worked steadily for years before he had a book worth showing. Lou's process and commitment to it are atypical. Such perseverance from a man who worked steadily for years before he had a book worth showing is something from which everyone can learn.

Lou still works full time and is having a tough time getting the book around to buyers. It's a slow process but one he has not given up on. In the meantime he has added mini-portfolios to the mix and is following up initial visits with his mini-portfolios. During the last year Lou has developed a Web site and is just now developing e-mails that will be sent to editorial contacts monthly.

Each step of the way will pose challenges for Lou. He will need to get his work out to buyers much more often and will need to develop a direct mail and e-mail program that can circulate as he works in the daytime at UPS. In addition, he will need to continue to shoot because shooting is what keeps Lou juiced.

Lou feels that he is ready to succeed. After a journey that started twelve years ago with a casual interest in photography, he now has portfolios and marketing tools to help him sell his work. He continues to progress while he waits for his break.

It is not an easy road to travel.

"Photographing is what I live for," Lou notes. "I don't know what my chances are of succeeding but I have no intention of stopping."

Lou has reminded me, and with an open heart I remind all of you, that while time and money are needed, the true keys to success are talent, commitment, and the belief in oneself and one's purpose!

CHAPTER 26

PERSISTENCE AND THE ART OF LISE METZGER

If you look up the word "persistence" in the dictionary, you would not find the name Lise Metzger, but I'm going to petition Merriam-Webster and ask them to change that.

As it stands, the current definition of persistence is "the quality of continuing steadily despite problems or obstacles."

Lise is the poster girl for persistence.

A few years ago, Lise called me and expressed her desire to develop a new body of work. She felt that her current portfolio was not representative of "the best" she could do and she was committed to developing new imagery.

Lise is a superb photographer. She photographs people in environments, telling stories through photographs of seemingly small, often quiet moments. Her images are elegant, whimsical, and sensitive. Lise's people are easy on the eyes, and we are enticed by the peek we have into the worlds she creates, leaving us wanting more.

We began the portfolio build process by discussing how we would work together, and we set a goal date for completion. At that point, Lise explained that she had a very full life. She was a professional photographer and had a relationship with an agent. She expected that she would be quite busy servicing accounts.

In addition, she was also a mom, a wife, and a caregiver to her mother. Lise's commitment to caring for her mom, who was quite ill, was a big part of her life.

Lise also made it clear to me that despite her limited amount of time, she fully expected to have a book built within nine months. Her determination was obvious and her timeline reasonable. Timelines are built around the number of shoots needed, the photographer's life beyond the book build, and a bit of luck. Luck was not with us as we began.

Lise builds her photographs around people. She finds interesting subjects and develops stories around them. Locations are key to her process. Clearly, weather and the availability of models are issues for any lifestyle shooter. On this project, location, weather, and models were all major factors, and in the beginning, few were coming together. Models were unavailable, and for weeks the weather was not cooperating.

After much discussion and many rescheduled shoots, models were found, the weather cleared, and we finally got on a roll. Shortly after we started to make real progress, Lise's family commitments grew as her mother's health began to decline. Her opportunities to shoot became more limited. To add to the challenges Lise was facing, she and her agent called it quits. While I fully expected her to take a hiatus from shooting, the portfolio build continued. Lise and I developed new shot ideas. We continually changed shooting dates as needed, working around school vacations and doctor visits. The portfolio build proceeded very, very slowly but steadily. Lise persevered and new portfolio shoots resulted in stunning imagery.

As the months went by and the seasons changed, we completed the shooting stage of Lise's book. The images were gorgeous and the book had a very clear and consistent message. We were now ready to begin the process of building the housing for Lise's book.

Anyone who has ever built a portfolio with a book builder knows that the process involves choosing the size for the finished portfolio, testing paper, and choosing the materials for the outside covering. The process of choosing materials usually takes a month or so. But Lise's choices of fabrics were not working, and she repeatedly needed to review options and choose new coverings. Her original due date had long since passed. Often frustrated, she continued on, not satisfied to settle on choices that simply did not fit.

While we were making choices for the exterior of her book, Lise began the long process of learning the art of printing multiple images on a page. Eighteen months after we began, and nine months after the goal, Lise's first book was completed.

Next on our list was the completion of Lise's Web site.

We started by choosing designers that we felt were right for the look Lise was seeking to develop. We chose to work with Alan Kegler and Joe Murphy. They are a design team that I had worked with before and whose talent I felt would complement Lise's style.

As Lise and her design team worked on the inner components of the Web site, she and I tackled the task of editing the images for an online audience.

During this time her mother's health declined and Lise's presence was needed at home on a more constant basis.

It is important to note that Lise was expending a huge amount of energy. She was the support for her mother and her family at a time that she was giving enormous energy to her business. There were days when she cancelled appointments and missed deadlines, but she never stopped, she never gave up.

Ultimately, we completed her Web site and *PDN* cited it as one of the year's best Web sites!

I know of no formula that gives us a road map or a specific approach to take when we are handling so much. We simply do the best that we can, making decisions about where to put our attention each time it is called into play. And yes, we just keep moving forward.

The one element that kept our project moving was Lise. From the outset she held her attention on her intention to develop a new body of work. Regardless of her many responsibilities, she kept her focus on her goal.

Today, years after we began, I am still in touch and working with Lise. Her mom has passed on, she has a new agent, and now we are in the process of editing new work for both her portfolio and for her award-winning Web site.

The message here is that life may be full, commitments may be huge, but your dedication to your art and to your process must be complete and whole. Events will come and go.

Deadlines will be set and sometimes missed. But if you stay the course, continue to persevere, and do not become defeated by life or yourself, you will succeed.

Lise knew what her goal was. She was determined to build a new portfolio and Web site, tools that represented the best of what she has to offer clients. As each challenge arose she faced it and created solutions, all the while focusing on the end goal. She never compromised her visual integrity and she never let the delays become her reality. She kept moving and shooting and editing and printing. Now Lise has a portfolio that is stunning and a true representation of not only her talent but of her character.

CHAPTER 27
SHERMAN SELLS

Veteran photographer Stephen Sherman is on a roll. After working incredibly hard for months to build a portfolio that will reposition him as a lifestyle shooter, he is now actively and consistently going on personal visits and utilizing drop portfolios as key components in his effort to sell his new photographic vision.

"I was getting tired of glorifying corporate CEOs and their culture. After 9/11, corporate work began to seriously dry up," Sherman explains. "After twenty-five years in the business I had a decision to make. I needed to visually move on. Corporate work for me was all about telling stories. Lifestyle photography appealed to me as it provided me an opportunity to continue my narrative."

Once Steve's lifestyle book was in production, he realized that it would speak to a different audience. Graphic designers were no longer his key prospects. He needed to reach national art buyers.

Unlike the majority of photographers in the commercial arena, who do not go on appointments to sell their work and who choose to market their services exclusively via e-mail, direct mail sourcebooks, and Web sites, Steve knew that he needed a strong sales component in his program.

SEEKING FACE TIME

Steve comments,

> My lifestyle book was completely different from the corporate work. I needed to build a whole new

client base and I knew that putting marketing efforts in place would not be enough. I was convinced that I needed to get out and sell the new work. I think it's absolutely essential to have a real physical presence in the minds of as many people as possible rather than be another name among the thousands out there. Taking the time to personally meet art buyers was what I needed to do. I choose to utilize drops only when I absolutely can't get in the door, and after a portfolio drop I always try to get an appointment the second time around.

While other shooters loathe selling and do everything to avoid the process, Sherman sees the selling aspect as "good business."

We are all businesspeople. If you forget that selling is a daily responsibility, you are bound to fail. As businesspeople we have to sell our product to survive. In-person visits give me the chance to connect with buyers. The first rule of any sales experience is that one has to position himself or herself first as an individual worth doing business with. Creative work is no different than any other in this regard. If anything, talent positioning is more important in our field than in others. You have to build trust in the client's mind before they will commit to hiring you.

As the marketplace has become more globally focused and the Internet has become a huge tool, many photographers have chosen to eliminate in-person meetings, contending that no one sees anyone any more. Sherman has had little difficulty getting appointments and he cites his approach as key.

I have a nonstop program. I use a targeted national list. I send mailers out to the list and then start calling my preselected leads a few days later. I make lots of calls and send e-mails requesting portfolio visits if I don't reach prospects by phone. I am targeting art buyers

nationally and I have chosen New York City as a geographic area to saturate. I plan on visiting three to four times a year and I send out six to eight drop portfolios per month.

Sherman uses drop portfolios as front-end marketing tools. The book is sent out before a job is on the table to introduce the talent in the hope of beginning the "dance." Many shooters opt out when it comes to sending books ahead, using the Web as their opportunity to show their work. Sherman sees drop visits as a way to obtain more visibility and develop the relationship.

When I am calling for an in-person or drop-portfolio appointment, there is a personal connection. When they look at my work it's in 3-D. It's not a small image on a screen. There is more opportunity to build presence and branding when a book is in someone's hand. I have a great Web site. It reinforces what viewers have seen in my book and it continues to build the identity with folks who are not on my sales contact list. But my Web site alone is not enough. I need lots of options to sell and I need enough time for viewers to get what I do. The response so far has been very positive.

While initial reactions to Steve's portfolio have been positive, he will need to continue to hold fast and have faith. The assignment photography market is crowded with suppliers, and as a result of stock and royalty-free photography, assignments have diminished. Marketing efforts have always been and continue to be cumulative. Thus, it may take one to three years of constant sales and marketing efforts before Stephen hits his stride and obtains assignments on a regular basis. Stephen will need to continue to sell, seeing clients and sending out portfolios. In addition, he will need to continue to facilitate his marketing program. "I know how competitive the market is and my goal is to be a major player. That's not going to happen with one or two ad opportunities," he states.

MULTILEVEL MARKETING PLAN

Steve's thoughts are correct. Photographers need to have a multilevel plan that incorporates many direct and indirect advertising options. Steve's list of ad tools is long and designed to give him maximum exposure.

"I have two Web sites, one for lifestyle and one for business," he offers. "The messages of each site are different, and in time I may drop the business site. I want my ad clients to get a singular message and not confuse me with my corporate past."

He continues, "My Web presence is carried on multiple portals. I realized early on how important a good Google ranking was, so I worked incredibly hard to develop a Web presence that has placed me on the first Google page when a client surfs for lifestyle photography. Multiple links are an important key for ranking, and Web portals help. In addition, they provide me a much wider audience for my site."

Sherman has not forgotten the importance of direct mail contact with buyers.

We send out a large postcard run approximately every six weeks. Visual e-mails with links to our site go out four times a year. I will be increasing the frequency of our e-mails, as they have been very effective in driving viewers to my site. I usually send out four to six thousand e-mails at a time. After the last blast I sent, I received five or six requests for removals and over twenty people thanked me for sending the information. My Web site had several hundred hits that very day.

Citing no response to recent sourcebook ads, Steve has dropped this option, replacing that sales trail with portal buys that directly link to his Web site: "For the money I spend on one sourcebook page I can be on several portals. My exposure is not limited to one publication and my audience reach is much wider. When I was in NYC recently, 50 percent of the buyers told me they never use print sourcebooks anymore."

As Stephen progresses, his faith that he is on the right track will need to sustain him. In addition to faith, feedback from clients at this point is vital. Having books called in for bids,

prospects asking after a drop to keep portfolios for project consideration, and increases in Web site traffic are all indications that his efforts are accomplishing the goal. Steve has good reason to be optimistic.

"The reaction to my portfolio has been very positive. A few days after my first trip to NYC I received an opportunity to bid on a project. Several times after a portfolio drop my book has been put in the mix for current assignments. Right now I am waiting on word from another agency in NYC on a possible job. I am getting close and I know it's just a matter of time."

Steve is so very right. If he continues with the pace that he has set, he will succeed. While Steve cannot control how long it will take until buyers have a need for his services, he can certainly continue to direct his sales and marketing efforts proactively, assuring him success!

CHAPTER 28
A SUCCESS STORY

In today's market, stories regarding the negative aspects of our industry abound. It's not surprising. Editorial contracts have been slashed, independent stock agencies are disappearing as they continue to be absorbed by the big three, and assignment photographers are still facing a buying public that does not seem to be buying as much assignment photography as they used to.

In the midst of what is clearly a very difficult time, there are success stories, positive sagas that can get lost if not repeated, tales that need to be told as they have the ability to inform, inspire, and help us to keep perspective. The tale of Los Angeles–based editorial shooter Tom Johnson is a story worth sharing.

The first facts that you need to know about Tom are that he is not yet making tons of money, he has very few clients, and he is far from being a household name. Equally important, Tom is extremely talented, has photography in his blood, works hard, has a "never say die" attitude, and is rarely satisfied with his own efforts. These qualities may make life a bit difficult for Tom from time to time, but I am convinced that they are the tools that will help him to achieve financial and creative success.

Tom came to a workshop I gave in Los Angeles for the American Society of Media Photographers (ASMP) about ten years ago. Shortly afterward, he contacted me and was determined that we would work together. He was committed to becoming a successful, national editorial photographer. He told me that he needed a new portfolio.

I looked at Tom's existing images. They were exciting and highly competitive. I was surprised when he told me that the images were not good enough for him. He told me that he knew that he could push harder, creating visuals that had more refined vision, impact, and personal connection. He wanted to break through more visual boundaries and create images that he would be proud to show. It was then that I knew that Tom was a man who could be very successful.

For the next eight months Tom and I worked closely, concepting new shots, viewing and editing images, and talking about life. We decided early on that Tom's editorial portfolio would contain two books, a book of portraits and an ongoing body of work about Lakewood, a community that was built in California in the fifties after the war. Lakewood was one of the first planned suburban communities in the United States. Tom had grown up there, his mom still lived there, and he had been documenting the community for years. The idea behind the two books was to show his talent via single portraits while giving editors the opportunity to see how Tom handles stories and longer projects. Lakewood would also give editorial photo editors an in-depth look into Tom's purely artistic vision.

We determined that his book would contain both black-and-white and color images. Color was a stretch for Tom as he was more comfortable in the medium of black and white. This was a potential stumbling block, but Tom simply took it as a challenge. He spent little time wondering if, how, and when his vision would transfer into the medium of color. He just went out and created opportunities to shoot. He was clearly excited about finding his "voice" in the color medium. Tom had contacts that he was not afraid to tap. He wanted to photograph his uncle the painter, his neighbor Louise, the writers of *Law and Order*, and Vice President Al Gore's running mate, Senator Joseph Lieberman. Most of his subjects were not friends or close associates, yet Tom worked every connection, never stopping to question himself or his process. Not surprisingly, Tom found that many of these folks were constantly busy. While other shooters would have lost momentum, Tom stayed focused and was in touch on a regular basis with all potential subjects. Ultimately he photographed them all.

When we were ready to do a final edit and paginate the books, Tom was an incredibly active partner. He knew what he wanted to say and he was once again functioning from the perspective that each image had to speak to his expectation of excellence. He was ruthless, deleting images that months before had been deemed keepers.

Our next job was to house the portfolios. Tom worked with one of my bookmakers, Nicole Anderson, and together we built red leather portfolios that are bold, elegant, and eye catching. Clients were few and far between, and Tom's daily income would not financially support the completion of the books. Committed to finishing the project in style, Tom decided to invest in his portfolios, taking funds from his savings to finance the project.

The result is a stunning portfolio that contains images that are haunting, beautiful, strong, and full of voice. It was time to take the books out.

Many photographers today are convinced that buyers won't see them; consequently, they use this to justify giving up before they begin. Tom didn't take that path.

Tom was determined to go back to New York, to see the few photo editors that he had visited the previous year. Incredibly, he chose the first three weeks in August to visit the Big Apple. I was sure that he was setting an almost impossible goal for himself, as New Yorkers are known to love their Hampton weekends in the summer. Many a shooter has complained that in the summertime New Yorkers end their week on Thursday and begin again on Wednesday.

Tom planned a front-end contact campaign in which he would call both existing prospects and new ones, and then e-mail those he did not reach, in order to request an appointment. He reached only a handful of prospects before leaving for New York City but ended up at the end of his trip having shown his book to over thirty photo editors! His efforts were fruitful as he received a few assignments upon his return. He is currently following up his visits with the first of twelve pieces that each viewer will receive this year.

Why am I so excited about this photographer? It's a no-brainer. Tom Johnson is the example that I would like to hold up to every photographer who feels that it's a hopeless

market: the ones that say "editorial is dead" and " nobody buys good creative," the naysayers that are quick to say "buyers never see photographers."

Tom shows us that it can be done and he shows us how to do it. He is committed to holding himself to a higher standard. His willingness to fully commit financially and emotionally to an intelligent marketing effort and a spirit that is honest and relentless is nothing short of inspirational. Tom is already a success in my eyes, and if he keeps up this pace, buyers will be lining up in spades.

CHAPTER 29

ZAVE SMITH'S CONSISTENT MESSAGE

The strategy for successful self-promotion is one that few photographers follow. The rule is a simple one: Consistency is king. Consistency of vision, of effort, and of message delivery can be found in the programs of all photographers who continue to reach their creative and financial goals. While photographers often struggle to put this very important piece in place, one of my clients, photographer Zave Smith, has it down cold.

A national lifestyle shooter based in Philadelphia, Zave repositioned his business six years ago. It was then that he began to be a devotee of discipline and of constant effort.

I was shooting still life and needed to make a major change in my visual inventory, I needed to follow my heart. I saw the buying trend shift toward lifestyle photography and I knew that was where I wanted to land. My next step was to develop *my way* of photographing people. I realized that a consistent message to clients was critical, both in vision and in the tools I employed to deliver my visual product. I had never before committed to a multilevel plan and I was eager to try.

Zave's first job was to develop the imagery and let the visuals guide the program. We worked closely together, and after an

eight-month portfolio build Zave had a book that visually articulated his message.

"My photos are about the spirit of everyday life," says Smith. "They express the multifaceted emotions we all experience: laughter, fun, and awe. In essence, my images portray the small moments of everyday life."

Once the portfolio was created, the next step for Zave was to choose the actions that he would use to deliver his visual message to agency art buyers and graphic designers. Zave's tools include in-person visits, drop-portfolio showings, direct mail, e-mail, a Web site, and multiportal visibility for his Web site.

> I believe that even in bad economic times, talent will rise to the top and find a place, as long as it's visible. My task is to communicate my talents in all of the places that buyers go to when looking for photographers. However, I now know that the tools alone are not enough. In order to drive home my message I needed to visually brand all of my sales and marketing options. That way my efforts would be maximized. My portfolio housing is a deep purple, it speaks to emotion, and I wanted my ad materials to play off of the mood and feel of the portfolio.

Zave chose to work with a graphic designer to develop the look of his site, mailers, and e-mailers.

> I am not a graphic designer, so I hired Michael McDonald, a designer whom I knew and whose style I really liked. His job daily is to create materials that inform and seduce. The first tools we developed were direct mail pieces and a Web site. I send my mailers out six times a year and I wanted them to begin to establish my name and brand. Michael took on the job, designed a look for my company, and then carried that visual message over to the Web site.

Zave knew that beautifully designed Web sites couldn't do the job if they have no visibility. He also believed that buyers

rarely Google a photographer, opting instead to use established Web portals that contain hundreds and thousands of individual photography sites. "Once the site was completed, I followed my consultant's advice and began to search out portals for Web site placement. My site was listed on a few portals in the beginning and now is accessible through the Black Book, WORKBOOK, Alternative Pick, APA, ASMP, and Photo Serve (*PDN's*) Web sites."

Knowing that he needed face time with buyers and not wanting to lose touch with his current core base, Zave chose to start his in-person visits networking in his hometown.

"I had previously joined the Philadelphia art directors club and made a point to work on committees. I have been on the board for quite a long time. I realized that my name on a membership list was worthless; I needed to work side by side with the people I wanted to meet, my buyers," he states.

As time went on, Zave consistently followed his plan and then decided that he was ready to build on what he had already developed. He sought more contact with prospects, and, remembering that his goal was a national client base, he began to show his portfolio to New York City art buyers on a consistent basis. He currently averages about thirty in-person appointments per year.

At this point Zave had portfolio visits, drops, networking opportunities, direct mail, and Web placement working. He wanted to add more but felt that his budget was not able to sustain additional efforts.

We discussed developing a template for e-mailers. Zave decided to give it a go. We did not see this as another visual hit; rather, we saw this as an opportunity to share a bit of Zave's personality. It could be a chance to share information about Zave's philosophies on creativity and teamwork. The e-mail document designed by Michael McDonald carries a copy message about the creative process. It always contains a recent shot, and contacts are encouraged to visit Zave's site by clicking a link that directs them there. The e-mail has since become one of Zave's strongest tools.

"My e-mailer is part of my creative process," informs Zave.

They are all copy based and seek to initiate a
dialogue with people that I might never otherwise

hear from. I have written about teamwork and the creative process as I see it. Prospects e-mail me back their opinions about and reactions to what I have said in my e-mail. It's wonderful. Sure, I get people who opt off the list and some who are less than pleased to get my e-mail, but they are such a small minority compared to those that seem to really like my correspondence.

Zave is clearly happy with the results.

"Immediately after my e-mail goes out," he says, "I get several hundred hits on my site and numerous requests for my portfolio."

Zave started with a few advertising actions and has continuously built his program each year, adding on new efforts. During the last four years his efforts have been continual.

Marketing is not like booster shots. It's more akin to taking vitamins. You take vitamins daily for optimum health. You need to market every day in order for your business to stay healthy. Look around at other types of businesses. The most successful companies in the world market continually. Its not a once-a-month effort, it is an integral part of daily life. There's a lot of competition amongst photographers and lots of amnesia on the buyers' side.

For those of you who may be thinking that Zave must have a huge team to help him, think again. With the exception of his graphic designer and me, Zave handles the tasks by himself. His plan when he is busy shooting is quite simple.

I work with Selina and set my yearly marketing tool calendar twelve months ahead. It is one that I can keep up with in busy times. I plan mailers before I need them and write my e-mails when I have down time. I am not perfect and I occasionally do trip up; however, having a plan in place allows me to get right back to where I need to be. When I looked at how I spend my time I realized that I spend approximately 30 percent of my

time on assignments, 30 percent shooting stock/ personal work, and 30 percent of my time marketing and handling back-end office tasks.

Results are what everyone is looking for. In order to gauge success, you need to know what your goal is upon commencement of your program. Zave is clear about his accomplishments.

Now, four years after repositioning and consistently following my plan, I have a profitable business. This is during one of the worst of economic times in a third-tier market. Had I not been consistent with my efforts, I never would have achieved profitability and would have closed shop long ago.

For me success is doing the work I like with people I enjoy and leading a comfortable lifestyle. I sleep very well at night.

PART VI

FAITH

THE GROUND WE WALK
ON, THE PLANTS AND
CREATURES, THE CLOUDS ABOVE
CONSTANTLY DISSOLVING INTO
NEW FORMATIONS—EACH GIFT
OF NATURE POSSESSING
ITS OWN RADIANT ENERGY,
BOUND TOGETHER
BY COSMIC HARMONY.

—RUTH BERNHARD

CHAPTER 30

HOW TO SURVIVE DURING DIFFICULT TIMES

As I travel around the country presenting lectures, I hear comments and am asked questions that reflect the difficulty that many photographers are experiencing: My phone is not ringing. My billings are down. Should I stop marketing and save money? I have less money this year and I am not sure where my marketing dollars are best spent. Why should I create a new portfolio when I have a Web site? Why should I shoot for my portfolio when clients are cutting back on budgets?

And of course the question that is on everyone's lips, but no one wants to ask: Is assignment photography a dying industry?

No! Please hear this loudly and clearly. Assignment photography is not dead. Not by a long shot. But your business might be if you are not proactively marketing.

It is critical that you continue to work on your portfolios, create Web sites, and send out e-mail and direct mail that will brand your business and create visibility. In fact, the biggest mistake you can make during tough times is to drastically cut back on your selling and marketing.

The reasons to continue to sell and market are clear:

You need to work and clients are still hiring.

While some companies have changed their buying patterns, others have seen little or no change. Magazines are

still publishing, and many art buyers report that their buying habits haven't changed, although some projects have been put on hold. Assignments may be on hold, but your selling should not! Most importantly, selling and marketing your work is a process that needs to be ongoing. Your consistent efforts, or lack of them, have a cumulative effect on your sales. You can't afford to randomly start and stop your process.

With many photographers choosing to cut back on their selling and advertising, your chance for greater visibility is improved.

Unfortunately, not all talent subscribes to the idea of constant marketing. These are the times that will give those who are off-and-on-again marketers the green light to relax and kick back, telling themselves that no one is buying, so why should they sell. These folks will cease marketing. This is excellent news for you if you choose to be proactive, as there are fewer people selling and more opportunities for you to connect with buyers.

Clients who are not producing work have more time to see you.

Art directors who are not producing ads and graphic designers who are waiting for approval on assignments *may* be more accessible now. Call contacts on your list and see if they are available for portfolio visits. Use any quiet time well. Reconnect with clients with whom you have not worked in a while. Check in and find out how they are and use this time to build on existing relationships.

Jake Armour of Armour Photography, based in Minneapolis, reports that they were extraordinarily busy the last quarter. "We had record breaking billings," states Jake. "I attribute our success during these tough times to our long-term commitment to our branding and positioning. What's happening now was put into motion quite a while ago."

The Armour team has recently built a new, much larger facility—a move that Jake has never regretted.

> I knew that nothing would happen if I did not make it happen. We had to stir the pot. We needed more space in order to expand the business profile, so we built a new studio. Many people may have questioned

our timing but I am not looking at next week or next month. I am here for the long haul. We had plans to move to a bigger facility; the current recession was not our priority, meeting the future needs of our clients was. In retrospect it was the only way to go.

STEPS TOWARD SUCCESS

By listening to Jake it becomes clear that he has worked hard to develop and keep clients. I have worked closely with him and I know that there are specific steps that he has taken that helped his businesses remain active. These are steps that you can take now, regardless of your finances.

Develop your visual value: Have a specific, tangible product to offer clients. Use any quiet time to create images and to test and edit visuals for a new or existing book. Review your current portfolio and play client. What message do you get from your book? What type of assignment would you hire yourself for? Conversely, what's lacking in your book? Content, presentation, credibility? This is a great time to create a portfolio that you can market.

Develop a qualified list of contacts: Buying a list is always helpful. AgencyAccess, ADBASE.com, and FRESH lists are good resources. If finances are a problem, learn how to create your own list of potential clients. For corporate leads use the *Standard Directory of Advertisers* (found in the reference section of the library), for advertising leads the *Standard Directory of Advertising Agencies* will be helpful or go on the Web to *http://agencycompile.com*. Graphic design studios and editorial publications can be accessed through their Web sites, which are a terrific source of visual as well as specific information for all potential clients. Once you have highlighted companies, publications, and firms, call and ask who the photo buyer or buyers are. Ask agencies and graphic design firms to e-mail or fax you a current creative list.

Create a well-rounded affordable sales and marketing program. There should be two components to your new business development efforts: sales and marketing. All too often photographers develop marketing efforts but forget that sales

efforts are key. What's the difference between a sales effort and a marketing effort? Portfolio visits, in-person appointments, portfolios sent to buyers that you are interested in working with—these are all sales efforts. Direct mail, sourcebook ads, visual e-mails, and Web sites are all marketing tools. They support the visual in the actual product, your portfolio.

Consider developing an advertising program that involves the portfolio and two to three other marketing efforts. Buyers need repetition. They need to see your imagery over and over and preferably in different formats. Providing potential buyers the opportunity to see your images in a direct mail piece, a visual e-mail, and in a portfolio presentation is critical. Buyers buy at different times, and they will find you through different avenues. You need to cover your bases and create visibility. Does this take money? Yes, but it needn't be hugely expensive. If finances are tight, create a portfolio and use visual e-mails and lovely handmade (not homemade!) cards. Send to fewer contacts but send consistently. Once a month is not too much in my book.

Brand all of your sales and marketing tools. One of the key ingredients in any successful program is branding. Using your vision to set the tone, create a palette of colors, materials, and design elements that will be present on your Web site as well as in your portfolio and direct mail. When possible, work with a graphic designer or art director to set the look of your program. Branding helps to create visibility. Moreover, in reality, you are building credibility with your audience when you develop a thoughtful visual solution that conveys your book's message, as you will be living the language and purpose of advertising and graphic design. A well-designed program builds trust as it says professionalism, knowledge, and confidence.

For any naysayers in the crowd, those of you who are coming up with excuses as to why you can't build a book and sell or market your talent, I ask you to think of my plumber. He's a great guy, he works 9 to 5, he drives a Jaguar and goes home to dinner every night at 5 pm. But he doesn't create visuals; he doesn't get the opportunity to brainstorm ideas that he will eventually see in a magazine or in an ad. He doesn't get to use a god-given talent and make money doing so.

Our industry has experienced its share of tough times but the tides will turn. They always do. Nothing stays the same. Now is the time to begin what you never started or to pump up what you began a while back. All efforts put out now will reap rewards later, when buyers start to buy and the market turns around. When clients are ready to once again buy in full force, it's the creative who continued to market and sell that will have a visibility factor among buyers. They are the photographers who will be very busy—make sure that you are one of them!

CHAPTER 31

AFFIRMATIONS: YOUR NEW MARKETING TOOL

I have long counseled my clients and readers to develop intelligent, well-rounded sales and marketing programs. Having an arsenal of tools, all designed to deliver your message, is critical to succeed as a creative professional in today's environment. In addition to the tangible actions I have spoken of (portfolios, Web sites, and direct mail), I suggest that you develop and utilize "affirmations" as a marketing option.

An affirmation is a simple, thoughtful, positive statement that you craft and consistently repeat. Its purpose is to put your wish for change out into the universe. It is a powerful tool that connects your request to higher consciousness. It enables you to not work alone. When you craft an affirmation and repeatedly put it out, the universe becomes your team player. The extra good news is that it costs you nothing but time and faith!

We all know that there is a mind-body-spirit connection. That fact has been well documented by experts and others in the medical and scientific, as well as the spiritual, communities. While some creatives have developed their inner beings and actively utilize their connection to the universe, many have yet to harness the power they possess. Developing and using affirmations is a wonderful beginning for someone new to this way of thinking and is always helpful for those already using their spirit to fuel their business.

An affirmation takes your wish, a specific thought, and puts it into a tangible physical form. Many teachers and leaders have talked of the power of thought and words. Deepak Chopra, a spiritual guide to many and a physician by training, states: "It is not you are what you eat, rather it is you are what you think."

Florence Scovel-Schinn was a widely known artist, illustrator, metaphysician, and writer, who in 1925 wrote a wonderful Big Little book: *The Game of Life and How to Play It.* In this important work she discusses the power of thought.

> The subconscious mind is man's faithful servant, but one must be careful to give it the right orders. Man has ever a silent listener at his side. Every thought, every word, is impressed upon it and carried out in amazing detail. It is like a singer making a record on the sensitive disc of the phonographic plate. Every note and tone of the singer's voice is registered. If he coughs or hesitates, it is registered also. So let us break all of the old bad records in the subconscious mind, the records of our lives which we do not wish to keep, and make new beautiful ones.

The "right orders" that Florence is referring to are your daily and momentary thoughts. Taken one step further, her words are a perfect example of how affirmations can work for you.

YOUR WISH LIST

If you are interested in the concept and ready to harness the power of thought and attention, begin by asking yourself: What it is that you most want in your business? Are you looking to develop a vision that represents who you are? Are you looking for more clients? For more money? For more balance in your life?

Write your wish down. Make sure that it is for your higher good and the higher good of others. Once you know what you wish for, you will be able to craft your affirmation. Refer to your

wish and write down a positive statement that speaks of your wish in the present tense. For example, if you wish for more balance in your life, you might create an affirmation that states: "My life is in balance. My time and energy are directed toward my business, my family, and my spiritual practices. I am at peace and comfortable with my life's direction." Note that you phrase the affirmation as if it already exists. The reason for doing so is because it truly does. The word "affirmation" is no accident. What you will be stating does exist in the potentiality of being. Stating your affirmations simply brings your wish into your sphere.

Make sure that your affirmation is personal, positive, direct, and clear. Bonni Carson DiMattteo, a well-respected business coach based in the Boston area, states: "I find affirmations most powerful when they are self-generated based on one's personal strengths and gifts." She offers an example:

"I am capable of achieving what I choose to commit myself to."

This affirmation speaks to the ability to commit and achieve. It links commitment to achieving and connects both to the outcome of success.

Word your affirmation positively. Laura Bonicelli, a national agent based in Minneapolis, uses affirmations before sales calls and when pitching specific accounts.

"Affirmations are part of my preparation. One of my favorites," states Bonicelli, "is to use my talent's name in the affirmation. I might say, 'John's style is a perfect fit for this particular project.' It's simple, positive, and to the point. I repeat this many times before and/or after a pitch. I truly believe that you can't put the thought out enough."

Laura's statement rings true. Once you have created your affirmation, the act of active repetition is critical. Plan on beginning your day by sitting quietly, breathing slowly, and repeating your affirmation with conviction and heart several times. End your day with the same practice. In addition to repeating my affirmations in the morning and evening, I find myself repeating them in the car, in the shower, and while I'm cooking.

In addition to creating my reality with the help of affirmations, I find that they center me, helping me to remember

what's truly real, and they give me extra sustenance when I need it most.

INSPIRATION

Perhaps artist and guru Julia Cameron says it best. In her book *Heart Steps, Prayers, and Declarations for a Creative Life*, the author of *The Artist's Way* talks about how affirmations first came into her life.

> In 1979 composer Billy May gave me a small book of prayers. *Creative Ideas* by Dr. Ernest Holmes. He said the prayers "led the way for him." "I think of it like this," he said, "If you're working on a project and you have a hundred creative horses you want them all working for you. Now, if thirty of your horses are worried about money and thirty are worried about the way the project will be received, you only have another forty to do the creative work at hand. These prayers help you to gather your horses." What a revolution that booked caused in my life and in my thinking
>
> If we just speak the words they open the door that opens the heart.

If you find yourself wondering how the spoken word can create change in your life, Cameron would remind you: "According to scripture, *The Ancients sang the world into existence*." If they could do that, then surely you can use words to shift your world!

If you are still in doubt, considering going to www.amazon.com and ordering the DVD *The Secret*. My client Michael Boland from Vancouver sent me a copy and I have since gifted it to many others. *The Secret* details the universal law of attraction and explains how our thinking creates our reality. It contains interviews with scientists, doctors, metaphysicians, and others, each of whom discusses his or her experience with this universal truth. Affirmations are indeed a wonderful example of the universal law of attraction in practice.

TEAMING UP WITH THE UNIVERSE

Developing a healthy, successful business requires attention at many different levels. Sales and marketing activities involve showing portfolios, sending out direct and e-mail visuals, as well as building and maintaining Web sites and Web portal content to clients. While many creatives are now paying attention to these tasks, fewer are accepting the responsibility of knowing what they truly want and working with the universe to accomplish their goals. Adding the universe as your team member through affirmations can be a powerful addition to your plan. After all, many of you are tired of working alone. Reach out and discover what a great partner the universe can be!

CHAPTER 32

WALKING YOUR TALK

How many times have you told yourself that next week, tomorrow, or this afternoon will be the time that you will begin to "buckle down" and begin a new marketing program? Did you do it? Have you begun the process of building a new portfolio? Did you make the calls to show the book you just completed? Did your mailers get sent? Have you been keeping your promises to yourself?

If you find that you are not following through, take heart. You have lots of company. Possibly the hardest part of being a freelancer for many people is showing up consistently in their businesses. Showing up for clients is rarely difficult, but showing up for yourself, walking your talk, being present in your business, and doing the work you said you would do is difficult for scores of creative pros. While photographers can point to busy schedules, which leave little time for new image generation, others claim that slow times create depression and "Who wants to market when they are depressed?" So, busy or slow, no marketing takes place, clients are wooed by others (who are not caught in the no work, too much work, no marketing conundrum), and business is lost, depression sets in, and the cycle continues. . . . Until talent decides to break it.

I have looked long and hard at how photographers break cycles. Rarely does it just magically happen. Contrary to popular thought, there is no huge burst of energy that comes along, lifts you up, and magically places you in a different mindset. More often than not, a series of small steps you put into place alter your way of thinking. The actions you take may be

tiny, but over time, due to your consistent attention, you will experience attitude shifts and a newfound sense of energy and purpose. But it all starts by taking the first step.

SELF-INVENTORY

Knowing where and how to begin is hard, and often photographers get stuck trying to get unstuck. Assuming that your block is business related and that you are truly invested in avoiding an initial inertia block, I suggest that you take an inventory of all of your current business tools.

Look at the existing visual images in your portfolio and on your Web site.

Do they represent where you have been or where you want to go? Do your photographs represent client assignments, which have little to do with your visual interests and direction? Or are they images that you love and created during testing opportunities? In short, make sure that the visual message that you are sending out serves your creative as well as your financial goals.

Next, take a look at your sales and marketing program. Does one exist? What tools have you already developed and what tools need to be created? Take an inventory of where you are and be prepared to develop the tools that you need to complete your program, now.

Finally, check out your financial picture. Do you understand how to read a profit and loss sheet? Do you have one?

Do you know where current sales are compared to last year?

Are your sales figures high or low?

Look at your expenses. Are they stabilized? Or have you been overspending? Where is your money going? Have you been purchasing new equipment or have you been investing in your marketing program?

Have you been able to keep your commitment to saving funds for the future?

Does that commitment even exist?

Do *not* avoid this step because you think you will get depressed by seeing how much you have not created or how much you have to do! Be kind to yourself. Remind yourself that wherever you are, however much you need to do, it's OK. It's all OK, because that's

where you are. If you find yourself getting uncomfortable during the review, use the feeling. Be present and tell yourself that you are feeling uncomfortable because you deserve to be successful and currently your program will not enable you to achieve the success you deserve. Remind yourself that the review process is your first effort toward turning the energy around; be happy that you have chosen to proactively create success. Thank yourself for acting on your desire to succeed and then begin the review.

As you begin your inventory, start by analyzing your sales and marketing program. Remember that a healthy sales and marketing program has the following components.

- A vision-based portfolio created and ready to rock
- A database of targeted leads for your target markets
- A minimum of nine direct mail pieces ready to be sent in the next twelve months
- Twelve e-mailers ready to be sent
- A Web site that is visually branded to the portfolio and listed on at least two to three Web directories

After you have compared your tools to the list above, determine your starting point. A vision-based portfolio is listed first, as I believe that this tool is central to every sales and marketing program. The images in your portfolio are your product. The book is what clients will eventually call in and is, more often than not, the final determining factor when assignments are imminent. Web sites are great marketing tools. Do not fall into the trap of feeling that your Web site will replace your portfolio. While some clients do buy from Web sites, the majority of buyers are still portfolio based.

BREAKING IT DOWN

Building a new portfolio can seem overwhelming to photographers, reason enough not to begin the process at all. In order to avoid getting stuck, choose to break the goal of building a new book into objectives and tasks.

Each objective is a step along the way toward accomplishing your goal. Each objective is made up of a series of smaller

tasks. As each task is accomplished you move further toward meeting the objective. As you complete each objective you move closer to your goal. Progress is measured as you finish tasks and complete objectives. The overall goal is no longer huge and illusive. It now becomes real, clear, and manageable. Let's continue to use the portfolio build as an example of how this works.

Goal 1: Build a vision-based portfolio.

Objective 1: Define visual integrity.

Tasks 1 and 2: Complete the exercises below to define your vision.

(The tasks listed below can be done one per day or per week. The key is to go at your own pace, but to keep going.)

Task 1

- View some of your favorite magazines, catalogs, annual reports, or any other print medium of choice.
- Choose no more than ten tears (editorial or ads) that represent work that you would have killed to have done.
- Lay out the tears and begin to describe the work.
- Look for consistencies in the words you used to describe the visuals. Make a list of the words that are repeated. For instance, moody, bold, humorous, elegant, evocative, contemporary, hip, romantic, people as props, object shot as designing pieces. *Write them down!*
- List the tools used in each (selective focus, people as props, digital techniques, light as a texturing tool, vivid color, and so forth). Make a list of the tools that are repeated. *Write them down!*
- Look at the type of work you chose. Was it editorial in nature or did you choose ads? Did you go to annual reports to draw inspiration or did you choose catalogs as samples?

Your choice of examples gives you a strong indication of which market you are interested in servicing. *Write them down!*

Task 2

- View five of your favorite images that you have created.
- Begin to use words to describe them (see above).

196

- Look for the consistencies in the descriptions. *Write them down!*
- List the tools you consistently used in the shots you chose. *Write them down!*

Now pull it all together. Using all the lists you created of words that describe the work you love and the tools you respond to and use, begin to write three or four sentences that describe the portfolio you will create.

An example for you: "I am a photographer who will photograph people and objects. My people will be photographed as props. My products will be seen as objects of design. Graphic composition, color, and motion will be the main tools I utilize to create images that sell in the advertising industry."

If you follow the advice and go through the steps listed above, you will have accomplished the first objective in building a new portfolio. You will have created your positioning statement, that is, the message that your portfolio must convey. The most important point is that you have completed this objective by creating tasks and completing them in a time period that you chose.

This example can be utilized whenever you have a major or minor goal to accomplish. If your inventory process found you in need of new visuals, a new portfolio, a Web site, or a marketing program, choose not to get blocked.

Perhaps your sales and marketing program is in order but your knowledge of your finances is lacking. Simply apply the same steps highlighted above. Sit yourself down and list your initial goal. Determine the objectives that you need to meet in order to reach your goal. List the tasks associated with each objective and give each a timeline. Then get going.

There are several ways to show up in your business, in your life, on a daily basis. Choosing to systematically move through steps that will help you to meet your goals is one of the most powerful, productive ways I know to avoid blocks while showing up. So put down this book and begin your inventory . . . now. Lunch can wait!

CHAPTER 33
SHOW UP

On a national photographers' listserv, a question was posed to a panel of experts. The question was, "How does a photographer attract his targeted audience?" While many panelists came back with typical responses like "send monthly e-mailers" and "build a kick-butt Web site," my answer was simply, "*Show up!*"

These two little words carry lots of power behind them.

For me, "showing up" means that you are present to your business, moment to moment. You accept the responsibility for your success and you work toward that goal on a daily basis.

"Showing up" is not a typical scenario for talent; in fact, it's not too far off the mark to state that most creatives wait until the phones stop ringing and the jobs stop coming in before they begin to realize that they are disconnected from their business in one way or in several ways. Waking up at this point can indeed be a rude awakening.

MONEY AVOIDANCE

While there are many opportunities to show up in your business, there is one word that sums up the area that most creatives still seem to avoid ... *money.*

I believe that if you were to poll photographers working in our industry today, you would find that many do not understand how to build a business that has a sound financial base,

and few have the pecuniary knowledge that is necessary when seeking to develop a profitable entity.

For some photographers financial avoidance may be limited to not developing a marketing budget or to caving during the negotiating process. If you dig deeper, you would hear other stories, tales about not invoicing for weeks after a shoot's completion, never licensing images, still charging day rates, giving clients all rights because it's "easier that way," and not working with an accountant "except for my taxes." You would ultimately conclude that "showing up financially" is not a natural occurrence for most photographers.

Why do photographers seem to have avoidance issues when it comes to money? Perhaps many are stuck in the old paradigm that "photographers don't need to worry about business because they are artists." It's ok to starve because "after all that's what artists do."

No, it's not. Artists don't need to starve. They can be and indeed are successful. It's time to stop all of the money avoidance, *now*.

It's a whole new world, has been for quite a while now, and today's paradigm demands that photographers show up, flex their business muscle, and begin to pay as much attention to their bottom line as they pay to the latest piece of hot new technology.

Building a lucrative business is not impossible in the world of commercial photography. In fact, there are many formulas for being financially successful, and none of them are mysteries. Why then does financial success elude so many?

ESCAPING A WORLD OF LACK

I would propose it is because scores of photographers live in poverty consciousness; they live in a world of lack.

This is a condition that I understand well, as it is where I began my journey thirty years ago.

When I was in the very early stages of my consulting business I knew nothing about the financial end of running a business. I was twenty-one, recently divorced, had a $20,000 debt (from a two-week hospital stay with no insurance), and had absolutely no

savings. Yet I was committed to starting a new business, one that did not exist anywhere, which meant that I had no model to follow. I knew I needed financial help, so I sought counsel from the small business development office. (The SBA is a government service that provides small businesses of all types with free marketing and financial advice.)

On my first visit with my new business consultant, I quickly realized that my counselor had absolutely no knowledge of the photography business, let alone any understanding of what I did as a consultant to photographers.

I immediately thought that I had made a huge mistake in seeking her advice and I was ready to hotfoot it out the door until she began to share her true expertise with me.

She showed me how to read a balance sheet and kindly hid her shock when I expressed little interest in developing a profit margin, explaining to her that all that mattered to me was that I loved what I did for a living and that I wanted to be of help to people. It was at this point that this woman, who knew nothing about my business, gave me the best advice that I had ever, up to that point, received.

She was very clear as she told me: "Selina, it's great that you love what you do. I am happy that you get fulfilled from consulting, but as a *businessperson*, your job, truly your only job, is to create a profitable business. Never forget that there is only one reason to have a business. The purpose in having a business is to make money."

The idea made me shudder. Immediately I found her words objectionable and I found myself starting to tune her out. As I proceeded to shut down, a voice inside my being shouted at me: "Pay attention!"

I did and her advice was ultimately a turning point for me.

I began to see that I could love what I did and still make money. One was not exclusive of the other. Making money was not only OK, it was what I was supposed to do. It was as if she had given me the permission that I could not give myself.

A short time later I began to examine why I had such a negative reaction to her words. I started to look at why I initially had an adverse reaction to the concept that I was supposed to be focused on making money. Was I scared of success? Had I just never thought about money as a goal? Was I holding onto some

outmoded idea that you can't love what you do and make money too? Was I afraid of success? Did I believe that people with money were not as good as people without money?

I realized that I was thinking all of these thoughts, and it took many more years before I realized that these beliefs spoke to the lack that I clearly was connected to.

UNDERSTANDING POVERTY CONSCIOUSNESS

I share this story with you, as I believe that many of the photographers who do not pay attention to the financial aspect of their business are grounded, as I was, in poverty consciousness.

Poverty consciousness is a term that speaks to a person's relationship with money. It does not refer to the amount of money they have or their potential for earning. Living in lack comes from a system of beliefs that you have around trust and control and a connection (usually unconscious) to continuing a pattern of negative thoughts.

You might be saying at this point, "I don't have poverty consciousness, I just never make enough money." Or maybe your justification is "I never learned about managing money in photo school," or perhaps you are telling yourself, "I have no money because my clients never have enough money for projects."

All of these are simply situations. How you choose to respond to them represents whether or not you live in lack. In order to see if poverty consciousness is an active block in your life, consider the following statements.

- I spend more money than I have.
- I often give expensive gifts to others that I can't afford.
- I spend money faster than I earn it.
- I buy things impulsively.
- I have no savings for myself, or my kids' education, or for emergencies.
- I never have enough money.
- I never have enough time.
- The world is so expensive.

- My clients never pay me enough money.
- Photography is no longer a profitable way to earn a living.

People living in poverty consciousness "never have enough," and the words "I don't have" in relation to time or money or *anything* is the main reason why people live in lack. Negative thought patterns create the position of lack, and repeating the words that mirror thoughts of negative beliefs and opinions keep the thoughts locked in place.

It's not the photo schools, organizations, your clients, or the world that has created your poverty consciousness. It is you. That's the great news. Changing the world is tough, but changing you is doable. Your job is to have the courage to show up, check out whether this issue is keeping you from achieving financial abundance, and if it is, begin to change your thinking.

If you find that you are indeed living in lack, "showing up" here looks like creating affirmations that you repeat daily (see "Affirmations: Your New Marketing Tool" on page 188) or getting help from an expert, teacher, or coach whose job it is to help you shift your thoughts.

Not everyone who chooses not to pay attention to his or her finances is in lack. New photographers often neglect to set financial goals and may be reluctant to discuss money issues with clients. In addition, there are experienced shooters who have never taken the time to take themselves and their business seriously.

If you are starting a new business or have an existing business that is suffering from financial inattention, change that now.

HOW TO PRICE YOUR SERVICES

Price your services intelligently. Take a poll among the shooters you know and see how their fees are structured. Most professionals charge clients based on an individual project rate basis.

I advise my clients to consider the following formula when determining the project rate for a specific assignment.

Base rate × number of days for shoot + licensing
= project rate

Here's how it works.

Determine your base rate by looking at your overhead costs and your experience as a photographer, then set a fee that is the least you would charge for your shooting per day. This fee becomes your *base rate*.

(Yes, this could be your old day rate.)

When a client calls with a potential assignment, get all the details. Determine how many days you will need to shoot and find out what the usage for the photos will be. Your client's licensing needs are based on where the photos will appear and how long the client wishes to use them in that medium.

When creating a project rate for the assignment, simply take your base rate and multiply it by the number of days for the shoot and add the licensing fee to get the total project rate.

Determining appropriate licensing fees is the difficult part of the process. Programs like Photoquote, blinkbid, information from stock agents, and just plain experience at quoting usage fees will help you here. In addition, you may want to work with an experienced photographer or a consultant who can teach you about building licensing fees into your project rate.

You will also need to pay as much attention to setting up your books as you put toward developing a body of work. Always know where you stand financially.

Consider building a *relationship* with an accountant, making sure that you understand the steps that you need to take to set up accounting systems, and have your financial advisor teach you how to read balance sheets. Review your balance sheets weekly and monthly. Understand where your break-even point is and know what type of profit margin you are aiming for.

These are some of the many steps you must take in order to "show up" monetarily for your business. Whether you are new or just fiscally challenged, there is no time like the present to become "financially literate."

If you are reading this and are a new or seasoned photographer and you find yourself resisting or wanting to put this essay

down, don't. Go back to the beginning and check out the questions that relate to lack. If you recognize at least three of them as statements that you have recently made, assume you are living in lack. Show up and begin the work to place yourself in abundance. For abundance is your true state, the place you deserve to be. If you need any further enticement to do the work and build trust with yourself, please remember this. When you ask clients to hire you, you are asking them to trust you. You are telling them *I am reliable*. I will show up. But if you are not showing up in your business, why would you ask your clients to trust that you will show up in theirs?

CHAPTER 34

FEAR

When was the last time you showed a prospect your portfolio? How long has it been since you promised yourself that you would update your Web site? Have you wanted to create new images for your portfolio but never seem to get around to beginning the process? If you find yourself answering yes, you probably think you are suffering from procrastination, but Ralph Hubbard would tell you that your actions are rooted in fear.

Ralph is a life coach and cofounder of A World Without Fear Foundation. It is Hubbard's belief that fear is the core reason why many of us fail to take action in our lives. He believes it is why we do not experience peace and happiness.

"Fear can be defined as simply not being at peace," he states. "Not feeling peace may look like guilt, anger, depression, or you might feel upset and anxious. Sometimes a person is lethargic and is just not engaging in anything. All are symptoms of fear."

He goes on to add, "While most people recognize fear more easily as the *fear of success or fear of failure*, what is often missed are everyday expressions of fear."

How might fear show up for a photographer? Hubbard believes that being reluctant to try a new creative approach, not shooting for yourself or for your portfolio, not selling and marketing when your business needs attention, are all daily signs of you in fear mode. He is convinced that photographers don't identify fear as the motivating cause of their inactivity and thus cannot correct their situation effectively.

Most people think that their inactivity is due to laziness or depression. While depression is an issue that some folks face, most inactivity is due to fear. On some unconscious level we experience blocks and beliefs that hold us back. These blocks are rooted in fear.

Perhaps a photographer is not selling. He wants business, but can't get himself motivated to make phone calls, show his work, or perform the many tasks it takes to sell his work.

With the opportunity to examine his beliefs, I guarantee you that we would find a fear thought that he holds that is blocking him.

What might be blocking you? Take a brief inventory now and create a short list of objectives that you have set for yourself. Look at the list and honestly note how many you have yet to start. Choose one, possibly something that you really want to do but never seem to "find the time" because there is always "something that comes up that is more important." Ralph is convinced that unconscious thoughts (which enable fear to rear its ugly head) prevent you from keeping your commitments to yourself. He tells us that discovering how your unconscious thoughts work is a key to releasing fear. He believes that not keeping commitments to ourselves is one of the most common examples of unconscious thought. And he explains how insidious it is.

"Many people don't keep commitments to themselves because they get stuck in past disappointment. This disappointment is self-created, yet few people realize that it exists." Let see how this pattern is created. Ralph continues:

When we promise ourselves that we will do something, initially there is a reason that matters to us. We have motivation. If you feel the need to exercise, your motivation may be that you want to look or feel fit. Your interest in looking and feeling better provides the juice that sets the commitment. When you don't go, when you find other things to do, you most likely don't say, "Gee, I've chosen something else to do today and I'm fine with that." Most likely you say, "Once again I didn't

206

go to the gym. Why am I always doing this? I always let myself down." Your reaction, your self-judgment happens quickly. These words set you up for disappointment, and before you know it (unconsciously) you have set up a pattern where you begin to equate going to the gym with disappointment. The motivation is gone and now you feel obligation in its place.

Each time you tell yourself that you *should* go to the gym, you feel stuck and not motivated to go. After all, who wants to get the gym when it feels like one big obligation?

The tricky part of all of this is that all of this happens so quickly. You don't see the negative judgment or disappointment coming, but its effects are experienced each time you try to keep you recommitment.

THE FOUR STEPS TO OVERCOMING FEAR

Repeated over time, unconscious thoughts generate fear, and this is what Hubbard wants to help you lose. In order to begin to rid yourself of your fears, Hubbard suggests you consider using his four-step program. The process he created has helped many people in all walks of life rid themselves of the fears that are impacting their lives.

Step 1: Identify the fear. Discover the link between your lack of peace and a specific fear.

Step 2: Look at your fear and name it. Fear of rejection, fear of failure, fear of success, fear of loss of control.

Step 3: Locate the beliefs you chose that hold the fear in place. Sometimes the beliefs *seem* justifiable but upon examination they are unrealistic.

Step 4: Give up your judgments (beliefs) in favor of peace. Actually ask yourself: Do I choose to hold onto the belief that causes the fear or do I choose peace?

Sound simple? Let's see how Hubbard's steps might apply to a photographer.

Imagine you are a photographer whose business clearly needs a sales program. You are not very busy and you have the time to create and begin to facilitate a program, but you just can't seem to start.

Step 1
Hubbard would ask you to identify how you feel about not getting your book out. Are you anxious or mad at yourself, are you feeling guilty?

Any or all of these feelings are fear-based reactions.

Step 2
Identifying the fear is next. Why are you not taking the book out? Are you worried about negative reactions? Are you afraid of rejection?

Step 3
Locate the beliefs that hold this fear in place.

A fear of rejection might be rooted in the belief that what others say about you is true. Or you believe that you are supposed to be perfect . . . or perhaps you believe that everyone is supposed to love your work.

Hubbard feels that most beliefs we hold are impossible standards that no one can live up to. For example, it would be ridiculous to believe that everyone will like or need your photography.

However, many people hold these unexamined beliefs and never realize that they even have them, let alone realize that they are at the core of their dysfunction. "When beliefs are looked at and examined, one can see them for what they truly are. It becomes clear then that the belief is not valid," Hubbard states.

Step 4
Choose the belief or peace. After seeing the belief for what it is, an unrealistic demand on yourself, you are able to give up the belief that "everyone should love your work." You will be able to show your portfolio without expectation, and be in peace.

It all sounds so simple. Hubbard is convinced. "As you identify the belief that *everybody should love your work*, you are able to

see how unrealistic that belief is. A new truth surfaces and you are able to see the reality that what you believed is false. You are now able to recognize that you have chosen the belief that has caused the fear. You can now choose to give it up in favor of no belief (no expectation about how people will react to your work). This is choosing peace."

Many of us have lots of fear stemming from a variety of false beliefs. Acknowledging and identifying them and then letting go of the beliefs (usually false) connected to them is quite beneficial.

FREEDOM FROM FEAR

Of the many gifts you can expect, Hubbard explains how freedom emerges:

> When releasing any kind of fear, freedom is one of the main benefits. Without fear of rejection you would be free to take your work out to prospects without worrying about their reaction. You would simply see portfolio presentations and all other sales tools as a necessary part of selling your work. Your attachment to any expectations would be gone. Freedom can also look like feeling free to create new images, developing a new photographic style. You are free to explore your creativity without worrying about others' expectations or opinions.

As you have chosen the freedom of running your own business, isn't it time to truly experience freedom by giving up your fears?

CHAPTER 35

PHOTOGRAPHERS ON FAITH

Leap and the net will appear.

—JULIA CAMERON

I think its safe to say that faith or lack of it is a key component in almost every photo business. However, what it looks like, the role it plays, the place it lands, the time it surfaces, and how it manifests is different for each shooter.

First off, let me be clear. Faith as discussed here has absolutely nothing to do with religion. What it has everything to do with is a trust that you are able to hold onto even when there is no evidence to support your conviction. Our business in one where sometimes trust is all you have.

Trust, as a rule, does not apply to only selected areas in your life. It's either there or its not. You either have faith or you don't.

You can't be in a state of trust when it comes to business matters and have a lack of trust in your personal affairs. Your values as they appear in your personal life will most likely mirror those you exhibit in your business world. Your choices will represent your values, and the tools you use as you move forward in your daily business mode, while different in their specific manifestation, will be similar in their content. Thus, your ability and willingness to trust, to have faith, will be of benefit to you in all areas of your life.

Faith is indeed a tool that is present in every successful photography business that I have had the pleasure to witness at close range, and lack of it has resulted in tragic outcomes.

For that reason I propose that you take your own faith inventory.

The dictionary definition of faith?

"Belief in, devotion to, or trust in somebody or something especially without logical proof."

In my experience as a consultant there are many times when faith as described here is the only thing that has kept a client going. In fact, in the midsection of every newly launched career or marketing plan, faith may indeed be the only constant present.

At this juncture talent has spent much time, energy, and money developing their visual product and the tools that will sell their service to the public. They have invested much time in putting their message out to the market, but the calls have yet to come in. The reality is that while in their world they have spent much time focusing on getting out their vision to buyers, prospects have not had enough exposure to them or time to need their services. All the photographer sees is that their phone is not ringing and the bids are not being requested. This is historically the time that talent starts to freak, and this is the time that I suggest you hold your faith close to your being.

For others, a major shift in the market or a life-threatening situation can appear and demand that faith be nearby. For many, however, it is simply the day-to-day commitment to one's business that begs the need for faith.

"To be self-employed, working in the creative fields, you have to be a person of faith," states photographer Zave Smith. "To survive and thrive against the odds, and almost everybody who works in creativity is working against the odds, you have to believe in your work and you have to have faith that through hard work you can achieve your dreams."

Zave's point is a good one, for many times during your career you will need to have the faith that your work will sell, that you will build a business that can support you and your family. Taking on the responsibility for starting and then growing a photography business requires you to constantly build something that did not previously exist. What is it that enables someone to build

something new, something that is different? Talent and drive for sure, but the glue that holds it all together, the gas that keeps it going, is the belief that what is being created will eventually serve an intended purpose. It is the conviction that what is being developed will ultimately meet the goal of its creator. This belief, this conviction with no evidence behind it, is faith.

Whether you are currently focused on developing a new business, repositioning your talent, or seeking a different visual direction, during the process of taking the steps needed to achieve your goal, you will need to hold onto the belief that you will be successful.

In the beginning of any endeavor this is easy. You are excited and the newness of everything propels you forward. But over time as the novelty wears off and you hit a few roadblocks, your commitment may begin to crumble. You may find yourself less motivated to accomplish tasks that just a few months ago were easy to complete. You may even see yourself making excuses for not doing the simple tasks that you need to perform in order to continue the trek. It is at this juncture that you need to call in some help. In order to get your momentum moving you will need to call on a power greater than your intellect or your guilt. You need something that is bigger than you. Something that will help you to move forward even when you are weary and tired and wondering how this is all going to work. The team player you need is your faith. It is the single quality that will enable you to move forward.

Consultant Leslie Burns cites faith as the reason that she has chosen to be of help to photographers.

"Faith is a very significant part of why I do what I do," Burns says. She explains the role of faith:

> I feel compelled to help people. I want to help others who are struggling to see, to be successful. Sometimes that means, quite literally, telling clients to have faith in themselves, in their gifts, and in their clients.
>
> It's easy to believe that business has to be something hard and competitive—we see that image in the media often—but I try to show my clients that not only is that not necessarily the case, but that often the more successful businesses outright reject a negative point of

view. They have faith in themselves and market themselves positively to share that with their potential customers. They have to have the faith that the right clients will "get it" and buy from them. It works.

Leslie's words speak to the point that faith is an everyday tool used in a variety of ways. Others, who may not normally call upon their faith continually, still rely on it for occasional guidance.

Ken Gehle, an Atlanta-based photographer, considers it a huge asset.

Faith is probably the most important ingredient that a photographer will need in their career. While it is not something that I call on everyday, there are times when I call upon my faith—to guide, to reassure, to confirm that the choices I am making are the correct ones. Faith is more than a gut feeling; it is a powerful energy that I bring from deep within myself that gives me the power to push forward.

Michael Furman, one of the country's most celebrated photographers, knows what it's like to need faith and have none.

A while back he transitioned through a very difficult period in his life, and he credits his faith in himself as his guiding light.

Without faith, there is no hope. Being in a hopeless state is devastating. Unfortunately, I know from personal experience. I have never experienced such an awful feeling. But, that was a lot of years ago, and I don't intend to go back to that ugly place. I have learned to rely on my faith in myself when going through difficult times. Faith gives me strength. When I am strong, then I feel I can help others. And when people have faith in me, that just makes me stronger.

Often the experience of trusting yourself, of holding your faith, as Michael mentioned, does help you to have faith in others. Being in trust is an important place to be. Often in our business we work in a team atmosphere where trust needs to be an everyday component. After all, you need to believe that your assistants

will support you during a shoot, that your stylist will show up with the right props, that the models will give you the look you want, that your clients will pay you, and that the mailman will deliver the check. But having faith in others begins with having faith in yourself.

"For me, when I have faith in myself, I am then better able to accept faith in others," says Furman. "I guess I feel that it is inappropriate to ask for support from others until you are willing to support yourself."

Often the support, the faith we seek, is not in response to daily tasks but is a reaction to an extreme situation or life-changing scenario.

For photographer Paula Lerner, faith came calling in what seemed like a royal twist of fate. A very successful editorial photographer, Lerner is one of the founders of EP, the editorial photography organization that has given a powerful voice to editorial shooters nationwide. It was during the onset of a very personal photography project that Paula was introduced to the power of faith. In her words, "It changed my life." She shares her story with us.

It's coming up on two years since I was asked to collaborate on a book about breast cancer walks and the people who participate in them. Many walkers are either survivors themselves or have a loved one that is, or have some other personal reason for making the commitment to walk. As my mother and stepmother are both breast cancer survivors, I had my own personal reasons for wanting to take this project on.

I began shooting the book in the spring of 2004, working together with editor Deb Murphy. I was moved and inspired by the people we encountered and their stories. So many of them had faced so much adversity, and yet they were still reaching out to help others.

A month into the project I went in for a routine mammogram. It came back "suspicious." After another month and a surgical biopsy, I myself was diagnosed with breast cancer. Nothing can prepare you to hear the words, "You have cancer." Life just turns upside down.

The following months were a whirlwind of doctor's appointments, procedures, and tough decisions. I was lucky: I was diagnosed early, and as a result I escaped chemotherapy and radiation, although I did endure several surgeries (one was seven hours long), a lengthy hospital stay, and three months of post-op recuperation. I am fortunate that my prognosis is good. I managed to finish shooting most of the breast cancer walk book before my treatment schedule caught up with me, and needless to say the experience of being diagnosed in the middle of it made the whole project more up close and personal than I ever imagined it would be.

Here is the part that was so amazing to me. After my diagnosis and while I was ill, I was astonished at the community of people that materialized to offer support. If I were to add up everyone that was there for me in one way or another, whether it was making meals, chauffeuring me or my kids around when I couldn't drive, sending flowers, cards, e-mails, humorous books to lift my spirits—the total number would be at least a couple of hundred if not more. I was honored and humbled that so many people came from every corner of my life to be there for me. I have never been on the receiving end of that much goodwill and care before. Seeing that renewed my faith in humanity, and reminded me that we as human beings do indeed have a profound capacity for selfless and generous behavior. My restored faith in humanity changed my life.

Faith is indeed the tool that empowers. The lack of it, however, can be devastating. Throughout my thirty-year career only a few times have I witnessed businesses that I knew I could never help. These were studios that were floundering because the photographers at the helm of the business had so little faith that their view of life was completely negative. Much as I tried to advise, console, and guide, it was clear that there was nothing that I could do from a consulting or marketing perspective to help these folks. Their grounding in negativity was so pervasive that ultimately they could see nothing but the dark. In time each of these businesses indeed failed, with their leaders blaming the

market, the economy, and everyone else, owning absolutely no responsibility.

I found this quite maddening. I wanted to shake them when they refused to listen and would not accept any concept of faith. When I realized that they were not at all open to my ministering to them, I thought that if I held their faith for them it would help.

But it did not. I have realized that each of us must come into our own understanding of faith. We must decide for ourselves what it looks like, what it feels like, and what part it will play in our lives.

We all have our own path.

For me, faith is ever present. I actively work to bring faith into my life and I send thanks to the universe daily for the gifts it brings to my door. The sense of gratitude that I carry is a constant reminder to me that my faith is close by.

And you? What part does faith play in your life? Is it a brief visitor or a constant companion? If your answer is not yet known to you, begin now to explore the depths of your being. My wish for you is that that you notice an unknown partner, one that is waiting to be discovered in order to come alive and walk beside you in grace.

WEB SITES

Nicole Anderson: http://nabookarts.com

Karineh Gurjian-Angelo: http://karinehnyc.com

Jake Armour: www.armourphoto.com

Laura Bonicelli: http://bonicelliassociates.com

Jason Brown: www.lost-luggage.com

Leslie Burns: www.burnsautoparts.com

Jean Burnstine: http://blackbook.com

Michael Furman: http://michaelfurman.com

Ken Gehle: www.kengehle.com

Michael Grecco: http://michaelgrecco.com

Marc Hauser: http://marchauserphoto.com

Jonathan Hillyer: http://hillyerphoto.com

Charles Imstepf: http://imstepf.com

Michael Indresano: www.indresano.com

Eric Kaas: http://funnel.tv

Robert Kent: www.robertkentphoto.com

Ira Kerns: http://irakerns.com

Paula Lerner: http://lernerphoto.com

Ralph Mennemeyer: http://mrepresents.com

Lise Metzger: www.lisemetzger.com

Scott Mullenberg: http://mullenbergdesigns.com

John Myers: http://johnmyersphoto.com

Frederic Neema: www.fnphoto.com

Quitze Nelson: http://quitzenelson.com

Marc Norberg: www.marcnorberg.com

Simon Plant: www.plantphoto.com

Ted Rice: www.tedrice.com

Lou Roole: www.louroolephotography.com

John Sharpe: www.sharpeonline.com

Stephen Sherman: www.shermanphoto.com

Patti Silverstein: www.pattisilverstein.com

Zave Smith: www.zavesmith.com

David Stewart: www.dhstewart.com

Ian Summers: http://heartstorming.com

Ed White: http://edwhitephotographics.com

INDEX

A

Abbott, Berenice, quote from, vii
Adler, Beverly
 print books and, 110
 stock photography and, 59
 unique vision and, 12
 vision and, 58
 Web sites and, 127
affirmation
 inspiration and, 191
 your wish list and, 189–191
agents
 asking questions and, 78
 brokering successful relationships
 and, 85–87
 building a good business
 "marriage" and, 82–83
 commissions and, 70
 contacting agents and, 81–82
 fine arts photo rep and, 87–90
 new breed of, 84–90
 realities of representation
 and, 77–83
 "rep material" and, 70
 success and, 130
Angelo, Karineh Gurjian, book
 building and, 116
Arbus, Diane, *Rolling Stone* and, ix
Aresu, Paul, approach of, 85–86
Armour, Hope, 96
Armour, Jack, Team Armour
 and, 96–100
Armour, Jake
 record billings and, 184
 steps for success and, 185–187
art buyers, keeping files on
 talent and, 19
assignment photography, marketing
 and, 131–132

B

Bach, Richard, *Illusions* and, 143
Beckwith, Harry, *Selling the Invisible*
 and, 142

Bernhard, Ruth, quote from, 181
Boland, Michael, *The Secret* and, 191
Bonicelli, Laura
 affirmation and, 190
 contacts and, 134
 "face time" and, 133
 reading list and, 142
branding identity, 59–60
 corporate branding and, 57
Burns-Dell'Acqua, Leslie
 faith and, 212
 licensing model and, 8
Burnstine, Jean, pull clients and, 130
business development
 balancing priorities and, 4
 being a client and, 19
 changes in today's business
 and, xi, xii
 creating your positioning statement
 and, 20–21
 defining your visual values
 and, 16–21
 do you have a product to sell?, 10–15
 "Dream Bio" and, 5–7
 escaping world of lack
 and, 199–201
 holistic perspective and, vii
 honoring yourself financially
 and, 8–9
 money avoidance and, 198–199
 new photo buyer and, 11–12
 pricing and quoting assignments
 and, 27–28
 pricing your services and, 202–204
 service component and, 22–29
 "showing up" and, 198–204
 success or failure and, 30–33
 surviving during difficult times and,
 183–187
 understanding poverty conscious-
 ness and, 201–202
 unique vision and, 12–15
 values shaping relationships and, 7
 your values and, 3–10

buying patterns
following the fad and, 104–105
habit or trend?, 103–109
stock options and business changes,
105–108

C
Cameron, Julia
affirmations and, 191
The Artist's Way and, 141, 147
quote from, 210
Chiqua, Sonia, *Your Heart's Desire*
and, 142
Chopra, Deepak
affirmations and, 189
choices and, 64
Chu, Chin Ning, *Do Less, Achieve
More* and, 143
clustering, creative exercise and, 157
consultants
finding and, 92–94
objective help from, 91–95
outline needs for, 94–95
questions for, 75
realities of representation
and, 77–83
services provided and, 74
corporate branding,
overview of, 57
creative blocks, working through
and, 153–158

D
Dalager, Kat, vision-based portfolios
and, 44
divinity
beginning the journey and,
147–150
channeling creativity
and, 146–147
photography and, 145–150
"Dream Bio", 5–7
drop books, self-promotion and,
138–140

E
e-mail
marketing program
and, 129–130
self-promotion and, 129

F
face time, overview of, 167–169
fads
following the fad and, 104–105
staying ahead of the curve
and, 108–109
faith
building new portfolios and,
195–197
escaping world of lack and, 199–201
fear of portfolio presentation
and, 205–209
four steps to overcoming
fear, 207–209
inspiration and, 191
money avoidance and, 198–199
new marketing tools and, 188–192
photographers on, 210–216
pricing your services
and, 202–204
self-inventory and, 194–195
"showing up" and, 198–204
steps for success and, 185–187
surviving during difficult times
and, 183–187
teaming up with the universe
and, 192
understanding poverty
consciousness and, 201–202
walking your talk and, 193–197
your wish list and, 189–191
fear
four steps to overcoming,
207–209
freedom from fear and, 209
fees, realities of representation
and, 77
Frank, Karen, seeing photographers
and, 127
Furman, Michael, faith and, 213

G
Gehle, Ken
faith and, 213
marketing assistants and, 72
Gelb, Michael, *How to Think Like
Leonardo Da Vinci* and, 144
Gish, Ellen, portfolios and, 15
Gladwell, Malcolm, *The Tipping
Point* and, 143

goals
 articulating clear goals and, 37–39
 creative goals and, 38
 financial goals and, 38–39
 goal inventory and, 39
 professional goals and, 38
Grant, Nancy, visual expertise and, 43
Grecco, Michael, agents and, 71
Grigg, Ray, *The Tao of Being* and, 143

H
Harvey, Millicent, "vision quest"
 and, 53–56
Hauser, Marc, reading list and, 142
Heartstorming, creative exercise
 and, 155–158
Hillyer, Jonathan
 online portfolio and, 119
 Web gallery and, 120
Holmes, Ernest, *Creative Ideas*
 author, 191
Hubbard, Ralph
 A World Without Fear
 Foundation, 205
 fear and, 205–209

I
I Am. . . , creative exercise
 and, 157–158
I Want, creative exercise and, 158
Imstepf, Charles
 choosing a visual direction
 and, 121–122
 constancy in vision and, 120
Indresano, Michael, commitment to
 service and, 22–23

J
Johnson, Tom, success story
 and, 172–175
Jones, Aaron, light-painting
 techniques and, 104
Jones, Grace, portrait of, 159

K
Kass, Eric, e-mail and, 129
Kegler, Alan, Metzger design team
 and, 165
Kendall, Nikki, Kent's visual approach
 and, 17

Kent, Robert, visual approach of, 17
Kerns, Ira, matching client's specific
 needs and, 46

L
Laidlaw, Tom, postproduction process
 and, 23
Leibovitz, Annie, early work of, ix
Leonian, Edith, law and, 27–28
Lerner, Paula, faith and, 214
licensing system, honoring yourself
 financially and, 8
listening, values and, 28–29

M
Maitreya, Selina
 changes in today's business
 and, xi, xii
 personal journey of, ix, x, xi
marketing
 assignment photography
 and, 131–132
 multilevel marketing plan
 and, 170–171
 new marketing tools and, 188–192
 pricing your services and, 202–204
 walking your talk and, 193–197
marketing assistants
 duties of, 73
 realities of representation
 and, 77–83
May, Billy, inspiration and, 191
McDonald, Michael, graphic designer
 and, 177–178
Mennemeyer, Ralph
 agents and, 79
 client's take on vision and, 58
 requests for services and, 81
Metzger, Lise, art of, 163–166
Monahan, Tom, *The Do It Yourself
 Lobotomy* and, 144
money avoidance, business
 development and, 198–199
Mullenberg, Scott
 custom portfolios and, 116
 handmade books and, 115
Murphy, Joe, Metzger design team
 and, 165
Myers, John, gift of choice
 and, 63

N
Neema, Frederic, portfolios and, 115
Nelson, Quitze
 personal touch and, 87
 Q.ink agent, 85
Newman, Arnold, quote from, 67
Norberg, Marc, evocative
 portraits of, 21

O
online body of work, 118–121
online portfolios
 choosing a visual direction
 and, 121–123
 integrating your vision on your site
 and, 123–124

P
Parrish, John, niche audience of, 86
PDN
 magazine for commercial
 photographers, 80
 Metzger Web site, 165
persistence
 a success story and, 172–175
 art of Lise Metzger and, 163–166
 creative blocks and, 153–158
 Lou Roole style and, 159–162
 multilevel marketing plan
 and, 170–171
 Sherman sells and, 167–171
 Tom Johnson story and, 172–175
 Zave Smith's consistent message
 and, 176–180
personal goals, articulating clear goals
 and, 37–39
Peters, Chris
 "face time" and, 134
 having clean print book and, 139
Plant, Simon, reading list and, 142
portfolios
 adding portfolios and, 47
 building new portfolios and, 48–52,
 195–197
 common questions for, 14
 custom portfolios and, 116
 developing vision-based portfolios
 and, 43–47
 drop portfolios and, 169
 fear of presentation
 and, 205–209

online body of work and, 118–121
online portfolios and, 118–124
outside of your book
 and, 115–117
portfolio visits and, 25–27
self-inventory and, 194–195
three main messages
 and, 111–114
poverty consciousness, understanding
 of, 201–202
Pressfield, Steven, *The War of Art*
 and, 143
pricing, pricing and quoting
 assignments, 27–28
print books, building
 and, 110–117

Q
quoting, pricing and quoting
 assignments, 27–28

R
Ray, Man, quote from, 101
reading, suggested reading lists
 and, 141–144
representation
 asking questions and, 78
 brokering successful relationships
 and, 85–87
 building a good business
 "marriage" and, 82–83
 contacting agents and, 81–82
 creating a successful team and,
 79–80
 fine arts photo rep and, 87–90
 new breed of agents and, 84–90
 objective help from business
 consultants, 91–95
Rice, Ted
 "living" the values and, 4
 reading list and, 143
risk taking, 41–42
Rolling Stone, Annie Leibovitz's early
 work for, ix
Roole, Lou
 finding the focus and, 161–162
 style of, 159–162

S
Scovel-Schinn, Florence, power of
 thought and, 189

self-promotion
 agents and, 130
 calling contacts and, 135–136
 cumulative effects and, 128
 dropping books and, 138–140
 e-mail and, 129
 "face time" and, 133–140
 focus of buyers and, 130–131
 marketing and, 131–132
 on the visit and, 136–138
 overview of, 125–127
 print portfolios and, 127
 seeing photographers
 and, 128–129
service component, pricing and
 quoting assignments, 27–28
Sharabura, Richard, *Shooting Your
 Way to a Million* and, 142
Sharpe, John, in-person visits
 and, 128–129
Sher, Barbara, *It's Only Too Late If You
 Don't Start Now* and, 143
Sherman, Stephen
 direct mail contact with buyers
 and, 170
 drop portfolios and, 169
 face time and, 167–169
 multilevel marketing plan
 and, 170–171
 selling and, 168
Silverstein, Patti
 collaboration and, 90
 Elemental PhotoArt and, 89
 fine arts and, 87–88
Smith, Zave
 building new portfolios and,
 49, 50, 51, 52
 consistent message of, 176–180
 faith and, 211
 marketing your product and, 10
Society of Photographers and Artists
 Representatives, 80
Standard Directory of Advertisers,
 corporate leads and, 185
*Standard Directory of Advertising
 Agencies,* Web site for, 185
Stewart, David, visual approach
 and, 17
stock options, business changes
 and, 105–108
stock photography, expense of, 59

success
 new marketing tools
 and, 188–192
 questions for improvement
 and, 40
 steps for success and, 185–187
 surviving during difficult times
 and, 183–187
success or failure
 becoming a client for
 a day, 31
 creating success and, 37–42
 overview of, 30–33
 risk taking and, 41–42
 take inventory and, 31
Summers, Ian
 clustering and, 157
 creative blocks and, 154–157
 Heartstorming and, 155
 I Am. . . , 157–158
 I Want and, 158

T
talent-based portfolios,
 backbone of photo business
 and, 48
team
 agents and, 69–71
 building a good business
 "marriage" and, 82–83
 consultants and, 74–76
 creating a successful team
 and, 79–80
 marketing assistants
 and, 72–74
 new breed of agents
 and, 84–90
 objective help from business
 consultants, 91–95
 realities of representation
 and, 77–83
 Team Armour and, 96–100
Team Armour
 keys to teamwork and, 97–98
 mission and, 98–100
Tharp, Twyla, *The Creative
 Habit* and, 142
timing, realities of representation
 and, 81–82
Tolle, Ekhardt, *The Power of Now*
 and, 144

tools
 building print books and, 110–117
 calling contacts and, 135–136
 creating a hot lead list and, 135
 dropping books and, 138–140
 e-mail and, 129
 "face time" and, 133–140
 new marketing tools and, 188–192
 one vision, multiple applications
 and, 114
 online portfolios and, 118–124
 portfolios: main messages
 and, 111–114
 reading and, 141–144
 self-promotion and, 125–132
 staying ahead of the curve
 and, 108–109
 stock options and business
 changes, 105–108
trends, staying ahead of the curve
 and, 108–109
Turner, Peter, quote from, 35

V
value equation, overview of, 16–18
values
 being a client and, 19
 creating your positioning statement
 and, 20–21
 defining your visual values
 and, 16–21
 listening and, 28–29
 portfolio visits and, 25–27
 pricing and quoting assignments
 and, 27–28
 service and, 32–33
 service component and, 22–29
 shaping relationships and, 7–8
 success or failure and, 30–33
vision
 adding portfolios and, 47
 articulating clear goals and, 37–39
 branding identity and, 59–60

building new portfolios and, 48–52
client's perspective and, 57–61
creating success and, 37–42
developing vision-based portfolios
 and, 43–47
development of, 31–32
gift of choice and, 62–66
integrating your vision on your site
 and, 123–124
matching vision and product, 61
multiple applications and, 114
reference tools and, 45–47
risk taking and, 41–42
vision-based portfolios
 developing and, 43–47
 reference tools and, 45–47
visual trends, stock options and
 business changes, 105–108
Volkswagen, "Drivers wanted"
 campaign, 60
Volvo, "safety" campaign and, 60

W
Web sites
 buying lists and, 185
 communicating your vision and, 47
 list of, 217–218
 Marc Norberg and, 21
 portfolios and, 115
 Robert Kent and, 17
 Standard Directory of Advertising
 Agencies, 185
Weegee, Rolling Stone and, ix
Wendt, Dave, list of books and, 143
White, Ed, building new portfolios
 and, 49, 50, 51, 52
White, Minor, quote from, 1
A World Without Fear
 Foundation, 205

Y
Yogananda, Paramahansa, Journey to
 Self Realization and, 144

ABOUT THE AUTHOR

© 2002 Marc Norberg

Selina Maitreya has been an international consultant, teacher, and guide to creative talent for the last twenty-seven years. She is, at her core, a vision driver—a steering force who believes in approaching each client with respect for his or her unique individuality. A proponent of taking responsibility for one's life, her vested interests lie in the "who you are" as opposed to "what you do." Selina's mastery as a consultant stems from her appreciation for both of these interpretations of the human/creative enterprise and her ability to strike an equilibrium between them for her clients.

Selina became involved in photography at the age of twenty-one when she attended the New England School of Photography. Shortly thereafter she represented Boston photographers nationally and then moved into the consulting realm, becoming one of the first photography consultants in the country. Her best-selling book, *Portfolios That Sell* (Amphoto Books), was published in 2003 to wide acclaim.

Selina's spiritual journey began when she was fourteen, long before her introduction to photography. Twenty-eight years later, and through her consulting practice, Selina was introduced to her current spiritual teacher, Janice Hope Gorman.

As Selina pursues her lifelong careers as both teacher and student, she brings significant industry knowledge and a deep spiritual perspective to the photographic community. *How To Succeed in Commercial Photography: Insights From A Leading Consultant* is the result of Selina's business wisdom and experience, heartfully wrapped in a blanket of spirit. Selina can be reached at selina@selinamaitreya.com.

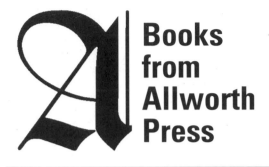

Books from Allworth Press

Allworth Press is an imprint of Allworth Communications, Inc. Selected titles are listed below.

How to Grow as a Photographer: Reinventing Your Career
by Tony Luna (paperback, 6 × 9, 224 pages, $19.95)

Photography Your Way: A Careers Guide to Satisfaction and Success, Second Edition
by Chuck DeLaney (paperback, 6 × 9, 336 pages, $22.95)

Digital Stock Photography: How to Shoot and Sell
by Michal Heron (paperback, 6 × 9, 288 pages, $21.95)

The Professional Photographer's Legal Handbook
by Nancy E. Wolff (paperback, 6 × 9, 256 pages, $24.95)

Pricing Photography: The Complete Guide to Assisgnment and Stock Prices, Third Edition
by Michal Heron and David MacTavish (paperback, 11 × 8, 160 pages, $24.95)

The Photographer's Guide to Marketing and Self-Promotion, Third Edition
by Maria Piscopo (paperback, 6 ¾ × 10, 208 pages, $19.95)

The Photographer's Guide to Negotiating
by Richard Weisgrau (paperback, 6 × 9, 208 pages, $19.95)

Liscensing Photography
by Richard Weisgrau and Victor S. Perlman (paperback, 6 × 9, 208 pages, $19.95)

The Real Business of Photography
by Richard Weisgrau (paperback, 6 × 9, 224 pages, $19.95)

Business and Legal Forms for Photographers, Third Edition
by Tad Crawford (paperback, 8 ½ × 11, 192 pages, includes CD-ROM, $29.95)

Publishing Photography: Marketing Images, Making Money
by Richard Weisgrau (paperback, 6 × 9, 240 pages, $19.95)

Photo Styling: How to Build Your Career and Succeed
by Susan Linnet Cox (paperback, 6 × 9, 288 pages, $21.95)

Starting Your Career as a Freelance Photographer
by Tad Crawford (paperback, 6 × 9, 256 pages, $19.95)

Creative Careers in Photography: Making a Living With or Without a Camera
by Michal Heron (paperback, 6 × 9, 272 pages, $19.95)

To request a free catalog or order books by credit card, call 1-800-491-2808. To see our complete catalog on the World Wide Web, or to order online for a 20 percent discount, you can find us at ***www.allworth.com***.